HOW FAMOUS PHOTOGRAPHERS WORK

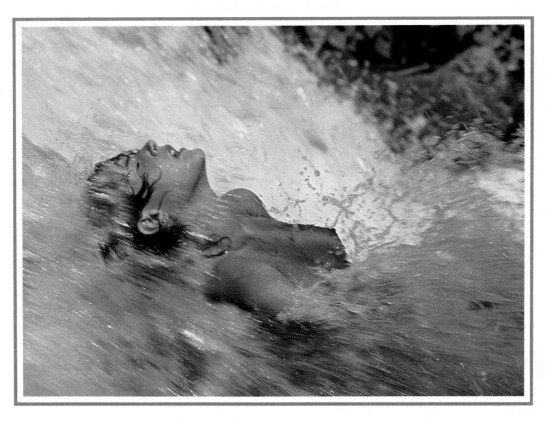

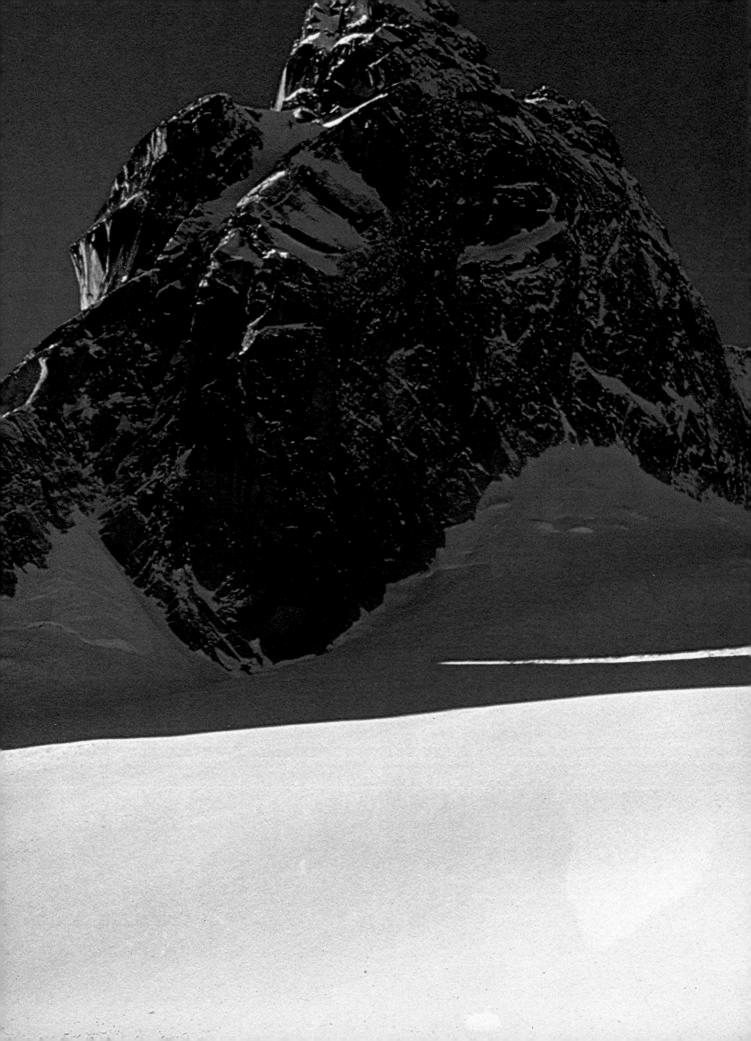

HOW FAMOUS PHOTOGRAPHERS WORK

COLLINS

Published in 1983 by
William Collins Sons & Co Ltd
London • Glasgow • Sydney • Auckland •
Johannesburg • Toronto

Designed and produced for
William Collins Sons & Co Ltd
by Eaglemoss Publications Ltd

The interviews in this book were originally
published in *You and Your Camera* and the
information has been updated.
© 1983 by Eaglemoss Publications Ltd.

ISBN 0 00 411768 9

Printed in Spain

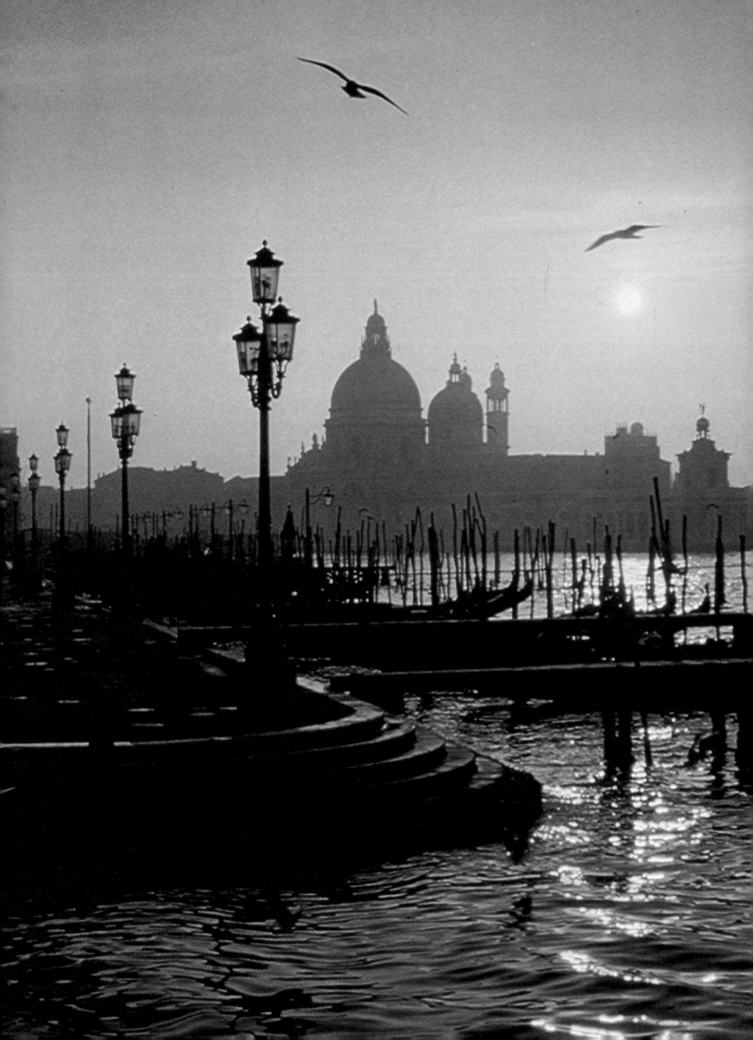

CONTENTS

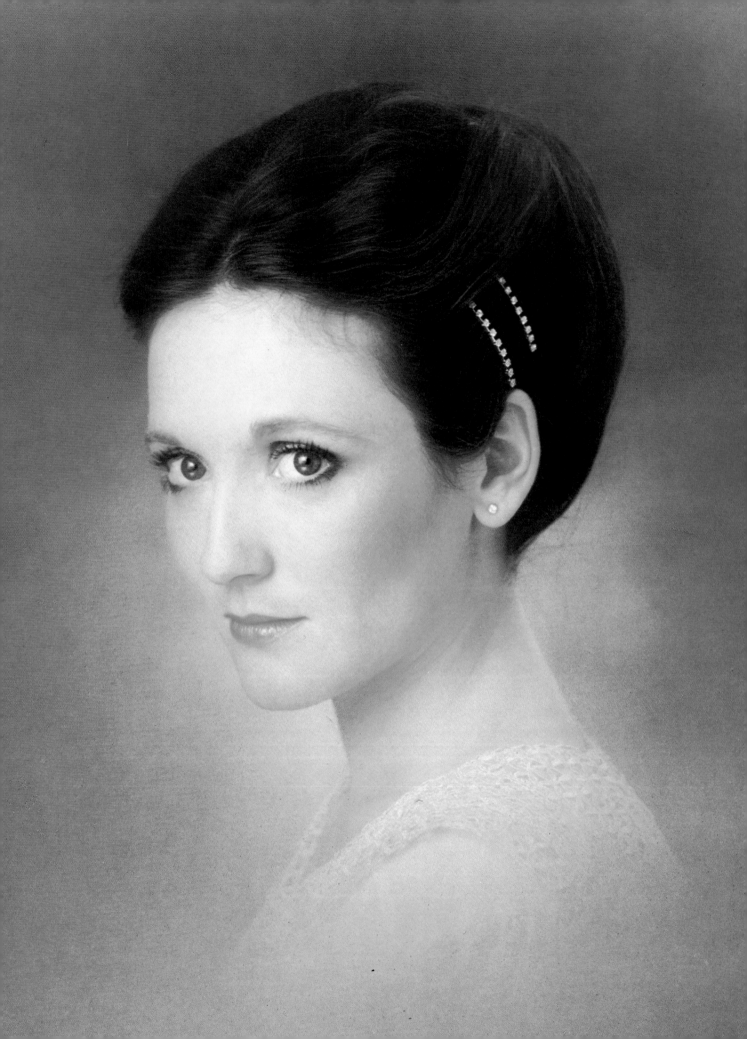

INTRODUCTION

If you really want to know how to take better pictures, ask the experts—the people who do it for a living. Unlike the amateur photographer, the professional cannot simply take pictures he likes when he sees them. Instead he has to be able to take top quality pictures day in and day out, come rain or come shine. Often the subjects are not ones the professional would choose for his own enjoyment, but then, he does get well paid for it.

However, because of the volume of work required, and because many subjects require great expertise, professional photographers tend to specialize in one particular area—sport, nature, children, beauty, still life etc. Specialization brings a high degree of expertise. Thus the professional develops ways of solving problems that may not be evident to someone outside the field.

This book is devoted to discovering and passing on the short-cuts used by leading professionals. Forty photographers were interviewed to find out how they actually work—the equipment and film they use and, most important of all, how they approach their subjects. Each interview is illustrated with a selection of the photographer's work.

How do people become top professional photographers? If there is a secret of success, it is that perseverance and commitment count for more than anything else. There are no artificial barriers. Anyone can become a professional, as long as they can deliver the results.

But I hope this book will not only be read by keen photographers and would-be professionals. Photographs now play an enormous part in all our lives, and the vast majority are produced by professional photographers. The portfolios here provide important insights into the sort of people who take these pictures, and how they go about it. These insights are surely relevant to everyone.

Jack Schofield

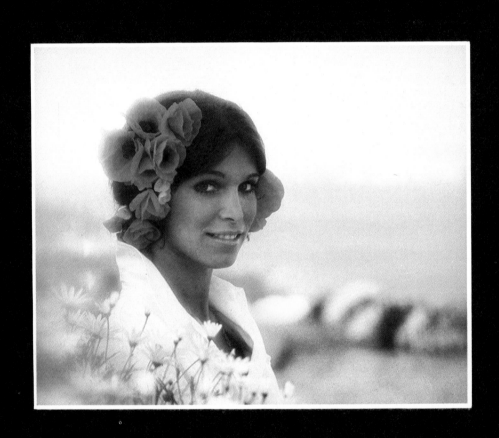

PEOPLE

Everyone photographs people. Every popular camera can be used for the job. People can be photographed anywhere—on the beach, at work, at play. How is it, then, that the professional photography of people still flourishes? The answer is that most pictures of people are snapshots. They satisfy the people in them, and the people who take them, but not much more. The professional aims to please a wider audience. This may be just to sell a product. At best, however, it may do more—capture the essence of a person, or a people, in a way that appeals to all of us, and perhaps even transcends time. Few succeed, but even the failures are interesting.

EVE ARNOLD

People come in all shapes and sizes, and so do people photographers. Eve Arnold is petite, white-haired and a grandmother. Anyone lulled into complacency by appearances could overlook the fact that she is extremely tough and has a mind like a razor. After 30 years as one of the world's leading photojournalists, she continues to tackle huge projects with great vigour. Most recently she has photographed China, producing both a book and a major exhibition, and spent three years photographing her native United States.

Yet, like many leading exponents of the art, she became a photographer almost by accident. She was studying medicine when her fiancé gave her a Rolleicord camera. Later she enrolled on a six-week course at the New School of Social Research in New York. The course was being run by Alexey Brodovitch, Art director of *Harper's Bazaar*, and most of the students were professionals. The class assignment was to do a fashion picture, and that led Eve Arnold to ask her baby's nursemaid if there were any fashion shows in Harlem. There were, almost daily. At the time, black was not considered beautiful, nor even acceptable. Brodovitch liked the pictures, and she followed up the story. Her husband mailed some pictures, without telling her, to *Picture Post* in London. They published them, and her career had started. In 1951 she was the first woman to be invited to join the great picture agency, Magnum.

'I don't let the techniques dominate me,' says Eve Arnold. The film director Joseph Losey, for one, knows she means every syllable of that: French *Vogue* commissioned him to direct her to produce 50 pages of fashion pictures during the 1977 Paris collections. Together they decided to tell the story of *haute couture* collections so that people who had never been would know what it was like. Eve had the strong conviction that to add light would be to change the atmosphere. 'What happened was we travelled in a mini bus, and behind us was a car filled with lights. I never *once* used those lights. The point I'm trying to make is that the amateur wants too many laws, too many rules. I try to break all those rules.'

Eve Arnold is constantly aware that the public knows the faces of the famous. Sometimes she works at catching the definitive expression which tells us more. 'And I find I get more interested in what goes on in the background of their lives. When I photographed the Queen for *The Sunday Times Magazine* we had her back on the cover and the faces of the public, registering their emotions at seeing her so close. When I went to see the Pope, I photographed somebody ironing his vestments.'

Surprisingly, she finds actors are terrified of being photographed. 'They know what a still camera can do. There's a click and the moment is frozen in front of your eyes forever. A movie camera is only part of the story—there's sound and action to distract you.'

Eve Arnold says she does not try to make people seem more beautiful than they are. 'When I go into a room with a camera there's nothing so grandiose in my mind as a search for Truth or Beauty in capital letters. As a photojournalist I have to have a point of view. There are things that I hate. War. Poverty. Disaster. The usual things. Also I have a certain sense of the banality of life and I try to get that across. What I look for is what is there: I try to project a heightened sense of what

ABOVE Eve Arnold's pictures are subjective, reflecting her mood, experience and background. She cares about her subjects. By showing them against a related background or absorbed in some activity she is able to 'get at the person beneath the surface'.

RIGHT Taken with a medium telephoto lens, this picture of a lady archer, from a series on Royal Societies, required close cropping and also perfect timing. Eve Arnold positioned the subject and then waited for the right moment in her reaction to what was going on around her.

is there without glamourizing it in any way at all.

'If my subjects appear to have dignity—and usually I want them to—it's because I feel that if someone has taken me into their home or given me their face to work on then I must have a certain regard for that person, I must try not to savage them. I don't set out to make them beautiful. I set out not to make them unappealing.'

Eve Arnold has tended to avoid using wide angle lenses for portrait work: 'You always get some distortion, but I think if you use a distorting lens you are setting yourself up as judge and jury. That's just not for me. I try not to impose myself. That's why I work with a small camera, why I don't set up lights, why I try not to intimidate. I try to let what is underneath come out.

'I work with Nikons. Early on in the fifties when I started, everybody in America, it seemed to me, used to work with a square format—a very difficult frame to fill but it was all part of that era.' She used her Rolleicord for her first year as a photographer until she felt she had taken the best possible pictures she could and then she moved on to a Rolleiflex. At the moment she does not think anything could woo her away

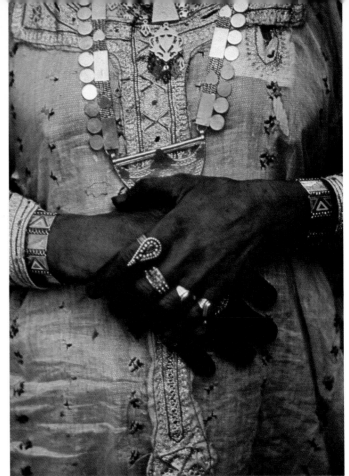

from Nikons. 'I've been using them for a quarter of a century. They stand up to a terrific amount of abuse. I work fairly intensively and I literally wear them out. I've got one portrait lens, a 105mm, which I call my compassionate lens. You can work from a distance of a couple of paces. It's soft but quite sharp. It gives you a sense of the face without being savage.

'Young people tell me they want to be photographers. If there's one thing I can pass on to the next generation of photographers it's that there should be this sense of letting yourself loose with your camera. Sure, you need to know what the speed of your film is. All you need to do is read the manufacturer's instructions inside the packet. The main thing for me is that it's intuitive. It's a matter of feeling the picture, seeing what there is, taking what's in the brain and combining it with the outside world.

'I play roulette. I take some chances. I'm aware that everything you work with on film is a variable. The speeds of your film are variable. Your shutter speeds are variable. Your subjects move. You move. Everything's going on at once and in the middle of the juggling act you have to hang on to your own ability to make the picture right. There's no formula. I just know when I go into a room whether I'm going to get my picture.

'I'm often accused of using too much film. This is not important. A photographer can't re-write. You can't go back, the moment's over. Again, some of my colleagues take me to task because I don't walk around all the time with a camera. I think maybe subconsciously I see pictures in my eye all the time. It would be wonderful if the eye could go snap instead of having to have this piece of machinery, the camera, in front of you. I think that I'm always noticing things, such as the way the light strikes somebody's face, and I think I must put it away for future use. But I'm not aware that I'm a photographer if I'm not on an assignment. I need the time in between to wash my eyes out, I need to relax, see what's going on in the world.'

Eve Arnold says that what's really fun about photography is that after all these years she's still learning. 'The day I walk away from a job and think, "Gee, you were smart to crack that one," that will be the day I retire. I'm never satisfied with anything I've done. There's always this nagging feeling that maybe I should have been a couple of paces to the left.'

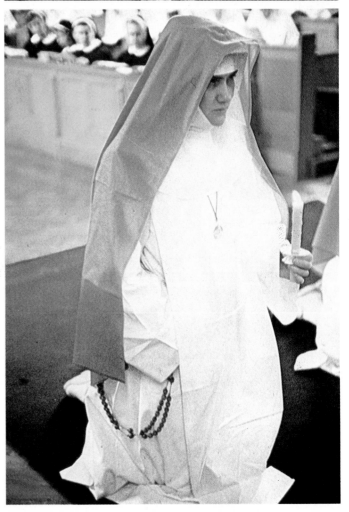

FAR RIGHT The gentle lighting in this picture of a Russian mother and child was achieved by photographing them in the shade of a tree. Eve Arnold uses her 105mm 'compassionate' lens for much of her portraiture as the longer focal length of the telephoto allows her to come in close, capturing the details and textures without distorting the faces.

ABOVE RIGHT Details can say as much about a person as the whole figure. The patient way this Arab woman's hands are clasped, the jewellery, the rip in the net on her bosom all give clues to her way of life.

RIGHT The final vow. Eve Arnold believes you have to move in close to make something happen between the subject and the person looking at the picture.

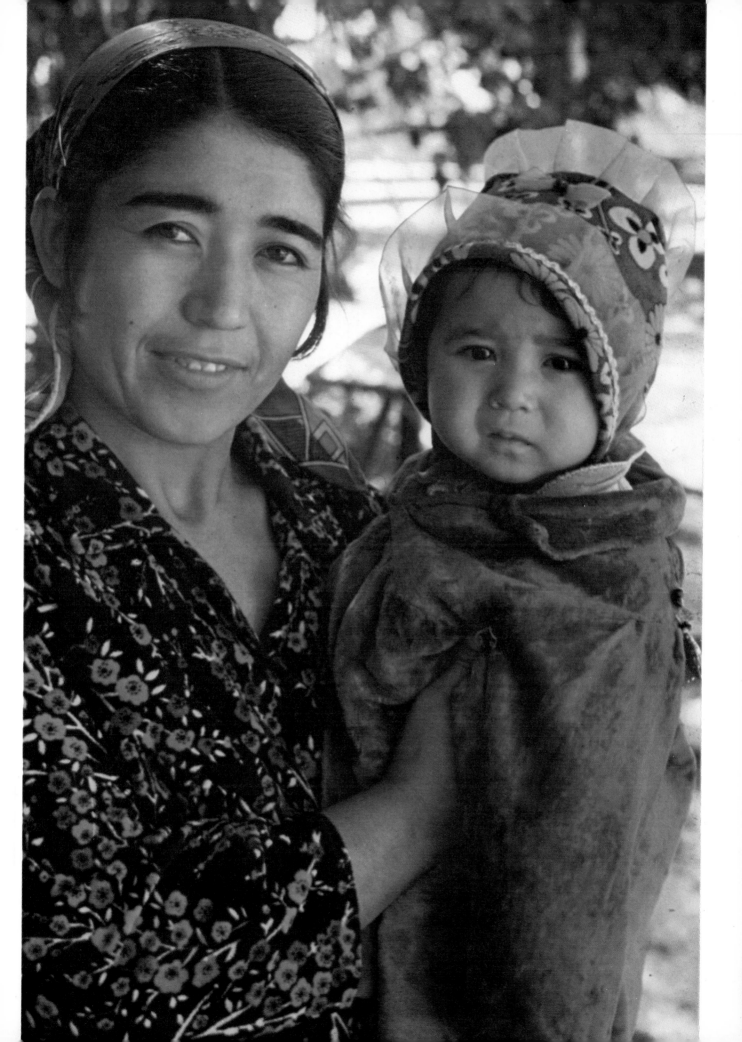

Anthea Sieveking

While Anthea Sieveking photographs people in general, she has become best known as a photographer of childbirth and children. She has taken pictures for a number of books and exhibitions on active birth, babycare and fatherhood, often working in delicate and difficult conditions. The essence of her approach combines simple photographic equipment—so that she is as unobtrusive as possible—with the cooperation of her subjects. She must always establish a trusting relationship with them.

After working in a portrait studio and as an assistant, she got her break when *Woman* magazine offered her a retainer to do reportage. She was working with a Rolleiflex twin-lens reflex camera that had belonged to her mother. She still has that camera. 'It is very quiet and, for its day, has a beautiful lens, but being non-interchangeable, it's a bit limiting.'

Then followed a course in photography at a technical college, where she acquired new skills. She feels she learned more for already having a certain amount of practical experi-

BELOW In overcast evening light, Anthea Sieveking photographed this group of cubs as they waited for their meeting. She used a 50mm lens on an Olympus OM-2 with Ektachrome 200 film.

RIGHT The sun had just set behind the hill. To get the figure in silhouette she set her OM-2 on 'automatic' and let it expose for the background. She used a 75-150mm zoom lens.

ence. With a growing number of commissions from magazines, it became possible for her to set up on her own. Her first studio was above a café in the King's Road, at a time when Chelsea was an exciting place to work. The darkroom was below the café and she was driven out by spaghetti, almost daily blocking the darkroom drain and oozing out on to the floor. Later she moved to a studio in Soho. Now she works from home, having had a studio built at the top of the house, with light coming in from all sides. Of course, she still does a lot of work on location. Recently, for example, she has completed a series of studies of artists at work for the Arts Council of Great Britain. Anthea Sieveking does all her own black and white processing, mostly using Promicrol developer.

Most of her pictures are taken by available light. But, she

LEFT AND BELOW Both pictures were taken at a local school Anthea Sieveking often visits. She finds that after a time the children forget that she is there, and she can capture unguarded moments. Both shots were taken with an OM-2 on Ektachrome 400 ASA film.

RIGHT This little girl was photographed in the back seat of a car with a 50mm standard lens. Because there was light from all sides there are no shadows and the face is perfectly lit. For most portrait shots Sieveking uses a 1A filter to avoid any hint of blueness in the skin tones.

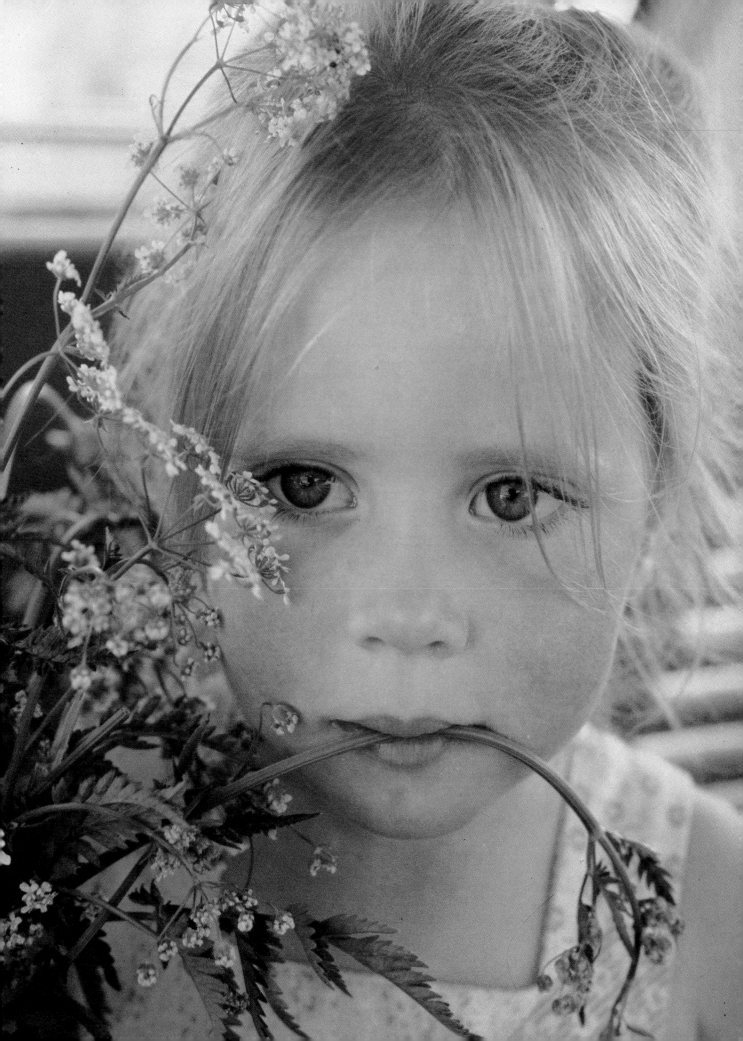

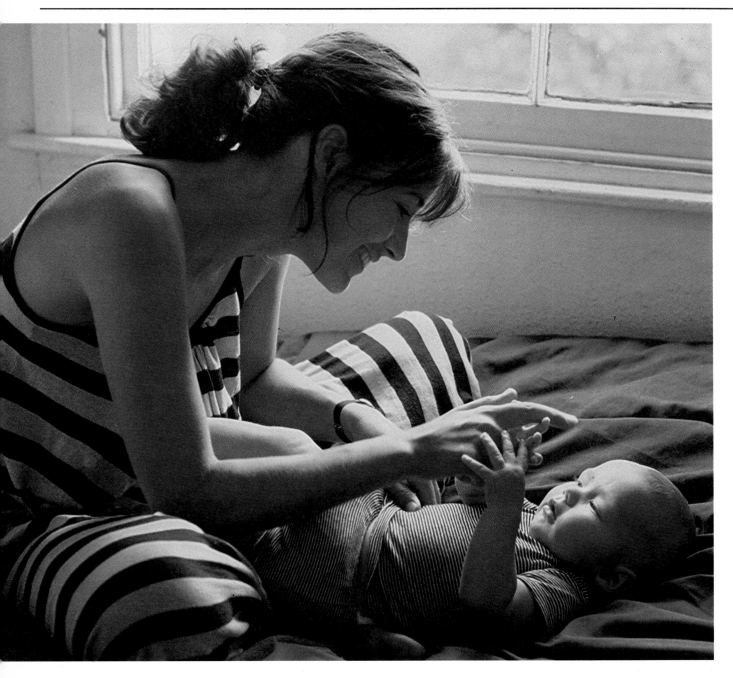

says, 'I do use portable lights—four tungsten-halogen flood-lamps which I sometimes need to use with daylight. They are used with dichroic filters to convert the colour temperature from artificial light to daylight. But lighting can tend to falsify a situation and it limits you to taking photographs in the area which is lit'.

Anthea Sieveking likes to photograph people beside windows so she can use side- or back-lighting. However, this can lead to problems because exposure meters are always fooled by fierce back-lighting: it is necessary to expose for the face. That means taking a close-up reading which excludes the background. To cut down the lighting contrast and provide fill-in, she arranges reflectors to lighten any shadows. These are plain white card backed with silver foil, and can be used either way round.

Currently she finds the films that suit her work best are Ektachrome 400, Ektachrome 200, and Tri-X with a speed of 400 ASA. She nearly always needs a fast film, and may occasionally uprate it—expose it at a speed higher than its standard ASA rating, and increase the development to compensate. When using Ektachrome and where skin colour is important, she often uses a Kodak Wratten 1A or even an 81A 'warming' filter. On overcast days this avoids getting a blue cast on the skin tone.

As for cameras, Anthea Sieveking has a Hasselblad roll-film camera, several 35mm Nikon SLRs and an Olympus OM-2. She feels it is a mistake to have two different 35mm systems—Nikon and Olympus—but each has its own qualities, which makes her unwilling to take the step of rationalization.

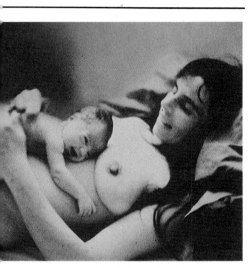

ABOVE This 'Leboyer' birth was photographed only minutes after the father had delivered the baby. The only available light was from a 25 Watt bulb reflected off the ceiling, which meant she had to 'push' Ektachrome 400 film to an effective speed of 1500 ASA. For absolute quiet, she used an Olympus OM-2.

LEFT It often happens that at the end of a photographic session the mother and baby become more relaxed and the photographer can get the best pictures. Using the available light from the window behind, Anthea Sieveking took a close-up reading from the face so that the figure would not be thrown into silhouette. She used a 50mm lens on a Nikon.

RIGHT Because the window light created dark areas on the left of the picture, Anthea Sieveking used a portable tungsten 'redhead' light to fill in the shadows. The light was reflected off the ceiling, and she used a filter to convert the colour temperature to daylight for use with Ektachrome 400 slide film.

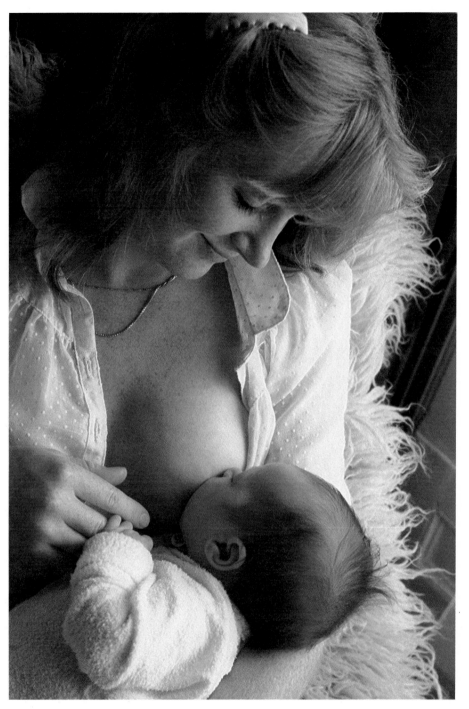

'Olympus cameras don't seem as strong as Nikons,' she says, 'but they are quiet, which is very important to my work, especially when recording a Leboyer birth where the sound of the shutter can be intrusive.' (Dr Leboyer has developed a method of natural childbirth which aims to reduce the trauma of birth by ensuring that the baby emerges into quiet, dimly-lit surroundings.) More recently, she has been working with Janet Balaskas, photographing births for a book for the Active Birth movement, where quietness is not so important.

Her great interest in photographing children developed from having her own. She is particularly interested in recording the various stages of development. This often begins with the pregnant mother, followed by the birth. For this she uses two cameras, one with a normal lens and one with a wide-angle.

Often a motor drive is invaluable. For older children she finds a 75-150mm telephoto zoom helps get unobserved shots.

When photographing babies, she emphasizes that patience is necessary to wait for those fleeting moments of animation, which often occur during or just after feeding. 'But the mother must be in the right mood, the baby's head must be supported by an arm or a knee, the clothes must be simple and light—or perhaps none at all—and there must be no light glaring in the baby's eyes. There is a lot to get right, but one wrong thing and the picture is useless.'

Anthea Sieveking feels the overriding success of her shots depends on speed of reaction. 'Unless you know your camera extremely well you can get bogged down by the mechanics of it all and you won't be quick enough.'

Patrick Lichfield

'Being a people photographer means making a study of people as well as of technique. Pretty well all people photographers are good communicators—it's no use trying to become one if you aren't. When I'm photographing anyone—whether it's fashion, a portrait or advertising—I keep up a non-stop chatter. I love anecdotes. They stay in my mind, and I can always fetch out one or two to keep things flowing smoothly.

'I do a lot of formal pictures, and there's certainly a call for them. I keep seeing Royal pictures which are informal described as *refreshing,* but if you have someone wearing a uniform you can't start larking about on the edge of a grouse moor. You've got to make it look as natural as possible, and hope that through enthusiasm, through chatter, you can relax them to the point where they don't seem stiff. The thing that ruins formal portraits is stiffness.'

The fifth Earl of Lichfield is far from stiff himself, and seems completely relaxed whether photographing royalty or shooting advertisements for 'unmentionable ladies products'

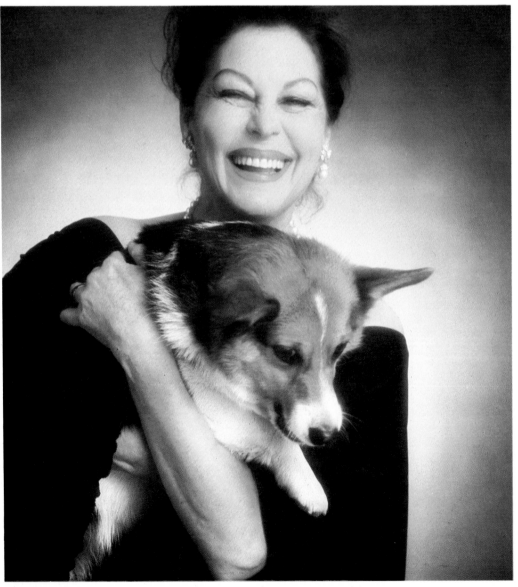

RIGHT Lichfield was given five minutes to take this fine portrait of Lord Goodman. He used a 150mm lens on his Hasselblad with an extension tube to get the extreme close-up. The light source was one flash with an umbrella reflector above and behind Lichfield's head. The telephoto lens is useful for portraits, giving a detailed close-up without intruding on the subject. This picture was taken on Tri-X film and processed for 12 minutes in D-76. Exposure was 1/250 at between f/11 and f/16, a half-stop extra being given to compensate for light loss in the extension tube.

LEFT Ava Gardner with her corgi taken with a 150mm lens on a Hasselblad. The lighting is from a wooden structure built by Lichfield and containing 30 domestic light bulbs for modelling, with a diffusing screen of tracing paper over them. The exposure is made by a flash inside this 'fish fryer', with its light being bounced off the white back, through the diffusing screen and on to the subject to produce this soft and flattering effect. It was taken at 1/250 at f/8.

or glamorous semi-nudes for Unipart calendars. 'It would be silly to say that having a title doesn't help,' he says, 'but it's knowing how to do the job that really matters. A title can't take photographs.'

After starting with a Vest Pocket Kodak at the age of seven, he now uses Olympus 35mm SLRs and Hasselblads in the studio. For the latter he finds the Polaroid back invaluable: 'it's the single most helpful thing that's happened since I started out! Now I can look at a shot—or at least an excellent impression of it—the minute it's taken.'

In his wallet he still carries one very important Polaroid: the test shot for his wedding pictures of Prince Charles and Lady Diana—the Royal Wedding. It was not the first wedding he had photographed. 'I'd done 157 weddings before that. I spent four years on "Jennifer's Diary" on *Queen* magazine. I had to do all the society weddings, and I got really quite adept at it. In the very early days we used 5 x 4 Speed

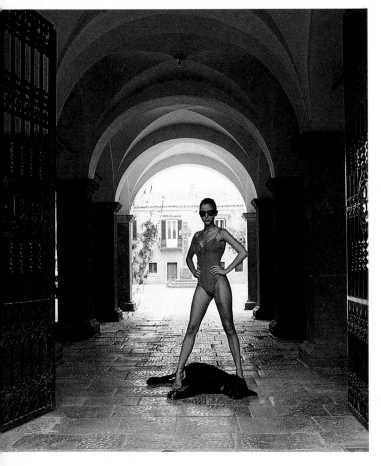

ABOVE The 1982 Unipart Calendar was shot on location in Sicily. Lichfield used the exotic settings for some unusual glamour pictures. This was taken on an Olympus OM-2 with a standard 50mm lens and Kodachrome slide film.

RIGHT The Royal Wedding couple taken on the balcony of the inner courtyard at Buckingham Palace. Lichfield used a plain white sheet as a background, his Hasselblad with 150mm lens, natural daylight plus fill-in flash, and only one roll of film!

Graphics which need reloading after every shot—and that wasn't just for groups—I was doing everything from the bride getting dressed to the confetti throwing.

'I shot the Royal Wedding on four Hasselblads linked together on a bracket between two tripods, and fired by a solenoid. As they were all motorized EL's they also wound on, but they couldn't be too close together as you had to be able to get the darkslides in and out.' Using four cameras gave him an edge over the other two photographers—'the agency bloke and someone from the rota'—who also covered the wedding. He shot black and white and colour at the same time, getting three colour originals for duplicating, 'and the insurance if one of the cameras stopped working.'

His most amusing idea was using a referee's whistle to attract everyone's attention. 'I'd looked at a lot of the pictures taken in the days before flash, and in the really big groups you could always see people moving during long exposures. Obviously if you start lining people up from left to right, by the time you get to the right, the first lot are already talking to one another. Then if you have to retreat to shoot from a distance, you have the problem of being heard. A blast on the whistle was really useful!'

His last idea was sneakier. He made a clicking noise to make the other photographers think he had taken his last shot, and after they had finished their films, he told the wedding group to collapse. Then he shot his exclusive picture of the happy group sprawled on the floor.

Even so, Lichfield says 'the best wedding photographs are always the candids taken on a small rangefinder camera'. He has taken many candids of people too. 'When you start,' he says, 'you put on a long lens and shoot from across the road, rather than go out with a 35mm lens and take risks. It's very unlikely you'd get beaten up—the worst I've had is abuse from people who don't want to be photographed, in which case you go away quickly.

'I learned this when I was doing a story on the great families of Europe for *Life*. I was at Blenheim and felt I was interfering, so I hooked on a long lens and shot from a distance. *Life* said "these look as though they were taken for *Paris Match*! They look like you weren't invited to be there. Now go back and do it on a standard." You've got to appear to be in amongst them, which you never are with a 400mm.'

If you are in among them, is there a secret to not being noticed? 'Yes there is, actually. When I photographed the Queen on a tour of the Far East I was with her for 20 days or so, and I was told to photograph everything she did. If you go on clicking you cause a major irritation, hopefully at a rather early point, and after that you go unnoticed. The man with the camera is always there going click click click. And it helps to use a quiet camera, to avoid using flash wherever possible, and to avoid rapid movements.'

Like most people photographers, Lichfield shoots a lot of pictures—about 300 per working day. 'I could be more economical,' he admits, 'but it's *always* worth shooting that extra roll, as the first roll is almost always a write-off because no-one has warmed up. I sometimes overact and fire away like mad. I find that's infectious. If you can dance about and be enthusiastic and say "that's terrific", and make the thing fun, the next picture is going to be even better!'

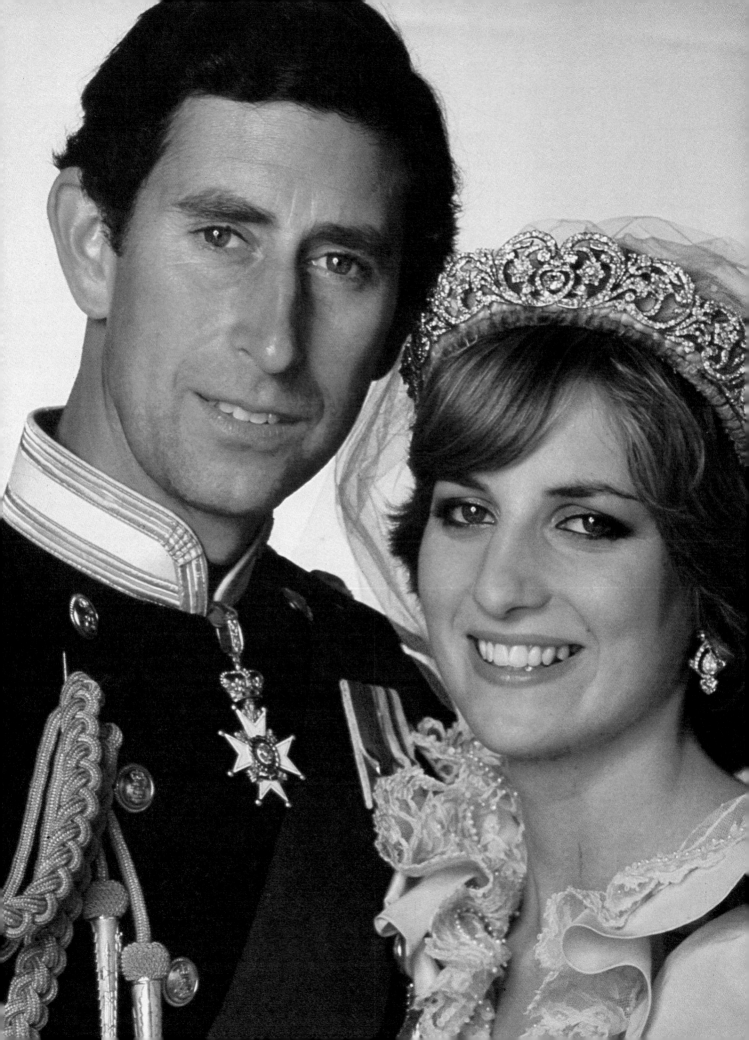

there is a discipline that comes with a proper business arrangement. A professional model knows how to make the most of herself, and most of all she knows how to generate that vital energy between herself and the camera. She needs to be something of an actress.'

He uses a make-up artist, but keeps a careful eye on things while 'the angel is manufactured'. Lipstick can be a problem—red lips always look redder on film—or a hair stylist will leave an untidy curl here or there.

He shoots his black and white fashion pictures on a 6 x 7cm format camera using Tri-X which he develops in D-76. He likes a white background for his studio shots and leaves it unlit so that it turns out a nice grey. For colour he sticks to 35mm and Kodachrome with a longish lens—usually a 135mm. The new colour films, he says, simply don't match the quality and 'cleanliness' of Kodachrome. He always uses a tripod, and hardly ever moves the position of the camera once he has started.

It is a matter of discipline: 'In a sense, the picture is taken before I start. Some photographers squirt off dozens of rolls, experimenting with different angles and different lighting as they go along. Certainly every session has its lead-in, a peak and a dying-off period. Expressions and detail change but the picture stays much the same all the way through.'

This self-imposed discipline has been a feature of Donovan's work from the start—a discipline which might have been applied to the culinary and not the visual arts. At the age of 11, he wanted to be a chef. His teachers decided that he was too young to cook and encouraged him to learn lithography instead, but later he got distracted by what was going on in the photography class down the corridor. By the time he was 14, he knew that photography was all he ever wanted to do.

From college he went into the army to do his National Service. While his mates spent their time shooting off blanks, Donovan was shooting off pictures of everything from machines to chest operations in the camp hospital, and finding time for the occasional wedding and portrait job. When he came out of the army he found himself a job as a darkroom assistant. (He still prints all his own pictures today.) He moved from one darkroom to another, each time finding a new short cut to speed up the boring process and each time being rewarded for his efforts with the sack. In the end he was taken on as an assistant by fashion photographer John French. There were two other young hopefuls working with him—one was called David Bailey and the other Brian Duffy.

'It does not matter what the job is,' says Donovan, 'you should always know how the technical side works. My father was a lorry driver whose main job was getting the food to the shops, but if he broke down he had to get himself moving

Terence Donovan has been one of the celebrated band of front-line fashion photographers in Britain for the past 15 years. The son of a lorry driver, he made his name in the 1960s by taking the sugar out of fashion pictures and adding instead a little spice.

Now in his forties, his pictures in *Vogue, Harpers, Cosmopolitan* and *Elle* show that he has mellowed a little over the years. Fashion photography, he says, should be about clean, visual reporting. He is very much against what he calls 'amusing' pictures—girls gyrating all over the place with lots of weird and wonderful props. As one fashion editor put it: 'You recognize a Donovan picture for its quality, not its gimmickry.'

Studio pictures, he says, work best with the model static—a motionless confrontation between girl and camera. 'The important thing is to find the look to go with the clothes to create a mood. Mood is vital, but it has to be a joint effort. You take the mood from the girl, and build your picture round it.'

He lets an agency produce a short-list of models for each session, and then makes the final choice himself from photographs. 'It's a terrible mistake to think that a girl who looked great at last night's party will necessarily make a good model. There is no substitute for a professional. For a start

RIGHT This picture, shot with the model staring straight into the camera, is tightly cropped to emphasize the mood and exclude distracting surrounding detail. When shooting a model in a car, lighting can be a problem; watch where shadows fall and try to use available light or well-diffused flash.

FAR RIGHT A striking portrait of actor Edward Fox taken in soft directional light, highlighting the hair but giving strong contrast. Donovan would choose a wide aperture to limit depth of field, focusing around the eyes and mouth to capture the details and surface texture.

again.If a photographer goes into a session worrying about the technical side of things, he is not going to have time to think about the pictures.'

Today, Donovan is as enthusiastic about photography as he was when he was 15. But his stills have become a labour of love; the financial rewards come from directing television commercials. In 10 years he has made more than 1600 of them. He put the man appeal into Manikin cigars. He has put failing bodies into Playtex girdles; Persil into washing machines, and his own convincing style into Falmers jeans. The commercials and the fashion, and more lately his nudes, leave him little time for portraits. But those he does are always a challenge, with the session starting well before he gets to his studio: 'You should know what people look like in advance. Then you have time to think how they photograph best by deciding what elements of the face are important.'

A single umbrella flash unit is often his only source of light. He shoots his black and white portraits of men on a 10 x 8 plate camera, producing 20 careful negatives during an average session. 'The large format produces good texture and savage sharpness. And the very size of the camera helps to create that sense of confrontation which produces an acute consciousness and the kind of reaction from a model that I like.'

The large format does not work for portraits of women. The sharpness is not glamorous, he says. So he sticks to 35mm and thinks nothing of using an exposure of one second with low soft lighting.

He admits that he has to find a girl attractive before he can photographer her. 'It's a gloomy moment when you look through the lens and find nothing there that excites you. You don't get any thanks if the picture goes wrong, so it's best to load the dice in your favour before you start.'

LEFT Donovan always uses professional models, choosing them from an agency's short list and making a final decision from the photographs they supply. Here he lets the background go out of focus and, with soft lighting, the mood he creates is sensual and mysterious.

BELOW Donovan uses a single umbrella flash to highlight the hair, eyes and lips. For black and white pictures he uses Tri-X film produced in D-76 developer to retain some detail in the hair. In printing this picture, he let most of the frame go dark, but held back the right hand side.

COLIN JONES

Of all the truly great people photographers, Colin Jones is perhaps the least well known. This is not because his work is not widely published—his reportages appear regularly in the Sunday supplements and the leading international magazines. Rather it is because he shuns publicity. 'There is too much to do,' he says, 'to have time to stand around and admire your own work, so I would rather it happened when I'm gone. Then people can do what they like.'

Colin Jones spends most of his time in areas of the world which are on the edge of catastrophe, due to war, drought or famine. 'In the "Third World", photography is not a creative medium,' he says. 'They can't afford such luxuries.'

His purpose is to alert us to the plight of our disadvantaged and oppressed neighbours. This does not mean he only photographs people suffering from starvation. In fact he regards that as sensationalism—the province of the news photographer, rather than the socially concerned one.

'It's not difficult to get those pictures,' he says, 'they are *there*. People are in too much of a daze to show any hostility. It is before it gets to that stage, before the tragedy really happens, that I try to get in. I want to show the situation where something is *going to* happen, to try and get something done before it's too late.'

That, of course, is more difficult. To begin with, many governments try to keep out photographers from overseas before the situation reaches disaster level. Colin Jones finds he often needs a permit signed by, for example, the Minister of the Interior of a country to be able to work. Often the permit will expressly forbid him from taking pictures of 'beggars and other undesirables' but these are just the groups he wants to photograph! It leads to endless problems with local officials.

'The last freedom for photographers was the Vietnam War,' he says. 'That was put on for the media. Now the situation is unbelievably difficult, and war is taboo. Part of the job, now, is

RIGHT It took Colin Jones three weeks to reach this pygmy hunting party in the Ituri rain forest in Zaire, central Africa. They are resting near a fire lit to ward off evil spirits. The shot was taken on assignment for The Sunday Times Colour Magazine *to document the way of life of the pygmies while there is still time. 'It's amazing that there are campaigns to save the whale,' he says, 'but not to save the pygmy, which as a race is even more likely to die out.'*

BELOW Sugali women from the village of Kalarapalli in central southern India. 'They are the lowest caste—a sort of Indian equivalent to gypsies,' he says. The picture was taken while on assignment for The Observer, *covering the drought on the Mysore Plateau.*

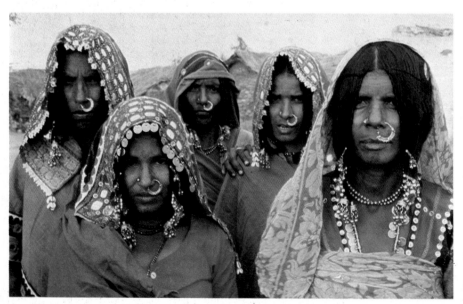

to sit down and work out how to get in after they've said no.'

Even when he reaches his subjects, he still has the problem of making friends with them. For some tribes the camera is a threat. For others, it is merely an instrument of western propaganda. In neither case are the people keen to be photographed. Then you have to work fast. 'It can take weeks to get to a place,' he says, 'but most of the situations I get into last about two minutes. And there's no way you can recreate them even with money.'

To avoid missing shots, he takes as much equipment as he can carry, and keeps it ready for use. He uses mainly Nikon FE and FM cameras, though he also has F2's and Leicas. 'I usually take four bodies,' he says, 'and lenses from 24mm to 300mm. Cameras tend to break down, but the best cameras are too heavy to take four—then you couldn't back-pack them. I usually like to take a tripod with me. Again, the best tripods are the heavy ones! I take a watchmaker's tool kit, and a lens

cleaning outfit—mildew *loves* these new lens coatings. . .

'When I'm working I use three cameras, or in a hurry I'll take two. Where the people don't like cameras you're down to one, and that's in your pocket.'

On most stories, just to get pictures is an achievement. To make sure those pictures are sharp and well composed is as much as most people ask. Colin Jones aims for something more. 'There are pictures that say where you are and what the story is about—they are good documentation—and there are pictures that make *me* feel good,' he says.

His aim is to take pictures that not only tell the story of a particular people at a particular time, but also have significance for all humanity. In other words, pictures that *move* people. 'I get my greatest satisfaction when I've done something that I feel might help the people I've photographed, that it might do the situation some good. That's where I get my impetus to work.'

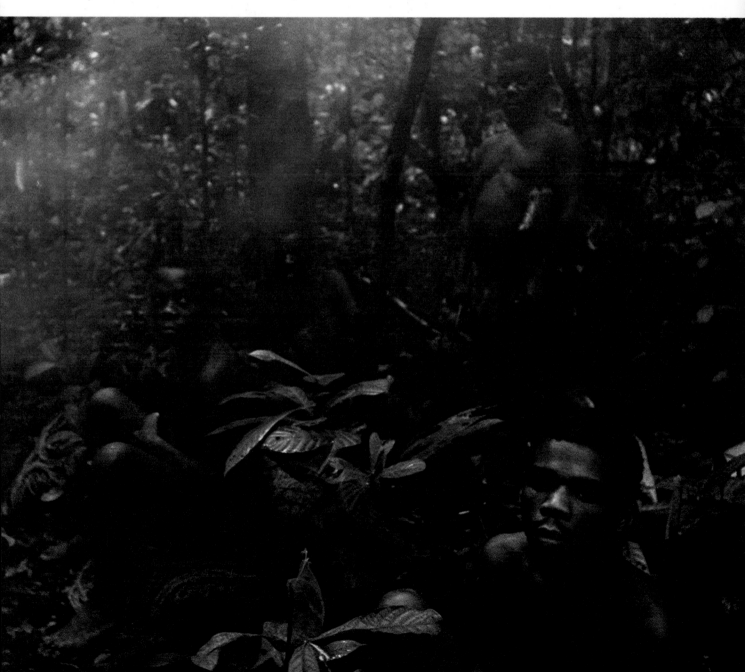

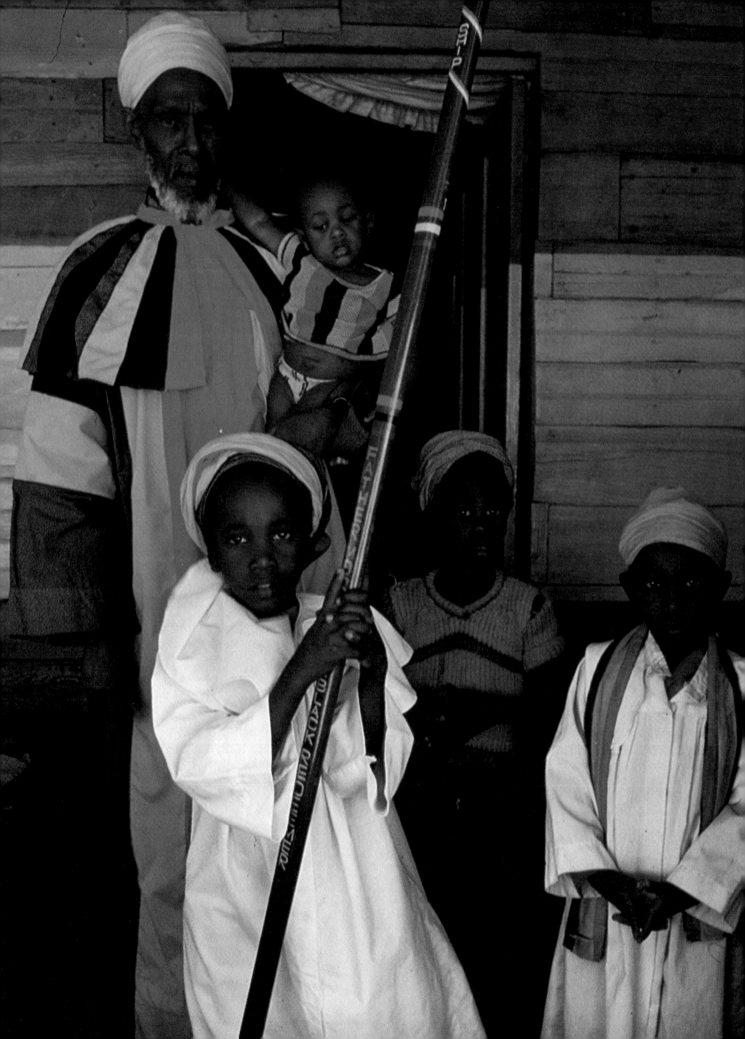

LEFT Colin Jones has photographed several stories in West Kingston in Jamaica, which he regards as one of the most dangerous areas in the world. This shot was taken there for The Observer and used on the front cover of the colour supplement. It shows members of the Rastafarian faith.

BELOW Taken for The Observer in Point Hope, Alaska, and used just before a meeting of the International Whaling Commission in London. The Eskimos drag ashore a 30 foot Blowhead whale. With a permitted catch of only two whales there was doubt about the survival of the village's way of life. It was minus 30° C and the exposure was 1/30 at f/2 on Kodachrome 64 film.

RIGHT Telephotos force you to work at a distance, so Colin Jones does not use them often. However, for this shot he used a 300mm f/2.8 Nikkor to fill the frame with the profile of a Bellah tribeswoman. It was taken in Gorom Gorom, a small village in Upper Volta, at the edge of the Sahara desert.

OVERLEAF Members of the lounhanan tribe in the New Hebrides, a group of South Sea islands 1,500 miles off the eastern coast of Australia. This 'cargo cult' tribe worships Prince Philip so their signed photograph of him is a prized possession. Colin Jones was working in the area when it became newsworthy, due to a breakaway movement on Espiritu Santo.

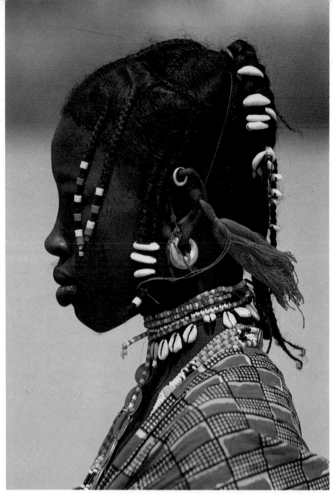

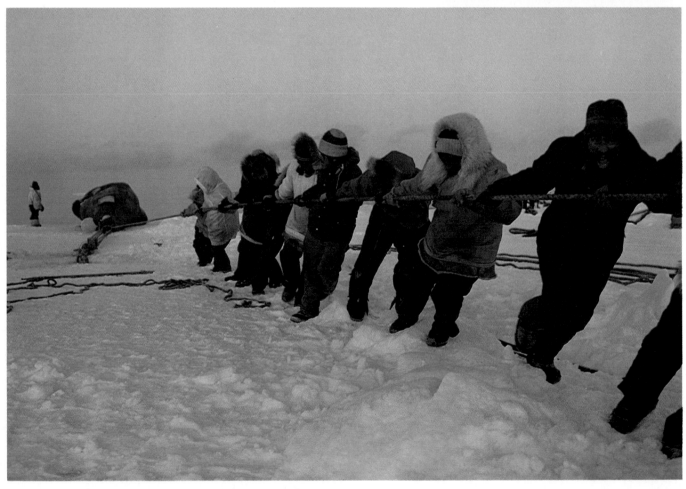

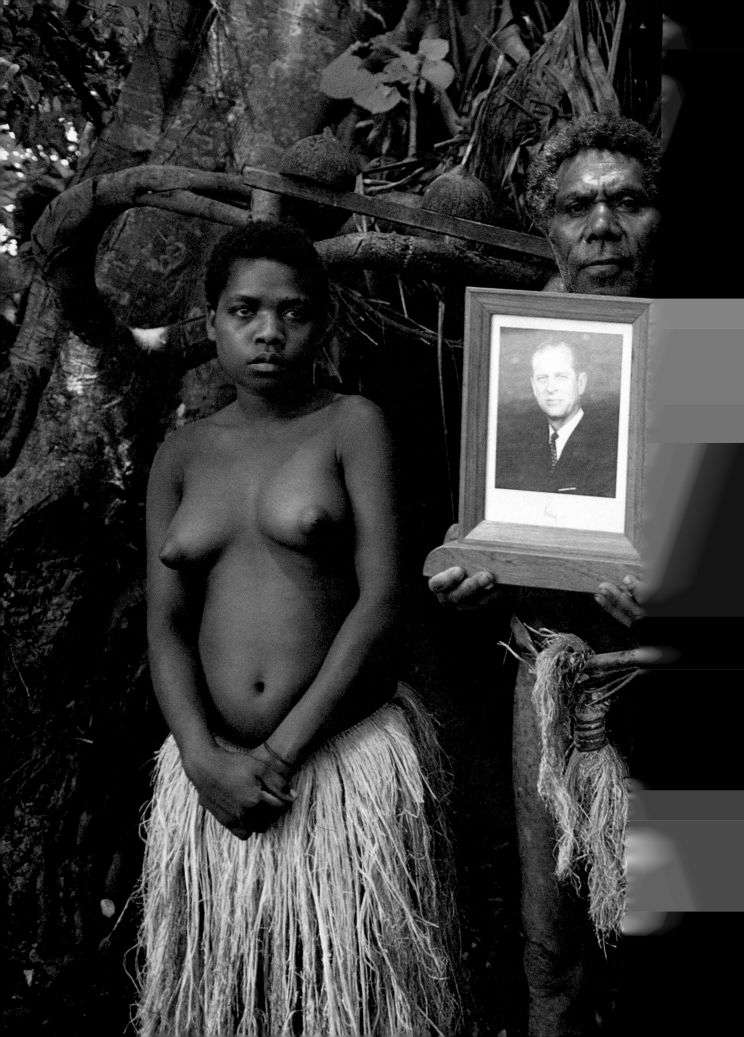

FASHION & BEAUTY

Fashion and beauty are the names given to two highly specialized types of photography of people. The people are, of course, male or female models, who appear not as themselves but as ideals to be emulated. You too could look as wonderful as this, they seem to say, if you buy X clothes or Y make-up. Even models, however, are not perfect. Producing pictures that make them look so desirable often involves a large staff of make-up artists, hairdressers, stylists (who select and provide props), fashion editors and assistants, as well as the photographer. Photographers who can bring all this together, guarantee technical perfection and add their own dash of originality and style are highly sought after. And expensive...

Robert Farber

Unlike most of the new generation of professional photographers, Robert Farber had no formal training in his craft. Today he is one of New York's major fashion and glamour photographers. He learned about photography the hard way—on his own. It all began at a beach when he saw an enormous woman clad in a tiny bikini. 'I wished I had a camera,' he remembers.

At the time he was a student at the University of Miami, an institution widely known for its photography course. But Farber was studying business and fine arts. Although his main interest was painting, he bought a camera and learned how to use it. Then he tried to get 'artistic' effects by experimenting with diffused lighting, grain and filters. He recalls: 'I was attempting to express the feeling of a paintbrush that I didn't have the talent to use.'

After university he continued to experiment in his spare time and sold a few of his pictures. After a while, gallery directors began to seek his work. He met art directors of advertising agencies who suggested he apply his talents to the fashion field. Working from his home, he started to sell pictures commercially—still life and landscapes with a painterly look. A photography magazine printed some of his nudes and he received an assignment from *Viva* magazine.

In 1973, Farber got his first big job from the Cotton Council, for a national advertisement showing a mother and daughter with colourful towels. The following year he rented part of a studio and soon his pictures were appearing in *Ladies Home Journal, GQ (Gentlemen's Quarterly), Playboy, Penthouse, Modern Bride, Esquire* and *Vogue*.

Farber had been a professional for two years when his first book *Images of Woman*, appeared. In it, he bridged the gap between photography and painting with images that recall the work of the Dutch masters and the Impressionists, and he explained how his special effects were created. His next book was *Professional Fashion Photography* and Farber wrote about all the things that he had learned as a self-taught photographer—such as dealing with clients, planning an assignment, putting together an effective portfolio, getting a foot in the door at advertising agencies. It also covers other aspects of the professional's trade, from finding locations to presenting finished work to a client. Farber followed up the success of this book with another one, *The Fashion Photographer*, which goes behind the scenes in the fashion industry.

His 35mm shots are taken with motor-driven Minolta X700 cameras and Rokkor lenses. He takes off the winder when he has plenty of time to shoot, or to deal with the nuances of lighting and composition. 'But when some of New York's most expensive models come to my studio', he says, 'I have to work fast.'

His lenses range from 16mm to 500mm, but he usually uses the Rokkor 35mm, 50mm, 100mm and 75-200mm zoom. For commercial work his film choice is Kodachrome 64 and for art work and books, Agfachrome 100 and 200. He pushes 100 ASA to 400 to produce a grainy effect, and uses filters and diffusion techniques to obtain the ethereal images that are the hallmark of his work.

His studio, in premises formerly occupied by a processing lab, consists of 325 sq metres (3500 sq ft), painted white. It includes a large dressing room, darkrooms for developing and printing, and two shooting areas—one for natural light and the other for artificial light. A studio manager and two assistants comprise Farber's staff, and an agent handles business operations.

RIGHT *Farber made this picture for his book* Professional Fashion Photography. *It is cleverly thought out to give the image drama and contrast. Flash from one side leaves half of the face in shadow so that it melts into the background. The light picks out the texture of the model's skin, the lace cap and her lipstick.*

Farber does a considerable amount of location photography abroad. An assignment for a catalogue of spring fashions took him to Club Méditerranée in Martinique (during winter, naturally). He flew there a few days in advance to scout locations and make Polaroids of them. Then the rest of the entourage arrived: four models, an assistant, a stylist, the agency art director and an account executive (the person who runs the advertising campaign). A film crew also came, and Farber set up a composition similar to one of his photographs for a TV commercial.

When he went to Jamaica for a client that advertises 'Jeans that fit as if they were painted on', he took a body-painting artist. Three hours were required to apply make-up to the model, who was photographed in a three-quarters back view. During the bus trip from their hotel to the beach at Ocho Rios, the model was on her hands and knees to avoid messing her make-up.

Farber has made advertising pictures for Revlon, Avon, Helena Rubinstein and many other big-budget advertisers. He has done campaigns for Caress soap, Monet jewellery and Toni hair products, among the many beauty, glamour and fashion accounts he has handled. In addition, he lectures to professionals in many cities, demonstrating the techniques he uses. Another book, *Moods*, includes a selection of his landscapes, still life and nudes. It contains these words: 'To achieve the image that corresponds with his original impulse, Farber uses the technology of photography fully. The final form of the picture depends on subtle manipulation of various types of film, film speeds, lenses, filters, filtering substances, and exposures—all the techniques that comprise the medium of photography. If a mood is created by diffusion of light, that effect can be enhanced by filtering, by selective focusing, or by pushing the film during development to break up the emulsion. Illumination can be emphasised by over-exposing certain areas, and dominant tones can be brought out by filtering or changing the type of film. However, all these techniques are secondary to merging the initial impression with the photographer's vision.'

The key word is *vision*. Farber tells aspiring professionals: 'Clients take your technical expertise for granted. They depend on your sense of design and your ability to transform an idea into a picture. If you're talented and believe in yourself, don't give up. Keep going and you'll be successful.'

RIGHT This was taken as a test shot to show some unusual jewellery. The model was lit by flash through an opal glass screen so that the reflections in her eyes and in the earring would look like a window. The light was positioned so that it would reflect in the metal circles showing the shape against the background. Farber used a 180mm lens on a Nikon with 64 ASA Kodachrome.

BELOW Farber took this picture in Martinique. He used a polarizing filter to cut out reflections and give more saturation colour with Kodachrome 64.

RIGHT Farber's picture of model Lynn Brooks was taken as an experimental shot. To get the diffused image effect, he sprayed a UV filter with hair lacquer. The picture was taken by window light on High Speed Ektachrome, which was uprated and push processed to increase the grain. Farber overexposed slightly to exaggerate the high key quality of the shot. It was taken on a Nikon with a 105mm lens.

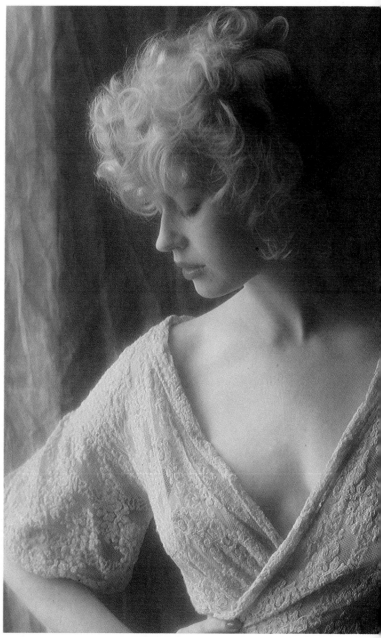

ABOVE Pictures for fashion or beauty portraits are often improved by softening the image. The very fine grain of Kodachrome 64 can be too sharp for an attractive result. Here Farber used a filter to get the gentle soft focus effect. The viewer's eye is drawn to the model's bright red lips. The rest of her make-up is very pale and so the lips provide a focus of attention and contrast. The shot was taken in the studio by natural light with a 105mm lens.

LEFT Lighting is one of the most important elements in fashion photography. For this shot Farber smeared some Vaseline diagonally across a skylight filter in the direction of the light ray. He exposed for the shadows to record the detail and allowed the highlights to burn out. He uprated and push-processed Agfachrome to get more grain.

JOHN SWANNELL

John Swannell is a quiet, gentle man and a prolific photographer. His large, Victorian, north London studio is a hive of activity as he is shooting a six-page fashion feature for *Vogue* Promotions. The telephone is constantly ringing, music plays in the background and while the models are being dressed, Swannell and his assistant prepare the set. That morning he had been photographing on location outside the city and the afternoon session in the studio is expected to continue until

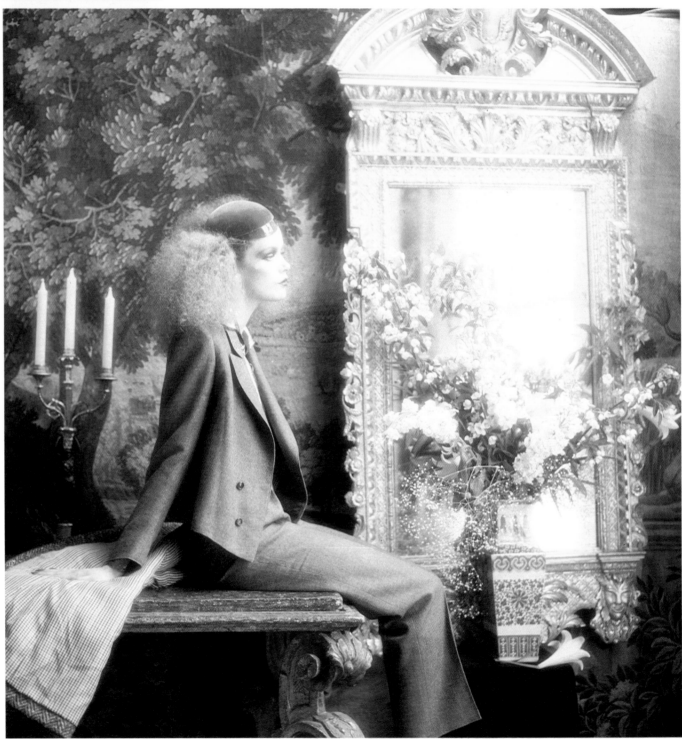

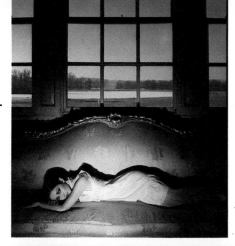

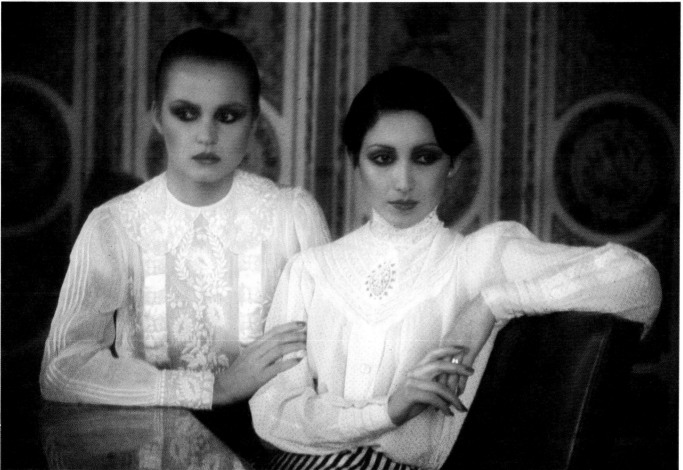

the job is finished at perhaps ten that night.

The clients had requested a curtain backdrop for his clothes but Swannell has adapted this to a draped sheet of mottled grey canvas stapled in folds. His assistant stands in the model's position while Swannell positions the camera and checks the exposure. Two flash units are positioned on either side and slightly in front of the camera, each fitted with a snoot to concentrate the light on the face. He always places one light solely for the face. The other light is set lower down to light the clothes.

A glamorous blonde model glides down the stairs dressed in an elegant suit. From the front she looks the essence of smart chic. She turns and reveals a line of pins pulling the costume tightly to her body. She stands in position against the backdrop and Swannell takes one Polaroid print, just to check everything. The hairdresser combs through the girl's hair one last time, the fashion editor is happy and 10 minutes later

Swannell has got through three rolls of film. The model changes her position slightly after each click of the shutter and Swannell directs her, but only to alter the position of her face so that the shadows will not distort her features.

It all seems to happen so quickly. Swannell works by instinct. If it does not 'feel' right he'll want to start again from scratch.

He made up his mind to be a photographer when he was 12 years old. He cannot really remember why but his single-minded attitude saw him through three years as an assistant to his current position as a much-sought-after fashion and beauty photographer. At 18 he managed to get a foot in the door with the job of store keeper's assistant at *Vogue* studios. One day an assistant was ill; Swannell took his place and never returned to the store. He became David Bailey's assistant and began to learn what fashion photography was all about. Bailey always told him that if he chose the most beautiful models he

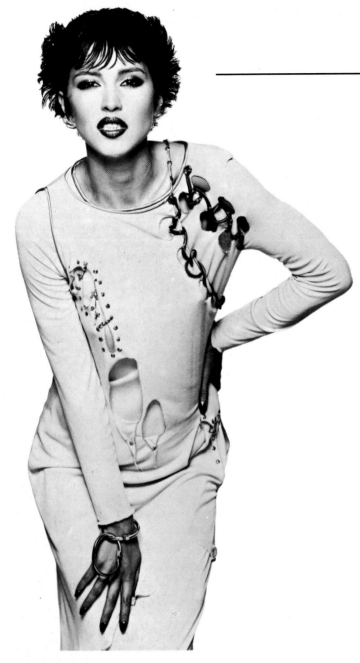

ABOVE *To photograph this model in a white dress against a white background, Swannell put up black boards either side of the model and just out of picture. The effect was to darken the edge of the dress making it stand out slightly from the white background but without taking any of the whiteness from the dress. The backdrop was lit with two flash heads and the model lit with flash bounced off a reflector. It was taken with the 6 ×7cm medium-format Pentax SLR.*

RIGHT *For most of the fashion pictures taken in his studio Swannell uses a 135mm lens on his 120 roll-film Pentax. Here the model was lit by flash with a unit either side and just in front of the camera, one light positioned for the face and the other for the dress. He used Kodak Panatomic-X film.*

was half way there. He also told him that the only way to learn was by recognizing mistakes—it was what *not* to do that was important; like avoiding a nose shadow across the cheek that might make the model look ugly. Eliminate the mistakes first and then just keep taking pictures—the more you take the better you get.

As with advertising, fashion and beauty pictures are put together by a team of people. Swannell employs freelance hair dressers, make-up artists and stylists to organize the clothes, accessories and props needed for the sets. Ideas evolve over a period of time but the people he uses know by now his way of working. 'My make-up artist knows I love pale, porcelain complexions with dark ringed eyes. But someone always has to make the final decisions about everything and that's me. I'm the only one who can tell if it's right in the camera.'

In the studio he prefers to use the Pentax roll-film SLR for the 6 x 7cm format. 'I was brought up with Hasselblads but the pictures composed on the 6cm square format had the sides cropped off when they were put into magazines. My pictures actually improved with the large Pentax.' He uses 135mm macro and 200mm lenses with the Pentax practically all the time. For outdoor locations he will use an Olympus with 35mm, 300mm and a 75-150mm zoom lens. But 35mm film doesn't produce the quality he wants in the studio. 'Unless someone wanted grainy pictures I wouldn't use a 35mm. Ideally, I'd like someone to make a versatile 10 x 8 twin lens reflex and I'd use that!'

'For locations I like big country mansions or modern architecture with strange windows and odd reflections.' Windows, steps and lawns with strong lines and shapes form many of his backgrounds. On an assignment in Israel he persuaded the hotel manager to empty the swimming pool for him. 'Everything about the hotel was ugly and made of concrete. The only good thing was the pool which was large and graphic but I wasn't shooting swim suits—I was doing dresses—evening dresses. The manager was a budding photographer and over dinner we persuaded him to empty the pool. It took 24 hours to empty and it hadn't quite emptied when I started to take the pictures. I had 10 minutes to shoot before they started filling it up again.'

He prefers working in black and white to working in colour. With flash he uses 32 ASA Panatomic-X, and when using daylight in the studio 400 ASA Tri-X, processed in D-76. 'I do all my own printing. It's very personal—you can't train someone to print your pictures just as you can't train someone to take your pictures. There's always going to be those little things you see on the film that no-one else would spot. Sometimes I do a little dodging to make the faces darker or lighter, but nothing drastic—if it's not on the negative you haven't got it. And besides, a good photographer can always tell.'

In black and white Swannell has done many fashion pictures and a series of portraits for *Ritz*, the newspaper part-owned by David Bailey. He has also produced a book of beautiful black and white glamour pictures, *Fine Lines*. The lines are those of his slim models, which he accentuates, sometimes, by using black boards instead of white reflectors. 'It's an old trick of Irving Penn's,' admits Swannell.

Most photographers recognize the influence of others on

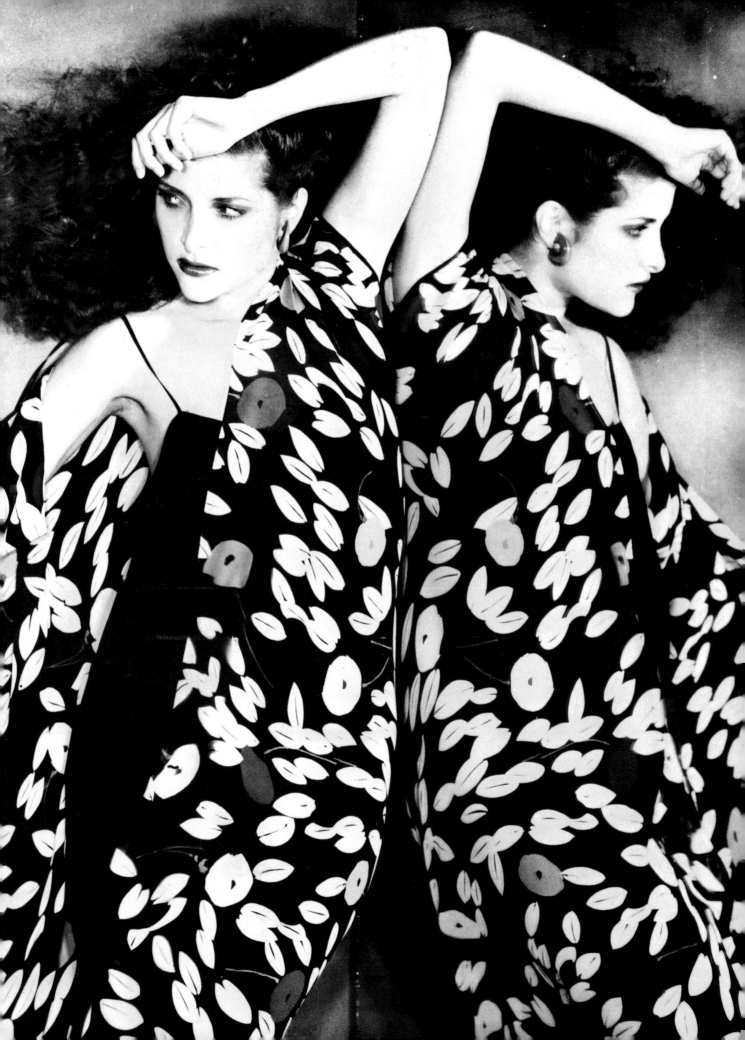

Swannell took the picture on the left to illustrate a feature on swim suits. An art director for Pretty Polly saw the picture and decided that if it were altered slightly it would make a strong advertisement for their tights. For the result, above, Swannell looked at 60 legs and the models he chose had to stand still in the same position for 15 minutes. The background was lit by one flash unit and the models were lit from behind with two lights and in front with one. Black boards either side of the models give the legs a dark line making them stand out from the background.

their work. Swannell particularly admires the photographs of the Americans Irving Penn and Richard Avedon and, of course, Bailey. But he has developed his own distinct style which is apparent in his choice of models, make-up, poses, lighting and backgrounds, which together gives his pictures a timeless quality rare in these days of rapidly changing fashions and gimmicks.

The Italian fashion photographer Barbieri once told him to change some aspects of his work just a little bit every six months—'not too much, just a little, take out a light or put one in and over three or four years your style will change quite a bit but you are progressing and your style will never stagnate!'

Swannell loves women. His short list of models is only four or five which he will use as often as possible. They have built up a mutual respect and confidence which he feels is essential for results. Not unnaturally, he has strong opinions on beauty and will call in a model from America or Europe for a picture if necessary. He likes girls who are elegant and work hard for the camera, listening and reacting to his instructions. 'Some women could sit on a chair six different ways—they're the good ones. They wriggle around until they're comfortable and they watch the fold of the dress and are aware of their arms and legs. They're just natural and while they're doing all that, somewhere along the line there's a picture, you see it, and say hold it. It's a lovely feeling. It's one of the reasons I'll never get tired of doing fashion.'

BELOW Swannell persuaded a girl to stand up the chimney so that the combination of her purple stockings, the fireplace and green room created a surreal image.

ABOVE AND BELOW These two pictures were taken for a Yardley advertisement for lipstick. Swannell was asked to photograph the model against a light-coloured background but he experimented with a dark background also and the two pictures are equally good. Swannell also composed the picture in both horizontal (above) and vertical (below) formats to suit single and double-page advertisements. On his Pentax he used a 200mm lens at f/22. One flash was bounced into a reflector with other reflectors spaced around to direct light on to the model's face.

German photographer Herbert Schulz has the kind of travel agenda that any photojournalist would envy. However, Herbert Schulz is a *fashion* photographer who works from New York for magazines and advertisers all over the world. The cities he visits regularly include the fashion capitals of Milan and Paris, and he regularly works in Amsterdam. To Herbert Schulz it seems quite natural. He enjoys travelling and he is not about to stop.

He describes his meteoric rise to fashion fame in half a dozen years as 'too fast'. He is still constantly amazed when people know his name and have seen his pictures in *Vogue, Ritz, Company, Avenue* in Holland, *Brigitte* and *Stern* in Germany, *Donna* in Italy and many, many more. So how did he start?

Six years ago he was successfully designing old farmhouses in Majorca. Encouraged by a friend he began photographing the interiors he designed. Max Maxwell, an ex-art director of *Vogue* and a photographer for *Nova* magazine, became his strongest influence. Maxwell advised Herbert Schulz to keep his photography simple, to concentrate on one type of film. Schulz bought Nikon equipment and began using 25 ASA Kodachrome for colour work and Plus-X for black and white.

The first professional job he got was for the German magazine *Stern* photographing interiors. 'Luck,' he says, with characteristic modesty 'played a large part'. His first big commercial break came when Volkswagen were looking for someone to take pictures to launch their new car, the Polo. They wanted a new approach. Instead of using studio shots of a gleaming car, they wanted 35mm shots of the car out of doors and dirty. The campaign was a big success, and he continued to work for Volkswagen for almost three years until he started doing fashion.

Unlike most photographers who would stay put once they had made a success, Schulz decided on a change of base. He moved to Amsterdam and eventually started working for *Avenue*, one of the best features magazines in Europe. Up until then he had photographed cars and interiors, but Dick de Moei, the inventive art director of *Avenue*, commissioned him to do a fashion feature. From that moment on Herbert Schulz was hooked.

As a consequence of getting involved in fashion it was necessary for him to move to a real fashion city where the best models, stylists, make-up artists and hairdressers are all available. He decided to move to London, and after greater success, moved on to New York. He recognizes that for young photographers who are just starting in fashion photography, these cities are not ideal. The competition is fierce. But he has

HERBERT SCHULZ

now reached the position where he can choose his work. Recent clients have ranged from major advertising agencies such as Young and Rubicam, to record companies such as Atlantic—where his knowledge of punk fashions is a help—to magazines like *Penthouse,* outside of the main fashion publications. In short, New York offers endless opportunities to the photographer, and he has no plans to move on again.

'The one problem with New York,' he says, 'is that often Americans cannot relate to the images they see. If someone wants you to photograph a grapefruit and you show them a picture of an orange, you don't get the job!' And this is not Schulz being arrogant: major American photographers have made the same complaint. It is partly a result of the intense competition which gives art directors tens of thousands of photographers to choose from. To succeed there you have to adapt. 'Outsiders always feel they can change New York,' Schulz observes, 'but they never do. It stays like it always was.'

However, Schulz has not changed his method of working. 'I still like graphic images with strong, simple shapes,' he says, 'and girls with very big lips!' His camera equipment consists of Nikon SLRs with a 300mm lens for location work, a 200mm Micro Nikkor for beauty work, and an 85mm lens for studio work. The 200mm was originally designed as a medical lens, and has a built-in ring flash.

Schulz adopted this medical lens because, he says 'I often want to get extreme close-ups, and if you do that with a normal lens you get so close to the model you get in the way of the lighting. I'm ignorant about technical things—I don't look at photographic magazines and books to find out how I should do things. I know what I want and how to get it, so I just stick to what I know.'

Nowadays he sticks mainly to Ektachrome film, having found a good processing lab, and he uses a lot of electronic flash. The one item of equipment he rarely uses is a tripod, as he prefers the flexibility of working with a hand-held camera. It enables him to relate more closely to the model. He feels the model makes a significant contribution to the picture. 'If you have a very strong model,' he argues, 'you are half way to a strong picture. It's much easier to work with models who know exactly how to behave in front of the camera. They don't want to appear in a bad picture, so they help.' But Schulz chooses models for deeper qualities than big lips, and works with his favourites as frequently as possible.

ABOVE AND RIGHT Both of these colour shots were taken with a 200mm lens with built-in ring flash.

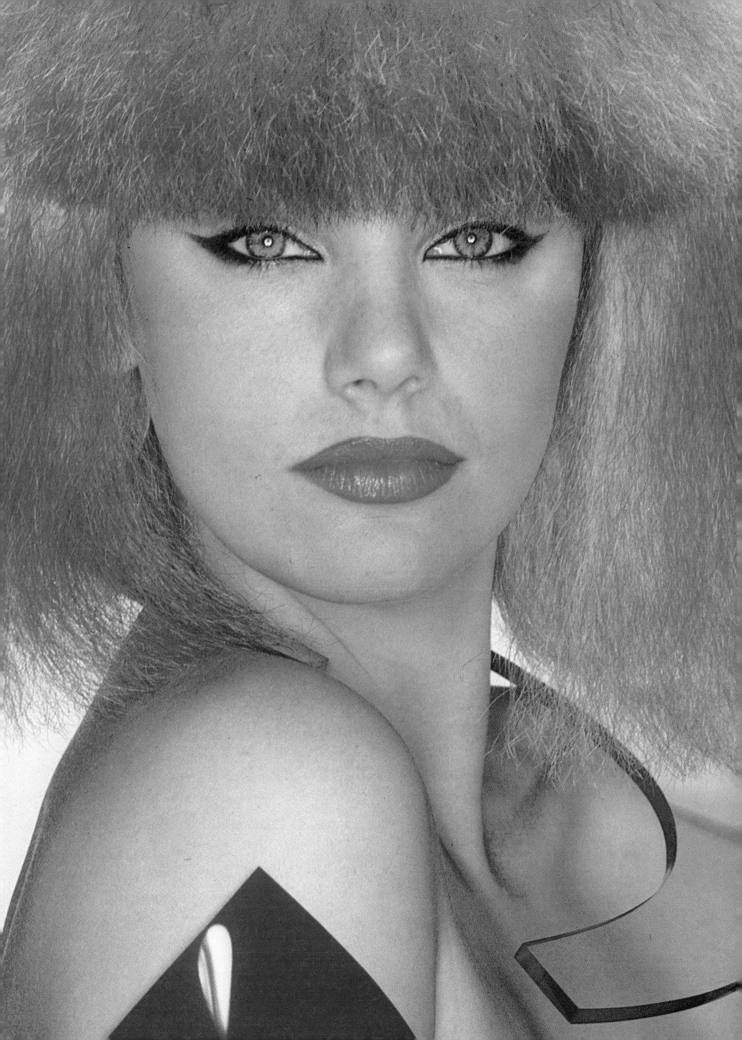

ABOVE This was taken for a poster to advertise the fashion magazine Company. He used a large bank of lights to get the soft light effect with flash on the background. It was taken on a Nikon with a 105mm lens on 64 ASA Ektachrome film.

ABOVE Tunisia was the location for this fashion feature. With the sun overhead to the left but slightly behind the models, Schulz used a flash on the girl's face to act as a spotlight to pick out her features. He used a 300mm lens.

ABOVE The model had problems getting the blue dye out of her hair after this session for Panorama magazine. She was positioned close to the background paper so that the studio flash on the floor would cast dark shadows.

ABOVE Steve Strange, a London cult figure was the subject of a feature in the Dutch magazine Avenue. His bizarre clothes and make up are part of his trade mark. The shot was taken with a 105mm lens on a Nikon on Ektachrome 64.

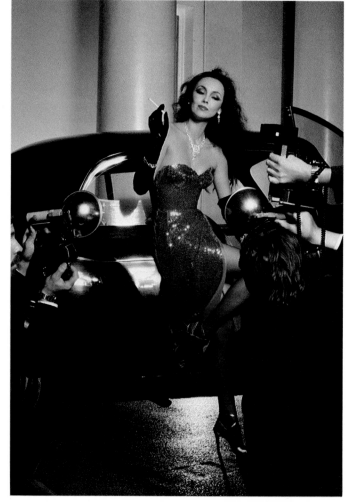

ABOVE Marie (Mrs Bailey) Helvin posing for a cigarette advertisement. Schultz suspended a bank of lights above the set to avoid getting shadows. A flash was also put behind the car.

RIGHT A dancer photographed for Stern magazine. A flash on the background paper brings out its whiteness. The girl was lit directly by the ring flash built into the 200mm lens.

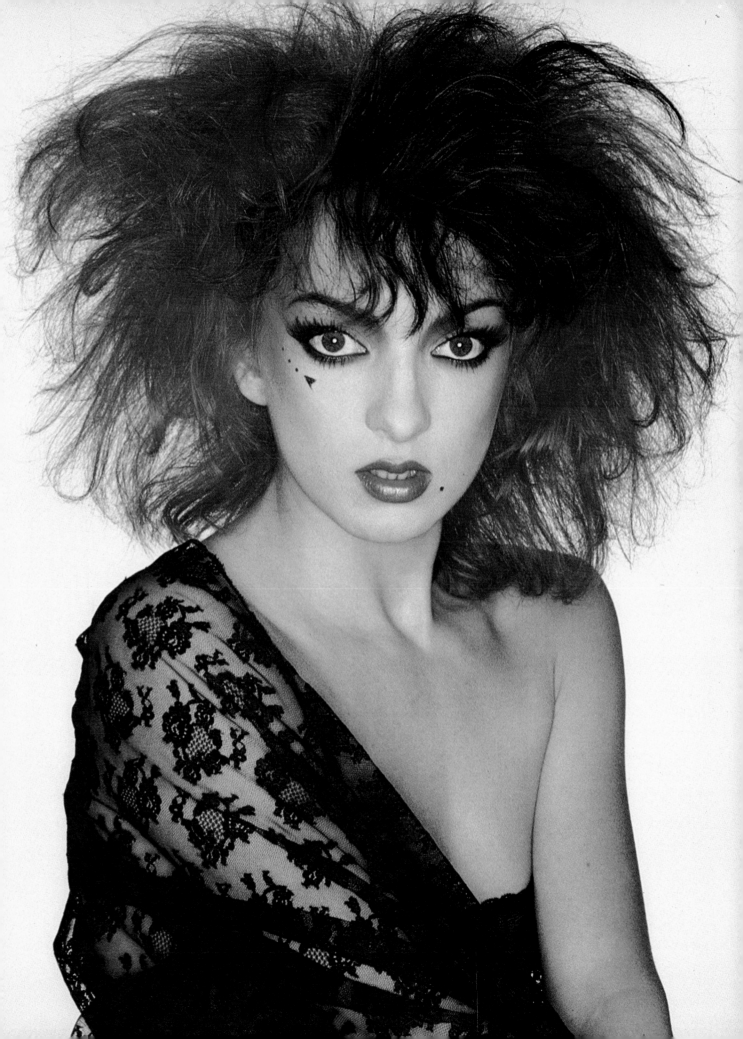

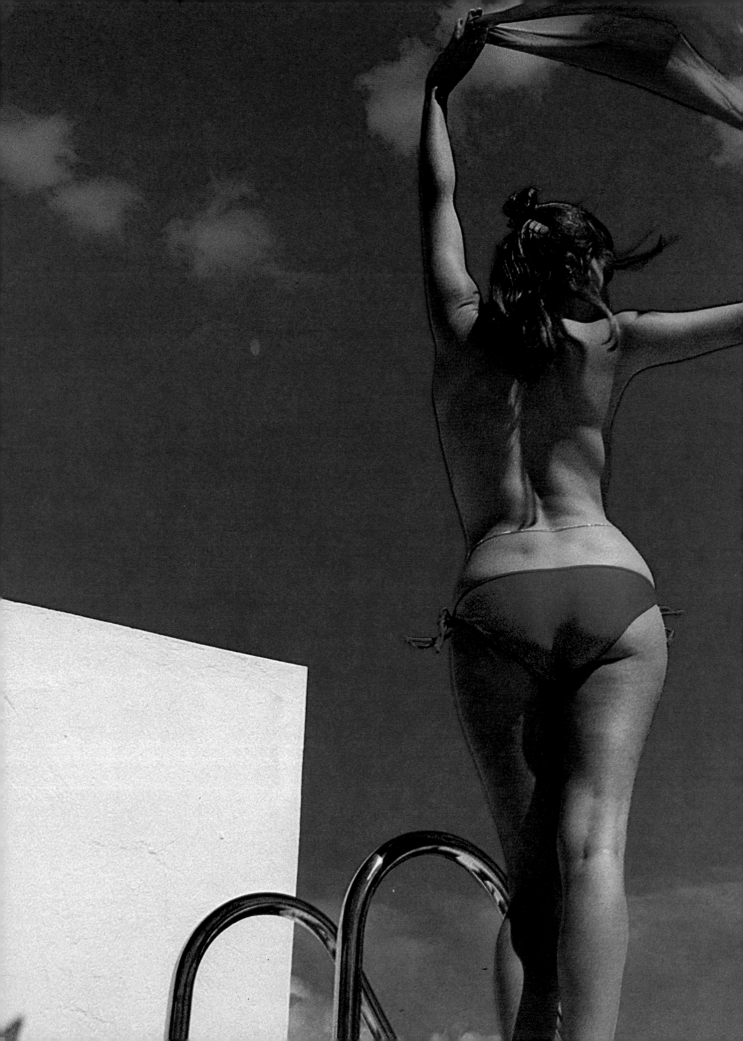

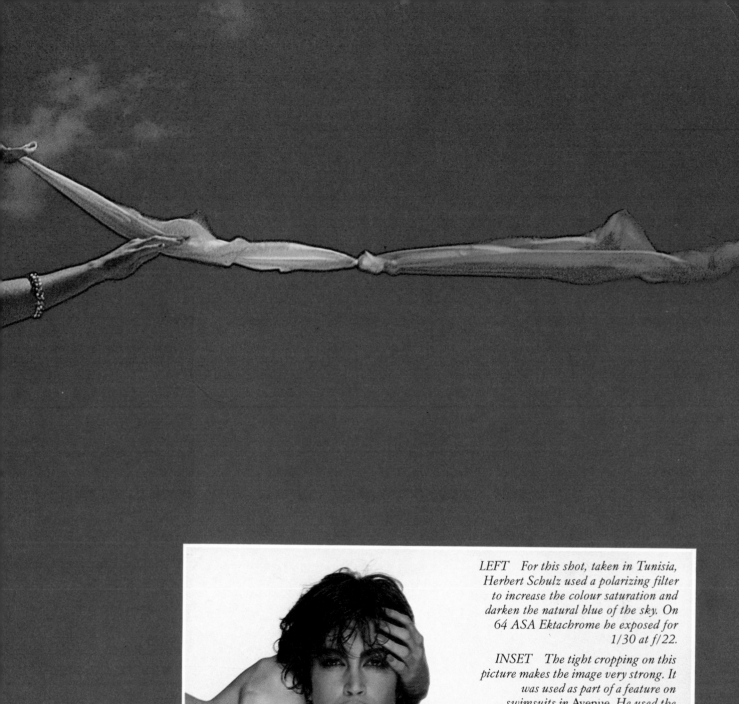

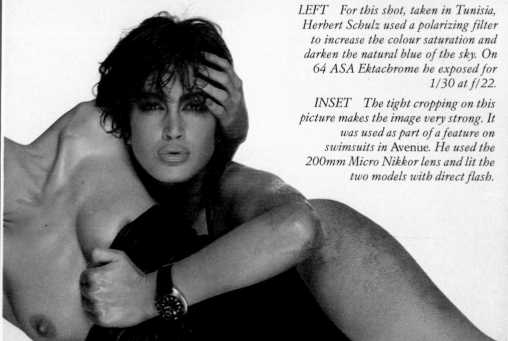

LEFT For this shot, taken in Tunisia, Herbert Schulz used a polarizing filter to increase the colour saturation and darken the natural blue of the sky. On 64 ASA Ektachrome he exposed for 1/30 at f/22.

INSET The tight cropping on this picture makes the image very strong. It was used as part of a feature on swimsuits in Avenue. He used the 200mm Micro Nikkor lens and lit the two models with direct flash.

Hideki Fujii

Born in Tokyo in 1934, Fujii has become one of the most famous Japanese photographers in the world. When an amateur, he happened to photograph a cinema on fire, and a newspaper published the picture. That started his career. He studied photography at Nihon University, was an assistant, joined a fashion magazine for three years, then the Nihon Design Centre and won many awards. He went freelance in 1963 and got his first major job from Max Factor. A poster they used, which he had taken with model Hiromi Oka, rocketed them both to pre-eminence in the fashion world.

Though he is recognized as an expert technician, little is known about how he works. This is more than Japanese 'inscrutability'. His spiritual approach to photography means he answers questions not with details of films, lenses and f/stops but with parables about states of mind.

He says that a photograph is not just a physical object, it is the idea the picture contains that is important. 'If you have a photograph,' he says, 'it's just a piece of paper. Turn it over—it's so thin. The important thing is not the piece of paper, but what is behind the picture—the invisible behind the visible, the depth of expression. The visible image is the reflection of something which is invisible, and that is the mind of the photographer.

'I was in Madrid a few days ago, looking at the paintings of Goya. The painter's outlook is reflected in each picture. A photographer's mentality is also reflected in his pictures—you can see this in the work of Helmut Newton, Sarah Moon, Sam Haskins. People think painting and photography are different because the photographer uses mechanical methods and the painter uses art materials. But that's not true. The methods are different but they are the same form of expression.'

Of course, photography does require certain technical skills first as painting does, and Fujii takes these for granted. So how much of good photography is a matter of technique?

'At the moment,' he replies, 'the general opinion is that photography is about 50% technique and 50% mentality. But for the future, cameras are getting more automatic, and the technical skill required will be reduced. This means that the remaining part—the mentality—will play a more vital role.' Fujii takes his mental training seriously, though it is hard to see some of his methods being accepted on a photography course at a typical college. For example, one part involves standing under an ice-cold waterfall in the winter. The physical punishment is to concentrate the mind on spiritual cleansing. 'The normal human being is like a dustbin full of trash,' Fujii explains. 'We get so much information, so many messages from the mass media, you have to clean it out at a certain point. It's like a home, every so often you have to throw the old things out of the drawer, then put it in order. You have to decide what is necessary and what is not. It is the same with the soul.'

The process of actually taking a picture starts with meditation. The aim of that meditation is to clear the mind. 'If you put a glass of water on the table', Fujii says, 'you cannot put anything else into it. If you put an empty glass on the table, if there is nothing inside it, then anything can be put into it. There are many possibilities. Thus is it possible to create.' By draining out preconceived ideas and feelings, the photographer can be open to respond to the subject he is photographing.

RIGHT It is possible to produce this effect either by using infra-red film or by using a blue filter with Ektachrome film. The model was sprayed with silver and lay on black plastic. She was photographed from above using a small light source directly overhead.

But this does not mean that the photographer has no effect on the world or on what he is photographing. According to Fujii, the model reflects, or mirrors, the feelings of the photographer. For example, if the photographer laughs, the model will laugh. If he is serious, the model will be serious. The model is the reflector of the photographer's mood—to translate what he thinks and feels, like a mirror. And so the picture he creates is a reflection of his soul.

'If, for example, an amateur uses an automatic camera, maybe he can take the same picture, which will be a good quality picture as long as the camera is good. But for the professional photographer it is very important to have feeling, and to reflect the feeling in the picture. That feeling comes from his religion, from his personal and cultural background.'

This kind of concentration on his cultural background and the Japanese philosophy of Zen Buddhism comes closest to explaining the effect of Fujii's photographs, which is to capture the essence of Japanese culture and spirituality. It is not that he uses special cameras, lenses or lighting effects. In fact the cameras he uses are German in origin—Leica SLRs—and his preferred lighting is ordinary tungsten floods.

He has produced several books. One has been published by the Canon Gallery in Amsterdam, and shows his personal work. Another is devoted to the very young, Japanese popular singer, Yashiro Aki. 'I spent three months on this, and my friend asked why. She's very popular, and he is artistic, you know. The answer is simple: I am interested in number. It is like the film and the camera. Nikon make a better camera than Kodak, but Kodak is a much bigger company. They could make a good camera, but they are not interested in doing so. A camera represents one profit margin, but film is endless.'

His distinctively Japanese imagery is Fujii's great strength. But it can also limit his work outside Japan. 'About 15 years ago I did a lot of work for Japan Airlines and I travelled around the world. Also I worked for Max Factor at a time when few Japanese photographers were interested in creating pictures with Western models. I wanted to work for *Vogue* and *Elle* and the famous fashion magazines. They told me my style of photography was unknown in the western world, so they gave me some commissions. But what they wanted was always typical photography, Japanese style! So I thought, if I am wanted for Japanese pictures, why should I work in Paris or London—I can take these pictures in Japan.' This is what he has been doing, very successfully, ever since.

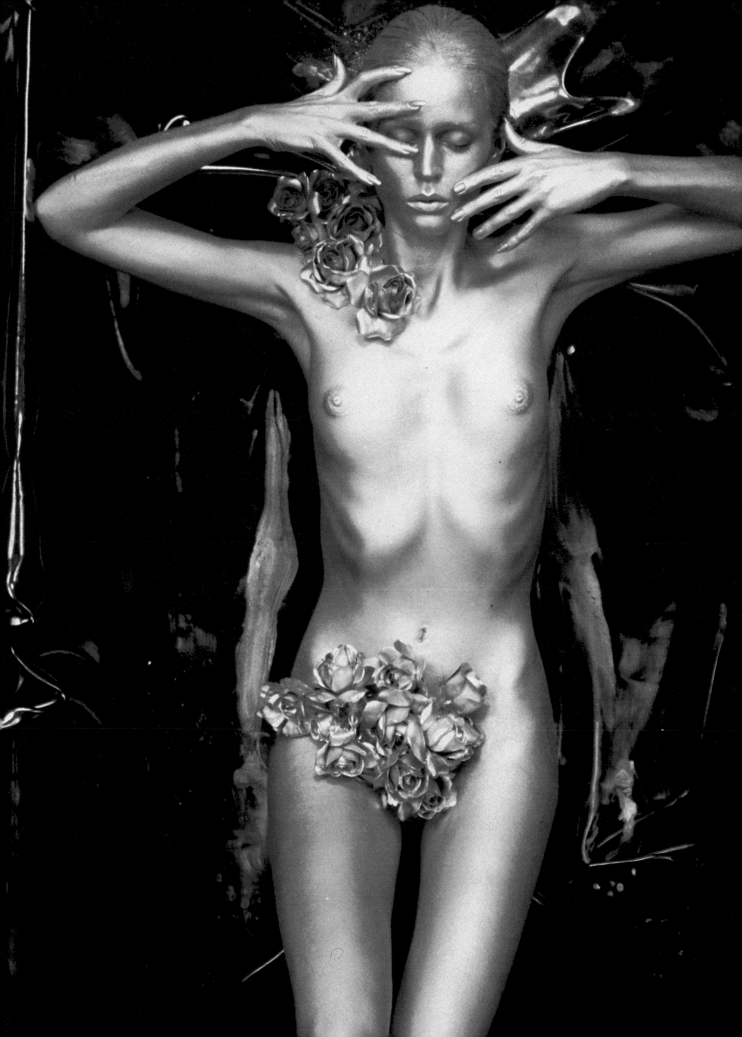

ABOVE Taken during a
long photo-session with
model Kumiko Kano, who
fainted just after this
exposure, due to the hot
lights and heavy classical
make-up. It has proved a
popular picture outside Japan.

LEFT The three most
'erotic' colours in Japanese
culture are red, black and
white. Here the red
'underwear kimono' (worn by
courtesans and geishas) is
considered more sensual than
nudity. This picture of model
Michico Igarashi was taken
on 35mm film. It was not
commissioned but has been
widely published since.

RIGHT Taken in 1970 on
the same session with
Michico Igarashi, for the
Ricoh 1973 calendar. On this
session Fujii used both 120
roll-film and 35mm film. For
this shot he used a Hasselblad
500C with 120mm lens and
64 ASA Ektachrome
Professional film. The
exposure was 1/60 at f16 with
electronic flash. For the 35mm
pictures Fujii used a Nikon F2
with 85mm lens and
Kodachrome film.

ABOVE Seen through a wide-angle lens, the white sand provides a bright background so that the model' shape stands out. The strong horizon line creates a graphic image.

LEFT By shooting against the light with a telephoto, Fujii has bleached out the background, so that the picture becomes monochromatic. This also emphasizes the unusual pose and semi-silhouette.

RIGHT This picture of Sayoko Yamaguchi was used for the cover of the Steely Dan LP 'Aja'. The makeup was by Kawabe. Fujii shot 6cm×6cm slides on a Hasselblad, and 35mm Kodachrome in a Nikon camera.

PHOTOJOURNALISM

The growth of pictorial magazines over the last 50 years, and the growth of travel, have made an international industry out of reportage, news and travel photography. Many photographers devote themselves to capturing news events, others to recording the way of life of everyday people, still others to capturing the magnificence of the scenery. Each photographer makes his own choice of equipment and approach, but all of them are determined travellers. Often, getting to the subject is the hardest part of the job.

TERRY FINCHER

Terry Fincher, arguably Britain's number one press photographer, started out as an assistant print glazer in Fleet Street when he left school in 1945 at the tender age of 14. However, he was not a glazer for long. His employers at the Keystone Press Agency recognized talent when they saw it and soon moved him on to measuring out the developer powder. After that he cut up film for the plate cameras and only then was he deemed suitable to become a printer. It was not until he was 20 that he was first let loose with a camera and sent to cover Princess Alice planting a tree in Kew Gardens.

It was an apprenticeship he would not have missed for anything. 'You must know the nuts and bolts of the business from the start—the capabilities and limitations of your materials and how to make the best use of them.'

Since that tree planting in Kew, Fincher has photographed royal comings and goings from Africa to the Amazon. He has despatched pictures of blood-stained bodies from the wars in Vietnam, Biafra and the Middle East, and a few days later sun-soaked bodies from a glamour session on some far-away island.

He has worked for three London daily newspapers, but now that he is no longer on the staff of a newspaper, his success owes as much to his ability to 'manufacture' features for the days when news is light: 'You have to wake up with ideas. You

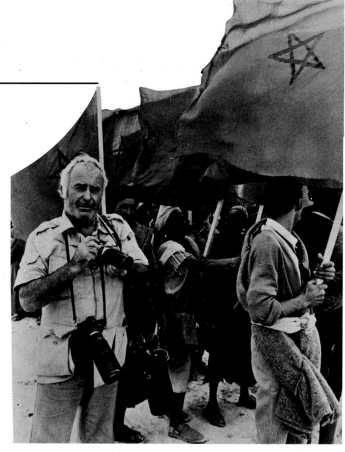

BELOW Often it is up to the photographer to react to the spontaneous mood of the model. Here Fincher photographed model Julie Ege on a tropical island where they were working on a series of pictures based on a survival theme.

RIGHT A news photographer needs quick reactions, versatility and strong nerves. He must also be able to get his film out and home. Fincher risked his life many times in Vietnam where this picture of captured soldiers was taken.

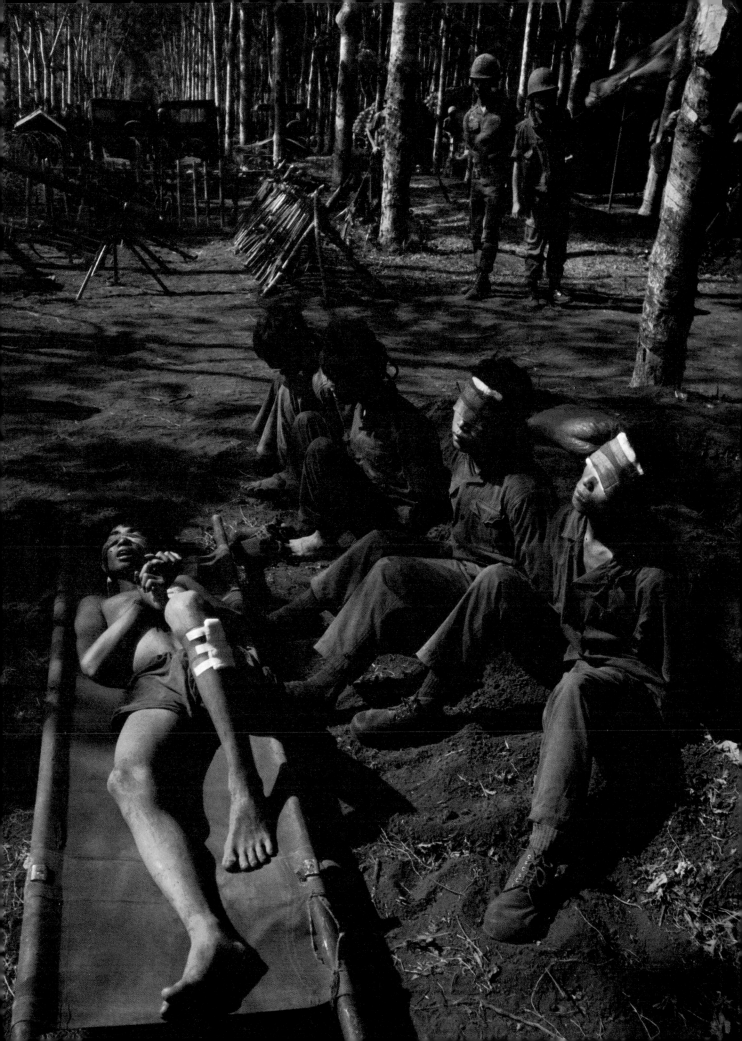

go to bed thinking about the news of the day and somehow you have to find a new way of turning it into pictures.'

In press photography, says Fincher, it is the content that matters, not the gimmicks. He would never use wide-angle distortion for effect and only rarely uses any kind of filter. 'Let the painters do the arty stuff,' he says. 'The important thing in the press business is knowing what's going on in the world, being ready to move off at a moment's notice and then knowing what to do with your pictures when you've got them.'

His standard equipment consists of four bodies and four lenses. The bodies are Olympus OM-1s. He uses a 28mm wide-angle as his standard lens; an 85mm for portraits and a 75-150mm zoom for middle distance shots. Then there is a 300mm telephoto and a two-times converter for the long shots; two small flash guns, motor drives and a pair of lightweight folding steps. While his colleagues were pushing and shoving for their pictures of Mrs Thatcher taking over at the Prime Minister's residence, Fincher was up on his steps calmly shooting over their heads.

His standard black and white film is Tri-X but in the studio he will use the slower Plus-X. He never uprates Tri-X, but thinks nothing of hand-holding his camera even at speeds as low as 1/8. Black and white prints for the UK market are never smaller than 38 x 30.5cm (15 x 12in)—'a decent sized print,' he says, 'turns people on.' For newspapers and magazines abroad the cost of postage restricts the size to 20 x 25cm (8 x 10in).

The printing is done in what used to be the first-class waiting room of a redundant railway station. The platforms

ABOVE This photograph of the Queen was the result of watching and waiting for the crucial moment when the expressions made this picture different from all the others taken.

RIGHT Fincher persuaded Prince Charles to pose at sunset by the banks of the Amazon. Bracketing his exposures to increase his chances of getting a good result, he used a 28mm lens with the camera hand held for an 1/8 at f/5.6 with fill-in flash lighting the Prince.

still belong to British Rail but the rest of the station belongs to Fincher. He has turned the signal box on the other side of the line into his own private office but life has become a little hazardous since a collector of Victoriana went off with the footbridge. Otherwise, the station makes an ideal base for Photographers International, Fincher's flourishing freelance business.

When he was 17 he jumped off a bus to photograph a policeman holding up the traffic for two swans to cross Putney Bridge. The three London evening papers of the day all used the picture. Since then there is not much that Fincher has not seen and photographed. He once talked his way into Ted Heath's bedroom. He persuaded the model Julie Ege to spend a week with him alone on a tropical island so he could produce a set of glamour pictures loosely based on a desert island survival theme (and his wife still speaks to him).

Fincher has won the British Press Photographer of the Year award a record four times, and written two books about his work: *The Fincher File* and *Creative Techniques in Photojournalism,* which describes his many adventures and working approaches. In it he writes, 'To my way of thinking, the photojournalist is a complete individual much more than someone working in any other form of photography. Even when working with a reporter, you remain an individual. In those moments before you take a picture, you think, "Correct exposure?" "Am I in the right place?", or about other small technicalities—so many things can go wrong. Finally comes the press of a button that will record for ever a really great picture.

'It's the photographer's final decision, his confidence, plus an element of luck, that's important. A reporter can always re-write; the photographer on a "hard news" assignment is not offered this luxury. There have been times that I have travelled thousands of miles and waited days to take a photograph that was all over in 1/250th of a second.'

His years in Fleet Street made him tough and ruthless. He will cajole and if necessary bribe to get his pictures. If he is in competition for the same picture, he will do as much as he can to make sure he keeps the picture to himself.

His major scoop was a case in point. Charlie Wilson, one of the Great Train Robbers, had been found in Canada. With half of Fleet Street in tow, Tommy Butler, the detective in charge of the case, had flown out to fetch him. There were to be no photographs, but by an extraordinary coincidence Fincher and Charlie had been mates—as boys they went to the same dance halls together.

He sent a note back to Charlie, and half-way across the Atlantic, Butler sent for him. Charlie had agreed to show his face for £30,000. His boyhood friend explained that he could not sign away that much of his paper's money but guaranteed him £200 and promised to do all he could to help Charlie's family. Fincher had his exclusive in the bag. Or so it seemed. Then the plane touched down at Edinburgh airport, and out of the terminal building poured the other half of Fleet Street. Desperate to protect his scoop, Fincher gave the authorities a hastily concocted story and Wilson and Butler were moved to seclusion at the front of the plane for the rest of the journey.

The following morning, the *Daily Express* ran Fincher's picture right across the front page. The rest of Fleet Street had nothing.

ABOVE By combining a dark background with dark clothes, Fincher has focused attention on Peter Sellers' face. He used an 85mm lens and lit Sellers with diffused flash from one side.

RIGHT This picture of cubs in Saigon makes an effective contrast to the brutality shown in many of Fincher's Vietnam pictures. He used a wide angle lens and Ektachrome 200, slightly underexposed for colour saturation.

RIGHT This picture of a soldier arresting a suspected terrorist after a grenade attack in Aden captures the dramatic tension of the moment. In most news situations there is no time to think about technique or your own personal safety. You must be at the right place at the right time with the camera pre-set for action.

LEFT The news photographer must be enterprising and persistent to get his pictures on the front page. Fincher's major scoop was a picture of Great Train Robber, Charlie Wilson. Shot by available light in the plane using a 21mm wide-angle lens.

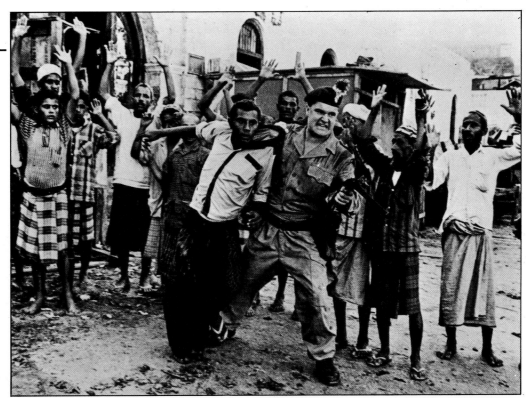

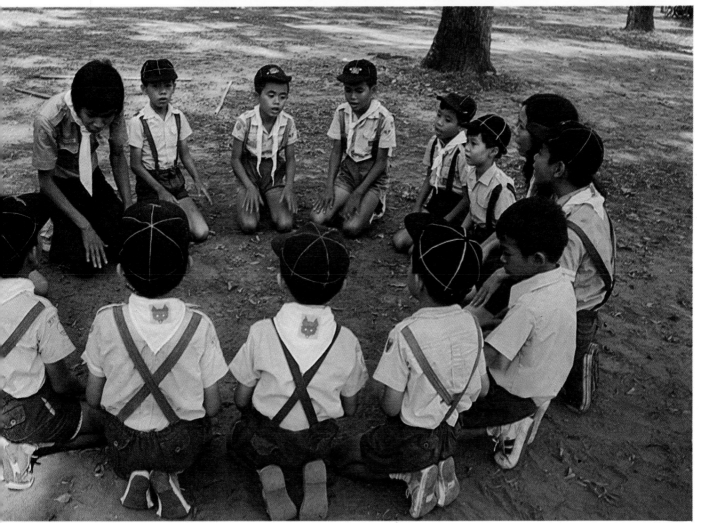

Romano Cagnoni

While newspapers want immediate news pictures in black and white, magazines want in-depth stories photographed in colour. Romano Cagnoni, born in Italy in 1935, covers news topics, but in magazine-style depth. His pictures have been published in *The Observer, The Times, Paris Match, Life, Stern, Newsweek* and many others.

He started by photographing busts in a marble works in his native Tuscany, then moved to London where, he says 'if I didn't succeed as a photographer, at least I could learn English. I found myself washing dishes in a coffee bar, and answered an advertisement to take wedding pictures. The wedding photographer turned up his nose when he saw my Leica, telling me that he'd only been able to give me small wedding groups with a small format camera! Then I started to find my own work, resorting to unusual means such as concealing myself on the roof of the Dorchester Hotel to get a picture of Elizabeth Taylor. On another occasion I joined a band dressed as a Mexican drummer, with a camera concealed in the ruffles of my shirt to photograph Princess Margaret. I made a lot of money and found I'd established my name in Fleet Street.' Disenchanted with this kind of work, however, he turned his attention to cultural and political subjects. This was the real beginning of his career as a photojournalist.

He says, 'I see my pictures as a means of communication, a giving out of ideas, and the visual impact is important. But selecting the story also requires judgement. I have to be like an editor when considering the coverage of a story. I don't just go for any story. I choose it carefully, avoiding anything that looks superficial. It must be dramatically photographed and all the facts must be available.'

A story may require months of preparation, including background research and the making of contacts, especially when it involves an illicit operation like smuggling drugs out

RIGHT Cagnoni's picture of peasant women in Southern Italy packs as much information into the frame as possible. He first spent some time with the women so that they would accept him and eventually ignore his presence once he began photographing. He had also cleverly used the hay ricks to frame the village in the distance. He shot on Ektachrome 64 using a Nikon with a 35mm lens and an exposure of 1/125 at f/8.

of Colombia—a news feature he did recently. To the local people such a racket may be common knowledge, but it is dangerous for an outsider to become involved. Breaking such a story is a scoop. *Stern* and *Time* magazine tried, in this case, but managed only peripheral coverage. Cagnoni persuaded *Bunte* to fund him, made the right contacts, and got the story. As usual he provided all the information for the articles.

Since the early days his favourite cameras have been quiet Leica rangefinder models. Currently he uses two Leicas and four Nikons. His one rule is: steer clear of automatic settings and trust your own experience. He says 'I carry a selection of lenses from 20mm to 500mm, but I tend to use the 35mm and 180mm most frequently. I don't use the standard lens because I prefer the advantages of the 35mm. It allows you to get more information in a frame and gives you better story-telling capacity. The 180mm lens I find is effective for putting objects in landscapes or bringing people together. It flattens things a bit, but not too much. I would like a zoom but they just aren't fast enough at the moment. If they made a wide-range zoom like those developed for the movies, I wouldn't need to carry all this equipment!'

The other things he carries are filters, to protect the front elements of his lenses and for use in artificial lighting, plus a small electronic flash for such emergencies as a night shot in the bush. Generally, however, he looks 'for the sort of natural lighting that will enhance a picture. Sometimes there is a dominant element in a scene and if you can afford the time to wait until the light strikes that dominant feature it embellishes the photograph.'

Most of his colour pictures are taken on Ektachrome 64 film, and he uses Tri-X for black and white. He shoots about 60 black and white and 80 colour films on a typical story. Sometimes he sends film back for processing ahead of his departure from a country. 'I don't insist on any one processor

In most communist countries, portraits of political leaders appear on posters and placards everywhere. Intended as a source of inspiration, these pictures are formally posed and probably retouched to depict a leader as an idealized figurehead. By comparison, Cagnoni's unposed portraits show a candid side and are more interesting for revealing relaxed or unguarded moments.

LEFT Cagnoni used a 200mm lens to photograph Fidel Castro speaking at a rally in Chile. Cagnoni first had to position himself so that Castro would be symbolically framed by the red flags, making the shot more dramatic.

RIGHT Having at first refused, Ho Chi-Minh changed his mind and allowed Cagnoni to take his portrait. Although Cagnoni was nervous and did not have time to check exposure, by instinct he saw that the flowers in the foreground would make a strong composition. In all he took 15 frames using a 105mm lens with tungsten-balanced slide film.

LEFT Cagnoni has covered both the Biafran and Vietnam wars. His portrait of a Cambodian soldier who had just been wounded is an evocative image of the war. He used a 105mm lens to get in close on the face without being so close to the man as to disturb him, allowing the background to go out of focus. The exposure reading, taken from the face, was 1/125 at f/8.

BELOW Another picture which shows the casualties of war is this Biafran with a damaged leg resting on a wheel that has fallen from its shaft. The closeness of the skin tone and the colour of the wheel make the two appear to merge. Cagnoni took this at 1/60 at f/2.8 on Ektachrome 64 film using a 35mm lens.

for my colour films. I think most of them do a good job nowadays. I'm much fussier with black and white and, depending on where I happen to be, I send them to a particular laboratory in London, Paris or Milan.'

Sometimes processing is critical, as with the story that established Cagnoni internationally. In 1965 Cagnoni and James Cameron were the first western journalists allowed into North Vietnam. They met the President, Ho Chi-Minh. 'I didn't even have time to check the exposure because he didn't want to be photographed. But suddenly he agreed. I only had time to compose the picture and shoot fifteen frames. Some of the pictures were blurred because I was so nervous. When I got back I asked the lab to clip the film and test process the first five frames, pushing the film one stop, and this was OK.'

He has photographed a lot of wars besides Vietnam. He was the first photojournalist into Biafra, and one of the last to leave. His pictures still dominate our memories of this war. After Biafra, Bangladesh. In the 70s he was in Chile, in the Middle East war, then in Cambodia. He was the first photojournalist into Afghanistan after the Russian invasion, often shooting blind with a camera concealed under his coat. He then went to Israel, and after that, to Poland . . .

He takes terrible risks for his scoops. Looking back on his experiences he is philosophical about it. 'A lot of people say war is futile. I do not think it is simply futile. It exists as a terrifying disease exists. It is part of our reality and we have to cope with it. As a photojournalist, war is as relevant a subject to me as any other social problem. People in wars in many ways give more of themselves and show a greater resilience than normal—pain, sorrow, and moments of joy. Only the camera can record this.'

BELOW These Red Cross doctors are performing an emergency operation inside a bunker built from palm tree trunks. Flourescent lights often produce unpleasant colour casts—usually green—on colour film, and on location in the middle of a war, the photographer can hardly do 'tests' to establish the correct filtration. On this occasion Cagnoni guessed what was required and fitted a magenta filter, ending up with an unexpected blue cast. However, this captures the atmosphere of the scene which flash—though giving more accurate colour—would have destroyed.

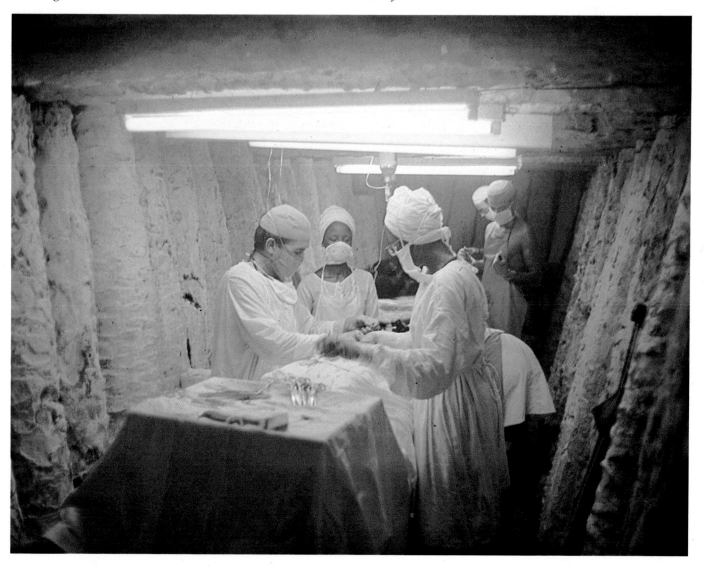

Kenneth Griffiths

Not all photojournalism involves high-speed action and risk-taking: the photojournalist must report the peace, as well as the war. Even so, Kenneth Griffiths is unusual in his choice of equipment. In an age of sophisticated SLR cameras, he uses mahogany and brass plate cameras hand-made in south London by the Gandolfi Brothers. (Production of these continues in the 1980s!)

Griffiths was born in Christchurch, New Zealand, in 1945

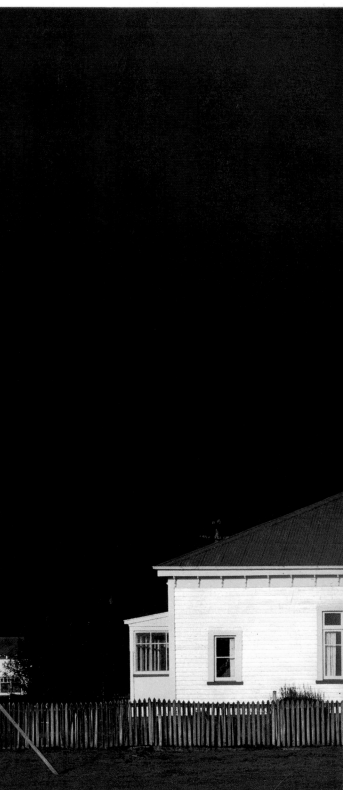

RIGHT Kenneth Griffiths took this picture on an assignment in his home country of New Zealand. He was able to capture a moment when the sun lit the house with the storm clouds in the background, giving an almost two-dimensional effect. He used a telephoto lens with a 1-second exposure and a Gandolfi camera loaded with 5×4 sheet film.

BELOW Here he exposed for the background, holding the detail of the washing and letting the silhouetted trees form a frame for the view and the light across the water. The shot was taken in the Solomon Islands. He used a standard lens on his Gandolfi, and a 5-second exposure.

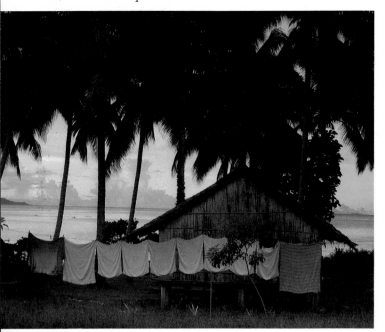

and studied graphic design at university, where he dabbled in photography with a Pentax. He sent some pictures to the Royal College of Art in London and was accepted as a student. There he experimented with constructing pictures with the camera fixed on a tripod. It was therefore logical to use a plate camera for the better quality given by the larger negative. Today he uses three Gandolfi whole-plate (6½ x 8½inch format) cameras, and lenses from 75mm to 480mm.

His technique is to decide first where to place the camera: after that he rarely moves it. Focusing is done under a black focusing cloth. The whole thing is very Victorian—except for the fact that he takes Polaroid test shots to check the image.

'Plate cameras suit my personality and the way I see things,' he explains. 'With a small single lens reflex camera it is like taking a picture with a frame already round it and all the attention is focused in the centre of the lens. With a plate

camera you are looking at the picture rather than through it, and it is more a matter of balancing shapes and light and shade. Because the image is upside down and back to front, it can look a bit odd until you get used to it. But one of the things I like about a plate camera is that I am never entirely sure what I am getting until processing. Sometimes little mistakes can animate a picture and make it work for you.'

Griffiths exploits his anachronistic image. 'People seem to think it is a bit of a joke using old plate cameras and so they are often very much more willing to help. And because the whole business of taking a picture is so obvious, they don't feel they are being spied on.

'It works no matter what part of the world I am in. In primitive countries, where they are more used to seeing old cameras similar to my Gandolfis, I give them a surprise by taking a Polaroid print out of the back. They think that is absolutely wonderful. In civilized countries, people just can't believe that I am seriously going to get under that black hood and take pictures, so they are equally surprised.'

LEFT A highly original way of photographing a group. Griffiths took great care setting up this shot, concentrating on one busy shape in the middle against the symmetry and pattern of surrounding fields. A 1-second exposure at f/22 in overcast light, with a standard lens, gives fine detail and sharpness.

BELOW Miss Yorkshire and Mr Universe. This was part of a series of pictures Griffiths put together for his own enjoyment. It was taken with electronic flash using a wide-angle lens. The exposure was at 1/30 at f/16 on 64 ASA Ektachrome film.

Ashvin Gatha

As a freelance photographer working for glossy travel maga-zines and international corporations, Ashvin Gatha has a tropical eye for brilliant colour. He also has an immense fund of the determination and drive that every freelancer needs to succeed, and which he calls luck.

He started photography in Malaya with his cousin's Box Brownie when he was 22, and entered one of his pictures in a newspaper competition. He won a prize of $30, and used it to buy a Yashica. He took this to Bombay where he slept at the railway station while saving his money to buy one roll of colour film per month. In the evenings he worked for a restaurant photographer taking snaps of the diners. After a three year struggle he had put together his own portfolio.

Gradually he began to get small commercial jobs, then he

made a breakthrough: a commission from Air India. Instead of money as payment he asked for a return ticket to New York where he wanted to work.

'I had just $8 in my pocket,' he remembers. 'When the flight arrived in London they discovered the economy seats had been overbooked, so I was upgraded to first class and found myself sitting next to a famous American art director. I told him I was going to New York to try my luck. He liked my dare-devil attitude and promised me a job on the spot. Armed with 30 or 40 rolls of film, all I had to do was take photographs of New York, anything that I liked. It was an advertising campaign for the New York Daily News, and I ended up with $9000 in my pocket.'

He got an agent and, after four months in New York, headed back to Bombay as an internationally successful

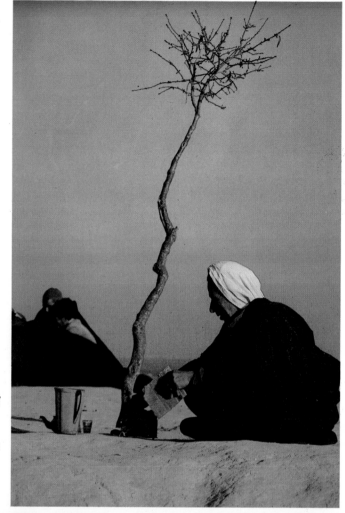

RIGHT To the natives of the Sahara border in Tunisia, making a pot of tea is a time to relax and indulge in gossip. Simple shapes, which stand out against the flat colour of the rock and sky, give the picture impact. Gatha used a 105mm lens on a Minolta XD-7 with Kodachrome 64.

BELOW Gatha was attracted by the vivid colours and patterns of a cinema on the Portobello Road, London. The inclusion of part of a human figure gives a sense of scale. Taken on a Pentax with a 105mm lens.

photographer with half a dozen assignments.

'Nowadays I think nothing of taking 200 or 300 colour films with me when I travel on assignment. And instead of having to make every frame count I can bracket my exposures, return for better shots when the light is right, and try lots of different angles.

'I stick to Ektachrome film—mainly the 64 ASA, and sometimes the 200 and 400. When a client asks for it I'll shoot Kodachrome, but I prefer Ektachrome because I can have test clips developed and ask for special processing when it's necessary. You can't do that with Kodachrome. I always

BELOW Company reports can be profitable assignments for a travel photographer. Gatha took this for the oil company, Texaco, in caves near Riyadh in Saudi Arabia. To try to cope with the contrasty light, he set an exposure half way between the readings for the light areas and the shade. He shot on Kodachrome 64 with a 17mm wide angle on a Minolta XD-7.

under-expose my Ektachrome by a half or three-quarters of a stop, to give the pictures better colour saturation.

'I started taking pictures on a Yashica, but as soon as I could afford it I bought a Pentax Spotmatic. Now I use Minolta SLR's with the complete range of lenses. I've got an autowind on my Minolta XD-7, not as a gimmick but because I focus with my left eye and without the autowinder I'd have to stop looking through the camera to wind on after every shot.

'When I'm shooting I don't like to hang myself up with too much equipment. I usually carry one body with an 80-210 zoom, and another with a 35mm lens. I also carry a soft bag with another camera body and two or three other lenses like a 500mm and a 21mm and 15mm, depending on the job.

'My technical knowledge is almost zero, I do everything by instinct, and I guess that comes from learning photography myself in the 'school of hard knocks'. I figured out how to photograph feature articles by looking at every magazine I could lay my hands on—comic strips too, like *Peanuts* and the

ABOVE With policemen outside the hotel room to guard the jewels, Gatha photographed his wife Flora for a fashion feature for a Japanese magazine. Flora knelt on the rug and he stood on the bed to look down on her. In the available light from a window he shot on Ektachrome 200 using a 24mm lens on a Pentax.

RIGHT While the tailor sews a wedding gown, the groom's female relations chant for blessings. Gatha found them at Soonmarg in the Kashmir. To frame the group he found a high viewpoint and used a 21mm wide angle with Ektachrome slide film.

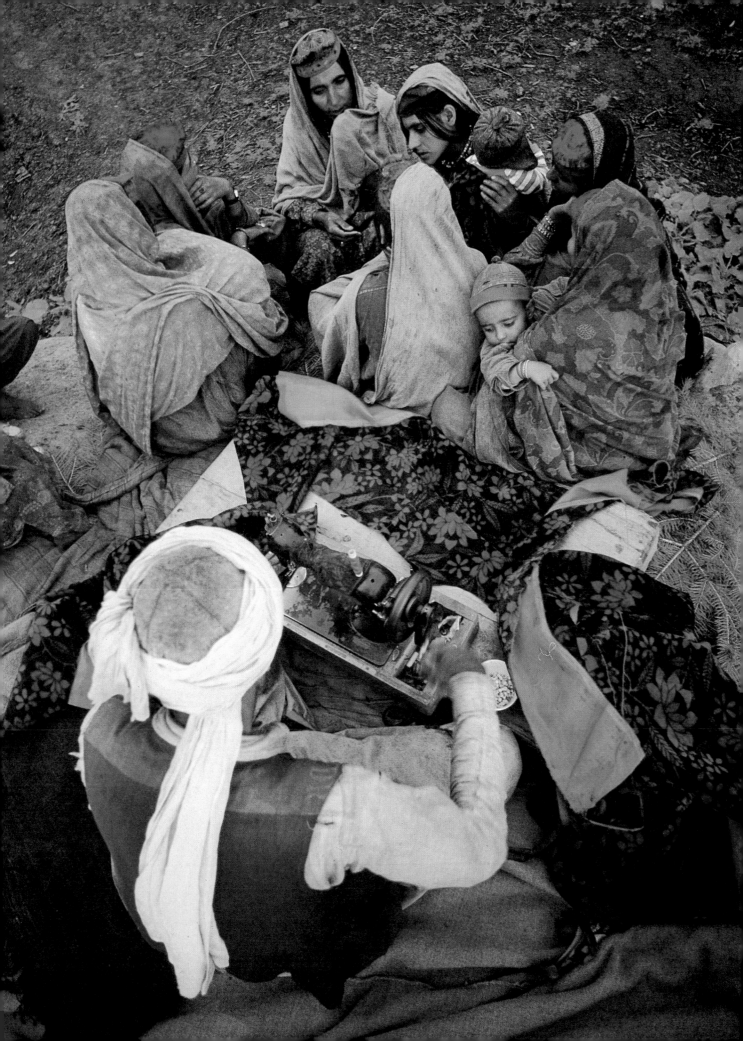

'Classic Comics' which are picture stories of books like *Robinson Crusoe*. Good comic strips tell quite complicated stories in a few vital pictures.

'I don't use flash, I don't like it. It reminds me of hard nights in Bombay restaurants. And I hardly use any filters except for a polarizer when I'm shooting from the air or taking a hazy city skyline. It makes flat colour more vivid.

'I do quite a lot of work for large US companies, illustrating their annual reports and taking pictures for audio-visual strips. But mostly I like photographing how people live in their surroundings. Poverty, yes, it's the easiest subject to photograph because it's so dramatic and you instantly have your viewer's sympathy. But finding humour and laughter in poverty is very difficult, and that's what I look for. I want to show that three-quarters of the world also laugh and smile just like the comfortably-off 25% of us.

'I've been all over the world, and especially Asia with my wife Flora. She's a dancer and she's featured in many of my favourite photographs. I've photographed wars, too. I was in Vietnam and got shot down while flying with the 7th Division on a "one-way ticket" over the Mekong Delta. Vietnam was exciting, but Saigon was disgusting, full of journalists all arguing and boasting about the best exchange rate for the thousands of dollars they were making by filing stories they had picked up without even moving out of the local bars.

'When *Asia* magazine and *Newsweek* asked me to photograph the war in Bangladesh, Flora protested. "How can you earn money that way? If you get a cover shot of a man who has just been killed, who needs the money, you or his widow?" She made me think, and I didn't go to Bangladesh. I agree that the terrible things nations do to each other have to be photographed, but now I concentrate on travel and feature stories.'

LEFT At Gujurat in India, Gatha met the local photographer. Poor people have their photographs taken against painted backgrounds and leave with the feeling that they have been to the city. To reflect the way he took portraits, Gatha photographed him against his decorative backcloth, his two women sitting respectfully in the background. Gatha used a 17mm fish eye lens to bring the women into the frame, and to distort the scene and add to the sense of absurdity.

ABOVE Forbidden to take pictures in the main street in Lagos, Gatha had to shoot secretly from a moving car. He used shutter priority automation on his XD-7, setting the fastest speed available with 400 ASA film.

Mike Yamashita

LEFT Yamashita composed this shot to make the geometric pattern run diagonally. He used a 55mm macro lens stopped down to f/11 for depth of field. The shutter speed was 1/30.

RIGHT A fisherman in Djakarta harbour against a hazy sunrise. Shot at 1/125 at f/8 using an 80-200 zoom lens with 64 ASA Kodachrome.

In 1971 while on a 'roots' trip to Japan, Mike Yamashita, a third generation American, developed a passion for photography that has lead to a photographic career. He accepted a job travelling, bought a camera, and soon found he was spending all his spare time on black and white photography, and all his spare money on lenses. By 1975 he was fairly proficient at handling a camera and offered his services to a travel magazine in Tokyo. Although he had not taken many colour photos, his fees were attractive and they offered him a commission.

'They sent me to the Philippines, where I took a range of pictures. It worked out well so I ended up with several more assignments to different parts of Asia and I started thinking, this is a great way to make a living! By the end of 1975, having built up a portfolio, I decided to return to New York where a writer friend and I approached *Stern* magazine with some story ideas. They advanced us some money and I found myself in Thailand. The plan was to start in Bangkok and sail to the South Pacific. It didn't work out, but I found myself continuing my education and working for a couple of small magazines there, barely scraping a living—though a couple of airline contracts to do promotional photographs helped my finances.

'At the end of 1977 I returned to the States with a better portfolio. It's difficult for a young photographer to get into travel photojournalism if you haven't travelled previously. I had travelled and also had a speciality—Asia—so I found it fairly easy to find work.'

On international assignments he takes everything he might possibly need—six cases of equipment in all—because he believes that he owes it to the client to bring back first class pictures, no matter how challenging the situation. His gear includes a lighting kit, five Nikon cameras (three of which have motor-drives), and a range of lenses from 15mm to 1000mm.

When shooting he knows what the situation will need and makes a lens selection accordingly, taking three cameras so he will not have to change lenses all the time. All he needs then is one bag and a fisherman's vest with pouches for extra carrying capacity. 'I rarely use a 50mm lens. A standard lens to me is a 28mm or a 24mm. Among the telephoto lenses I use the 105mm and the 180mm most frequently. As a general rule I prefer very wide or long lenses.'

Another piece of equipment indispensable to his work is a pocket tape recorder, because Yamashita needs to account for every frame and provide caption information. As he shoots he records information on the subject, the time, the place and the reason for taking the photograph. Later this data is transferred to note pads designated by camera body number, film, date and film roll number.

As for language barriers, Yamashita stresses that it is essential to have a good interpreter, a guide and a driver.

Throughout his work certain predilections appear—a liking for strong colour, strong graphic compositions with one centre of interest, and patterns. Apart from these pictorial con-

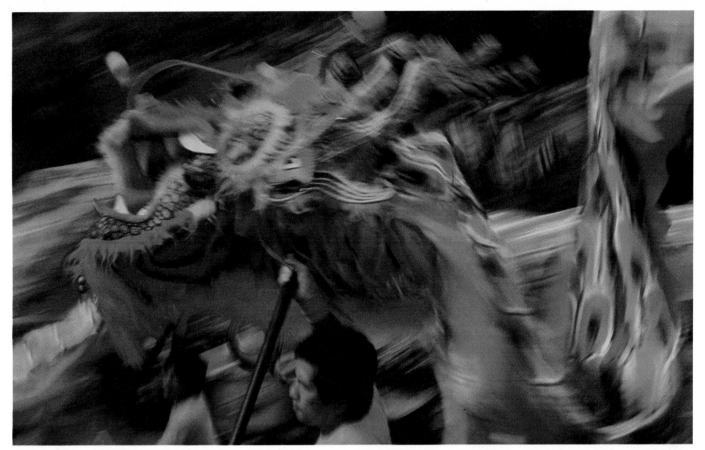

LEFT Using a 35mm lens and a roof-top vantage point, Yamashita patiently waited for the traffic to build up in Hong Kong harbour before making a time exposure to record the tail lights of the cars as streaks.

ABOVE To capture the excitement of these Dragon Dancers in Singapore, he used a 105mm lens set at f/16 with a shutter speed of 1/30 and panned with the movement to blur the dancers.

BELOW This boy is praying right by the hand of an immense Buddha at Sukhothai in Thailand. The statue is in a cave lit by a skylight. Yamashita used a 28mm lens for an exposure of 1/30 at f/5.6.

siderations, he is aware of the job his pictures must do. 'As a photojournalist I'm trying to convey as much information as possible in one picture. One of the greatest talents is to be able to look at a scene, analyze it, and concentrate on the most important aspects so you come away with two or three pictures that say it all.'

But he is not averse to arranging a scene occasionally, as he is quick to explain: 'The most difficult thing for me is to get the picture that has all the information with just a grab shot. For example, if I have to take pictures of a village of potters, I spend about half an hour just looking round, choosing a few angles and a few situations. All the elements are there but I may need to move someone over a little to join a group and perhaps I need more pots in the foreground. So I set up the shot in a believable way.

'The most difficult shots of all are where you don't have co-operation. I had particular problems with a nomadic tribe near the Red Sea. In this instance I had to resort to trickery. I took photographs from the back of a Land-Rover, which fortunately had a canvas cover, and used 500mm and 1000mm lenses, supporting the camera with bean bags. In the desert, the landscape is so flat you find you spend a lot of time shooting from the roof of your vehicle, or even climbing into trees to get a higher camera angle.'

For effects Yamashita has a set of graduated filters, a polarizer and neutral density filter to control contrast in the sky. He does occasionally emphasize an existing daylight colour bias.

Nobody is more aware of the 'golden rules' of light as they apply to landscape photography than a travel photographer. 'I

generally shoot for the two or three hours after sunrise and before sunset. However, there are many occasions when you can't count on being able to do this. In deserts, for example, people generally come to the wells after ten in the morning, and by then the light is harsh. But pictures taken then make a valid statement because they show the heat of the environment. Wherever possible I record a subject at different times of the day and from as many different angles as possible, as well as shooting vertical and horizontal frames to give the editor and the layout people a choice.'

BELOW The true travel photographer takes pictures even when it rains. Here Yamashita used the tourists' brightly-coloured umbrellas to provide contrast. The pointing figure directs the eye to the story of Adam and Eve in 'The Gates of Paradise' on the door of the Cathedral in Florence. Yamashita used his 180mm Nikkor lens and an exposure of 1/125 at f/4 on Ektachrome 64 film.

RIGHT For this photo of rice paddies, taken in Bali, Yamashita used a 180mm telephoto lens to isolate the section of pattern he wanted, and to give the effect of perspective compression. He used a polarizing filter to increase the colour saturation of the greens.

NATURE

Probably no branch of photography requires more versatility, or greater determination, than nature. Subjects range from motionless mosses to fast-moving insects, from deep-sea fish to high-soaring birds, from microscopic organisms to huge mammals. What is more, very few—if any—of them will pose to order. In addition, the nature photographer must also be a naturalist. Many subjects cannot be photographed without a knowledge of their behaviour and habitat. Then, of course, they must all be correctly identified if the resulting pictures are to be of use. Expert nature photographers are not just professionals, they devote their lives to it.

Heather Angel

Heather Angel read Zoology at the University of Bristol before working as a marine biologist until 1966, when she (and her oceanographer husband) moved away from the sea. It helped propel her into full-time photography.

'I came into photography by accident rather than design,' she says. 'I wanted to utilize my degree in a creative way. For several years the photography was subsidized by lecturing. Two abortive attempts to get general photographic agents to sell my pictures left me in no doubt that no-one could sell from a specialized picture library better than the photographer.' She therefore founded her own library, Biofotos, which now has over 75,000 transparencies. She has supplied pictures for film-strips, travel brochures, coins, advertising, television, magazines and more than 400 books. She has herself written half a dozen books on photographing nature, and 20 books on biological topics.

The library now employs two secretaries and an assistant, giving her the freedom to make three or four major trips a year. Recently she has been to Arizona, Australia, Barbados, Florida, France, the Galapagos, Hawaii, Kashmir, Madagascar, Mauritius, New England, New Zealand, Peru, the Seychelles, South Africa and Zambia.

'In the early days,' she admits, 'if the deadline was not too urgent, I would go out and shoot a subject, rather than admit to not having it in the library. By dealing directly with the picture editors and researchers I constantly have the feed-back of what subjects are in popular demand. These become top priority for taking in the appropriate habitat and season.

'Commercially it is far better to go for an unexciting subject which appeals to no other photographer, rather than go and take yet another robin. I did just this with bean-root nodules made by nitrogen-fixing bacteria, and it has sold eight times in colour alone.'

Heather Angel's advantage is that she is a practical scientist. 'Many natural history photographers take excellent photographs, but not so many are able to supply editors with a solid caption to back up the picture. After each trip abroad we compile a detailed catalogue listing the habitats and species photographed. All new transparencies are fully cross-referenced before they go into the library, so that they can be retrieved via the common or scientific names, the country of origin or the biological activity.'

The facts are vital, but the pictures must also be visually exciting. 'Gone are the days when a correctly-focused animal portrait will be snapped up. Now it is action—be it courting, mating, hunting or breeding—which catches the eye.'

Her prime objective is to portray her subject naturally. She uses daylight in preference to artificial light, and her only 'gadget' is a polarizing filter for reducing surface reflections if she is shooting marine subjects from above the water. She also tries to preserve the natural environment, by not trampling

ABOVE This picture of an adult sawfly was taken late in the day using an exposure of 1/30 at f/5.6 on Kodachrome 25 film with a 55mm Micro Nikkor lens on a Nikon.

RIGHT This flying frog was photographed in the studio with a Hasselblad using two Vivitar 283 flash guns. The exposure was 1/125 at f/11 on Ektachrome 64.

ABOVE Sally Lightfoot-Crab photographed with a 135mm lens on a Nikon SLR.

BELOW To photograph this seaweed she used a polarizing filter thereby eliminating reflections of clouds on the surface of the water and enriching the colour.

RIGHT For this shot of guppies, Angel used two electronic flashes angled at 45° to the front glass to avoid reflections. It was taken with a Hasselblad on Ektachrome 64 film. One method of photographing fish in a tank is to divide off a part so that the fish are confined.

seedlings underfoot for example. She goes to extraordinary lengths to ensure that the subject is seen in its natural surroundings. If one small part of the 'props' is out of place it disturbs her. If she is forced to move her subject to make a better photograph then she takes the immediate surroundings — a piece of seaweed, a certain grade of pebble perhaps — with it whenever possible.

No one crawling about in a field stalking a beetle can afford to be laden down with too much equipment, and Heather tries to restrict herself to a couple of camera bodies and one or two specific lenses. A favourite accessory is a ground-spike, which steadies the camera when photographing plant life at low level. She almost always uses a tripod or monopod for other subjects. She carries an aluminium mountaineering-type survival blanket to use as a reflector, to squeeze an extra f/stop out of the available light, and a small mirror or piece of white card to fill in shadows.

When she arrives at a site she does not take pictures haphazardly. She sits down and waits. She observes. She thinks. She says she has learned a lot simply by watching animals. Only when she knows she will get the picture she wants does she take the camera out. 'I don't take a picture at all costs just because I'm there. If the image in the viewfinder isn't doing what I want I don't take the picture.'

The cameras she uses are Hasselblad and Nikon, and she bases her choice of format on how the final picture will be used as much as on the bulk of the equipment. For the 35mm Nikon system, her favourite lenses are the 55mm and 105mm Micro Nikkors for close-ups, and a 400mm for photographing birds and animals. For the 120 roll-film system she most often uses the 80mm standard lens, frequently with extension tubes or bellows for close-ups. On 35mm she uses Kodachrome 25 and 64 films, and on 120, Ektachrome 64. She uses slower speed materials whenever possible to get the finer grain and better colour saturation which her high standards demand. While she will compromise on the equipment she takes, to compromise on film would be unthinkable.

When not travelling she takes pictures in the studio, taking time to create a natural habitat for the plant or creature she is photographing. She uses small electronic flash-guns for lighting, because they offer a cool light source. Often it is hard to tell whether a picture was taken in the studio or in natural surroundings.

Heather Angel constantly experiments with new techniques. At the moment, for example, she is working with fibre-optics coupled with a low-power microscope. She may already have taken over 75,000 pictures, but there is no danger of her running out of either subjects or ideas.

ABOVE To get a dramatic effect, she chose a misty morning for this shot of birches sprouting. She used a Hasselblad, and the exposure was 1/15 at f/8.

LEFT Heather Angel photographed this heron lit by the rising sun. She hand-held a Hasselblad and used a shutter speed of 1/250.

RIGHT Using a 105mm Micro Nikkor lens, Heather Angel has separated this beech tuft fungus from the dark woodland. Shot at 1/15 at f/8.

BELOW This shell was lit from behind with a tungsten spotlight to show how its chambers spiral. She used tungsten-balanced Ektachrome film.

Robin Fletcher

Robin Fletcher specializes in natural history close-ups. He lectures on British wildlife to adults in further education colleges using his slides as a basis for his talks.

For close-up work he uses a Pentax Spotmatic with a 100mm Takumar lens, mounted on a bracket with an obsolete Courtenay Courier flash. (The 480 volt battery for the flash gun weighs about 4.5kg/10lbs.) 'I object to the horrible black backgrounds you can get with small flash units. They make a butterfly look nocturnal and destroy the atmosphere of the habitat. The big reflector and high power of the Courtenay help overcome these problems by softening shadows and reducing fall-off of the light.

'Most of my work with insects is done between one quarter

BELOW Fletcher photographed these frost-covered Pyracantha berries using a Nikon EL on a tripod with a 55mm Micro Nikkor lens. The picture was shot on Kodachrome 25 by available light.

RIGHT The Silver-Studded Blue, reproduced about ×4, stands out against the dark, out-of-focus background. With a flat subject, the shallow depth of field of a 100mm Takumar macro lens is less important than making sure that the focus is even from edge to edge.

lifesize and lifesize. At these magnifications you have to focus very accurately. I pre-set the focus accordingly to the size of the beast—say 1:1 for a beetle or 1:3 for a butterfly—frame it, and then rock back and forth to focus. The trick is to stop rocking before you shoot. Keeping it in focus takes practice. I find the 100mm Takumar easier to keep in focus than the equivalent Nikkor.

'Choosing the point to focus on is another problem. You have to have a feeling for how much depth of field there is available. It's important to have the front of the subject in sharp focus. I focus as far into the beast as I dare while keeping the front sharp. I get a good range of magnification with a macro lens, providing up to half lifesize reproduction, and an extension tube giving quarter lifesize, on the camera, thereby giving a range from a quarter to three-quarters lifesize. The bracket keeps the flash close to the subject and that makes up for the extension. With the Pentax loaded with Kodachrome 25 and using this set-up I know from experience the aperture to choose for the amount of magnification. My Courtenay gives me f/16 up to about three-quarters lifesize.

'With an unfamiliar flash gun the guide number gives you some idea of the right stop. I'd shoot a picture at that stop and get a good idea of the right exposure within one or two stops. I'd then do a series of exposures in ½ or ⅓ stop steps each side of the supposedly "correct" exposure and look very closely at the results. Once you get the right exposure it works for most

things; if the subject is black then you need a bit of compensation.'

Fletcher also standardizes his flash set-up in the studio with the camera both on a tripod and hand-held. 'In the field, butterflies and insects tend to feed in a more natural way than in the studio. But you've got to be lucky to get a good picture in the field because of the background. You are confined to working in places with dense vegetation so that the flash fall-off doesn't give you a black background. You want the flash to light something behind the subject as well. Indoors you can use a separate background light.

'Insects need time to get acclimatized to a new habitat in the studio. Some do this quite happily, like my cellar beetles. They're happy in their jar in the kitchen feeding and reproducing. Sometimes I slow butterflies down by putting them in the fridge. It stops them bashing themselves about on the set. You have to wait for them to thaw out before you photograph them. Larger animals, like snakes, I prefer to do in the field. My 200mm Macro Nikkor is ideal for this, but even a 100mm lens is OK. Just move in gently; snakes expect people to jump, but they will sometimes tolerate a quiet approach.'

Three bags divide and carry Fletcher's mainly Nikon equipment; any two of them will fit into his rucksack. The first bag holds a couple of bodies, a range of wide angle lenses and several standard lenses—these are used for plants, land-scapes and things that do not move. The second has a body loaded with Kodachrome 64, and 80-200mm and 43-86mm zoom lenses—this bag is for action work. The third bag holds the Pentax—used exclusively for close-ups.

'I set my equipment up carefully. The first thing I do is use a blower brush on the lenses. Then I get the tripod out and look for a good viewpoint. I always wait for the wind to stop blowing; I probably spend longer at that than anything else. Sometimes I do a bit of "gardening", pulling or tying—never cutting—things away to prevent bits of fuzzy focus. I want impact in my pictures. I want them full of information. I also want a big "Oooooh!" from my audience, and I'm prepared to go to a great deal of trouble to get it.'

BELOW The nesting gannets were taken with a 35mm lens to show how widely the birds were distributed—the wide-angle lens 'gets more in'. Access to natural history subjects is often a problem. These nests were only accessible by small boat across 10 miles (16km) of open sea.

RIGHT The Cardinal beetle (reproduced about ×3) is lifesize on the original slide. Fletcher's 100mm macro Takumar can reproduce at ×½. Its range of magnification is increased by adding extension rings. Fletcher knows his Courtenay flash gun so well he can guess exposures accurately.

LEFT Fletcher pre-set the focusing distance, stopped the lens right down and gently rocked to and fro until the preying mantis's eyes were sharp. The trick with this method of focusing in close-up, is to stop moving before shooting! How little depth of field there was is shown by the insect's right foreleg, which is well out of focus.

ERIC HOSKING

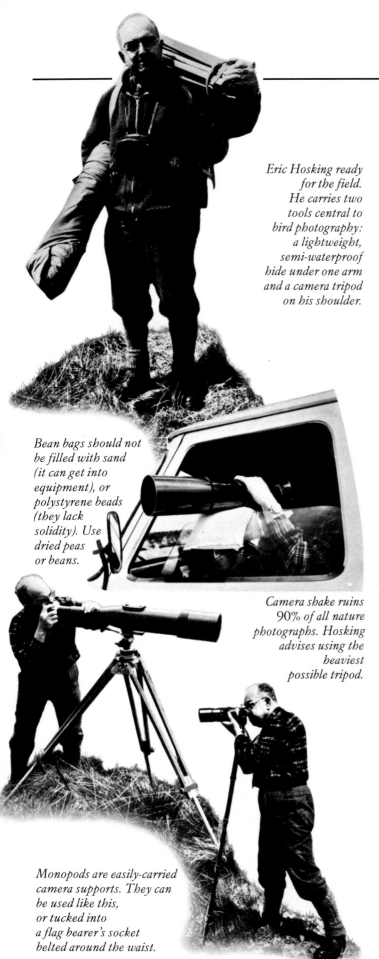

Eric Hosking was born in London in October 1909, and since 1929 has helped illustrate more than 900 books on nature and wildlife. He has been called the world's greatest bird photographer.

Where his interest in wildlife came from is a mystery; he knows only that it has always been there. But how he became a wildlife photographer, after being made redundant, is better documented.

A newspaper friend, knowing of his interest in photography and animals, asked Hosking to photograph a child feeding a huge baby elephant seal at London Zoo. The picture was a success. It was quickly followed by pictures published in the *Daily Mirror* and an invitation to produce his first book *Friends at the Zoo*. For years after that he supported himself by child portraiture and wedding photography while he learned more about wildlife photography.

'Everything is very different with the modern equipment,' says Hosking. 'For years I was the only professional photographer of birds in Britain. Now there is an enormous army of weekend shooters and the 35mm camera is so simple they are capable of superb work. Yet 90% of their failure is due to camera shake. You often need to use long lenses for successful wildlife photography but people won't be bothered to carry a monopod or shoulder support, let alone a tripod.

'For certain aspects of wildlife photography I use 600mm and 800mm telephotos. The longer the focal length, the more difficult it is to hold the lens still; but there are two answers to this problem. The first is a tripod. A lightweight one is more nuisance than it's worth, you have to use the heaviest that you can. The tripod I use with the 800mm weighs 12.7kg (28lbs). The other answer is the Hosking bean bag.'

The 'Hosking bean bag' is made from heavy duty cloth and measures about 30 x 20cm (12 x 8in). Hosking says that bean

Eric Hosking ready for the field. He carries two tools central to bird photography: a lightweight, semi-waterproof hide under one arm and a camera tripod on his shoulder.

Bean bags should not be filled with sand (it can get into equipment), or polystyrene beads (they lack solidity). Use dried peas or beans.

Camera shake ruins 90% of all nature photographs. Hosking advises using the heaviest possible tripod.

Monopods are easily-carried camera supports. They can be used like this, or tucked into a flag bearer's socket belted around the waist.

ABOVE Zoos and aviaries provide material for the wildlife photographer. This aggressive display by an eagle owl, part of a collection of owls, was lit by flash and shot on Kodachrome using an Olympus OM-2 with a 135mm Zuiko lens.

RIGHT East African leopard taking a siesta. At 12ft (4m) from the animal, Hosking put his head through the minibus roof, settled his Hasselblad and 100mm lens on a bean bag and used Ektachrome film.

bags should be filled with dried beans or peas but never with sand that could seep into the camera or lens. He sets the filled bag on a steady surface—like a car window frame—and 'moulds' the camera and the lens into it so that they balance. He focuses and holds the equipment down firmly and gently while he squeezes the shutter. Hosking says that the bean bag enables some pictures to be taken in positions where it would have been impossible to get a tripod.

He uses Olympus 35mm and Hasselblad cameras with Kodachrome 64 and Ektachrome 64, 200 and 400 films. He suggests that a beginner should start with a 35mm SLR camera and an automatic-diaphragm lens of 200-300mm that will focus down to about 30cm (1ft). Depth of field is small with telephoto lenses and the photographer will often have to work at f/16 or smaller to keep the whole subject in focus.

For subjects that do not run away—like those in a zoo or wildlife park or when working from a hide by a nest—Hosking advises using a 135mm or 150mm lens. Using a zoom lens minimizes lens changes but he would only recommend buying one of the more expensive models. The optical quality of cheap ones may not be good enough. A standard 50mm lens is also useful and can be used with captive subjects. The aspiring wildlife photographer will eventually acquire a set of extension tubes or bellows and some electronic flash equipment.

'It is a good idea for a beginner to practice with garden birds at a feeding table,' says Hosking. 'I arrange a branch of a tree and position it a little above the table and about 60cm (2ft) away. A bird will invariably land on the perch first, to take a look around before going to feed, giving the photographer sufficient time to take his shot. I like to photograph birds against a subtle, natural-looking background. Avoid photographing them against a brick wall or a background of trees that might give a spotty effect that distracts the eye from the bird.

ABOVE This great frigate bird on the Galapagos, has no fear of man. Some were so inquisitive that he had to run away from them to take their picture.

LEFT Hosking was 'lost for adjectives' when he saw Lake Nakaru with its pink flamingoes. He shot more than 400 pictures of the scene in 90 minutes using a Hasselblad—and ended up with a big blister on the shutter finger.

Hosking often uses his car as a hide. 'It is surprising how often you can park close to birds wherever they are. Just drift quietly up to them. I have been able to get so close that I have had to use extension tubes. When it comes to hides there are no set rules. It's experience that counts. You have got to know your natural history and become familiar with telephoto lenses.

'Small mammals each require a different technique. It's probably impossible to photograph the pygmy shrew completely free and wild. It eats its own weight in food every day and moves very rapidly. Yet the first thing a hedgehog does is roll into a ball. There is time to set up a tripod and then you must remain motionless until it decides to move. A hedgehog will react very rapidly to the sound of the shutter and will curl up again so you must shoot quickly and speeds of at least 1/250 will be necessary.

'Badgers you have to wait for at night. Having found the set, I focus on one spot, such as a stone, near the entrance because you can't focus in the dark. I use a single flash head for a main modelling light, and a second or third one to fill in

ABOVE Two Braun 700 flash heads were used to light this badger, one for main modelling and one to fill in heavy shadows. David Hosking used a 150mm lens on a Hasselblad.

RIGHT This blue tit has broken an infra-red beam across its nest entrance and triggered David Hosking's camera. The camera was synchronized with two custom-built flash heads with very brief exposure times to freeze the rapid movement.

BELOW A motor car can be used as a mobile bird hide either by driving up quietly to the subject or by waiting patiently for it to approach. Hosking used the technique to photograph this East African crowned plover with an OM-2 and 600mm lens supported by a bean bag. The telephoto throws the background well out of focus so the birds would blend into it.

the shadows. Then I settle down until the badger comes out. There is a terrible temptation to shoot as soon as it appears but you must wait until it reaches the stone.'

There are also new approaches to wildlife that have been made feasible by the SLR camera. 'I don't believe that the best photograph has been taken of any bird. A bird is essentially a flying machine, best photographed in flight. Many birds also have wonderful courtship displays. Very little successful photography has been done in the area.

'Big birds like gulls and vultures have to be photographed flying in a free and wild state. The method I use is to estimate the distance the bird will fly in front of the camera, set the focus and wait for it. I don't think many people can focus on a bird in flight or keep a flying bird sharp.'

Eric Hosking's son, David, is also his partner, and now following in his father's footsteps. He has been working with high-speed flash to find solutions to the problems of recording movement by using multi-flash with variable delay between images. Together there seems to be no photographic challenge the Hoskings will not tackle.

Peter Johnson

The wildlife photographer in Africa can end up photographing anything from ants to elephants. The techniques are basically the same as for less dangerous subjects, as Peter Johnson explains. He has completed five books of natural history photography, and to make his vocation clear, always talks of photographing, not shooting.

'I don't photograph a kingfisher simply as a kingfisher, or a frog or a lion just for their species. I want to photograph living things as part of their environment,' he says. 'That's why I go to great lengths, even in the black of night, to photograph the background as well as the animal. To isolate a creature against some nebulous black velvet background is unthinkable for me.

'You're unlikely to be walking around photographing buffalo, say, in the bush in the middle of the night. So there you are, incarcerated in a vehicle—a sardine tin on wheels—and all at once you see what you're looking for, a big bull maybe. And you're on your own, but you've got to get some light on him.

'Fortunately, I've developed a system of mounting quartz halogen lamps on top of the truck, with a blue screen over them so that I don't get too much of an orange cast on daylight film. I have one lamp stuck out on a long extension arm so that I can get a bit of light behind my subject to illuminate the bush.

'When I travel like that I always take three Nikons with me, two F2s and an F3 on which I can shoot six frames a second with a motordrive. I also have two Hasselblads. For big animals I use mainly long lenses from 200mm to 600mm and I've a 1.4x converter that will take me to 840mm and lose only one stop, which is fine in the African light.

'For really close-up photographs of tiny creatures like ants I use a bellows, and I've also got a superb 200mm macro-Nikkor that might have been made just for me. The beauty of it is that the front element doesn't move out when you focus closer as this might scare the subject away. Unlike most other macro lenses all the focusing movements takes place internally.

'My home is Johannesburg, but I was born in Rhodesia where my interest really started, pedalling a bike out into the bush and shooting (and I really mean shooting, but I don't like to think of it now) birds and small game. I began studying natural history in England, at Oundle. While I was there I used to shoot, skin, and stuff birds. I met bird photographer Eric Hosking as a result of my having an exhibit in a small museum. He pointed out that shooting was a rather deadly pursuit. He introduced me to the idea of photographing birds instead.

'I went on to study forestry at a university in Canada. It was a good discipline, learning to think like a natural historian. I came back to South Africa and I started doing academic research into South African birds. Some of my research was published and I needed pictures to illustrate it. I soon discovered that I liked taking pictures better than anything else. I already had the mental equipment for taking good photographs because I had the knowledge of exactly what my subject was going to do next. After all my years in the bush I feel some intimacy with the habits of species of African wildlife.

RIGHT Peter Johnson, pictured above with bushmen in Botswana, was driving through a region of the eastern Transvaal when he spotted this ram impala drinking from a puddle created by unseasonal rain. He took the shot with a Nikon. For the portrait of a doe impala (inset), taken in the Kruger National Park, he used a 400mm lens at f/5.6

'Taking photographs in the bush and desert follows a strange timetable—from dawn to 10 am and from 4 pm until dusk. The sun spends most of the day high in the sky, because it's so close to the Equator, and it's not good for photography. If you work early and late, the light has a much better quality to it and there's not such great heat—and heat haze—to contend with. Towards the evening you've got the best light of the day and interesting things are happening. If you've got lots of dust around you're going to have superb sunsets with wonderful pink light.

'When I've finished photographing in the best of the morning light I come back and write up my notes, label my films, and maybe wash my clothes or read a book until I feel drowsy. I work again from four o'clock until there's no more light. In the tropics, as in the desert, the light goes out *bang,* as though God has switched it off. There's no lingering twilight like in Northern latitudes, or in the Antarctic where there is low-level light all through the summer.

'When I'm not photographing natural history for the publishing world, I love pottering around in the bush making abstract pictures. Not long ago I came upon a lucky-bean tree with the pods open wide and empty, and the ground beneath was an inch thick in brilliant red, black eyed lucky-beans. For three whole hours I just paddled around in this thick rich carpet of red, looking for the compositions and patterns I liked. Or I might photograph vertically down on a patch of long grass to get a 'wasps-eye' view. The grass won't spring up and suddenly run away, and that's a nice occasional relief from the great demands that wild creatures can make on your patience and concentration.

'I took to photography in the first place because I'm a naturalist, but I think that what really entrances me is the challenge it presents. Nevertheless I didn't choose natural history photography as a way of life because of its difficulties. I chose it because I felt that I could compete with the best, and it gives me an outlet to express my own soul.'

LEFT Johnson was travelling by compass through the Kalahari, in central Botswana, when he saw this impressive lion. The dust-filled air gave soft, diffused light.

RIGHT Moonrise and sunset can happen at the same time in the Antarctic Peninsula. The setting sun left the soft pink glow on the water while the moon's trail is also reflected. He used a Hasselblad, hand-held for an exposure of 1/60.

BELOW This group of giraffes had just walked across open flood land to reach a drier area where it would be easier to escape predators. He used a 400mm lens on a 35mm SLR.

LEFT To get in close on this hippo's 'threat display' Johnson
used a 1.4×tele converter with a 600mm lens—effectively
giving him an 840mm lens but without the bulk and cost.

Stephen Dalton

If you show one of Stephen Dalton's pictures to an unsuspecting photographer, you'll probably get one of two reactions. 'A nice bit of montage work', or, 'clever retouching—you can't see the wires'. But neither answer is right. Dalton's insects and birds are live and wild, actually photographed in natural flight by high-speed flash.

'Insects had never before been successfully photographed in free flight, which made it an Everest I wanted to conquer.' That was the driving force behind Stephen Dalton, whose pictures are unique in the world of natural history photography. They are the result of years of painstaking work developing and refining the equally unique electronic equipment to overcome enormous technical problems.

His interest in photography began when he was a child and his father gave him a box Brownie. Rushing out into the garden, he photographed a greenfly on a rosebud from a couple of centimetres away. The blurred result was Dalton's first experience of the problems he was to come across later. In 1969 Dalton's three passions in life—insects, flight and photography—finally came together. He calculated the exacting specifications necessary to photograph minute insects, freezing wing beats of anything up to an incredible 1,000 per second, and from this planned the equipment he would need.

A trigger unit which could detect an insect the instant it moved into the small area of sharp focus before his lens, was the first requirement. 'Insects pose particular problems because they move so quickly in relation to their size. A dragonfly, for example, can manage well over 50 kilometres an hour. They are unpredictable, too, and tend to zigzag all over the

ABOVE Before specializing in flight pictures, Dalton's work included natural history subjects. This tree frog is a recent picture taken with a Leicaflex SL2 fitted with a 100mm Macro Elmar lens using a 'pocket' flash. 1/1000 at f/11 on Kodachrome 25.

FAR RIGHT One of 900 frames exposed to get the picture of a lacewing Dalton wanted. Three consecutive flash exposures, each of 1/25,000, show the same insect's wing movements in detail. 100mm Macro Elmar lens at f/11 on Kodachrome.

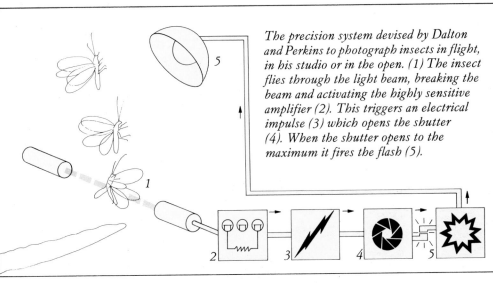

The precision system devised by Dalton and Perkins to photograph insects in flight, in his studio or in the open. (1) The insect flies through the light beam, breaking the beam and activating the highly sensitive amplifier (2). This triggers an electrical impulse (3) which opens the shutter (4). When the shutter opens to the maximum it fires the flash (5).

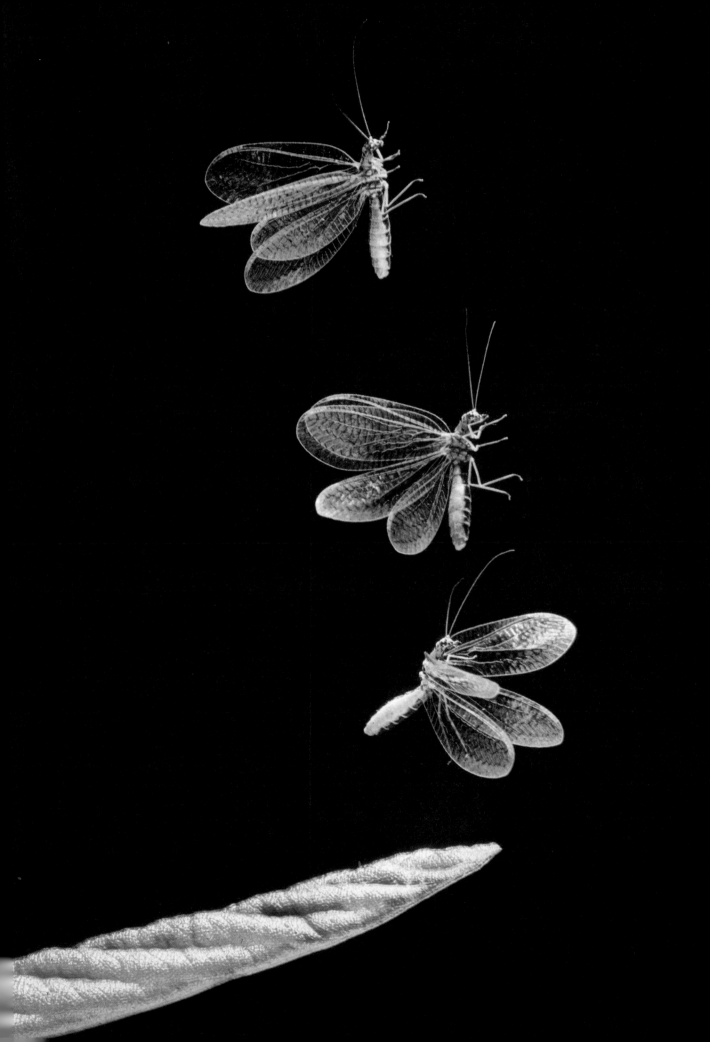

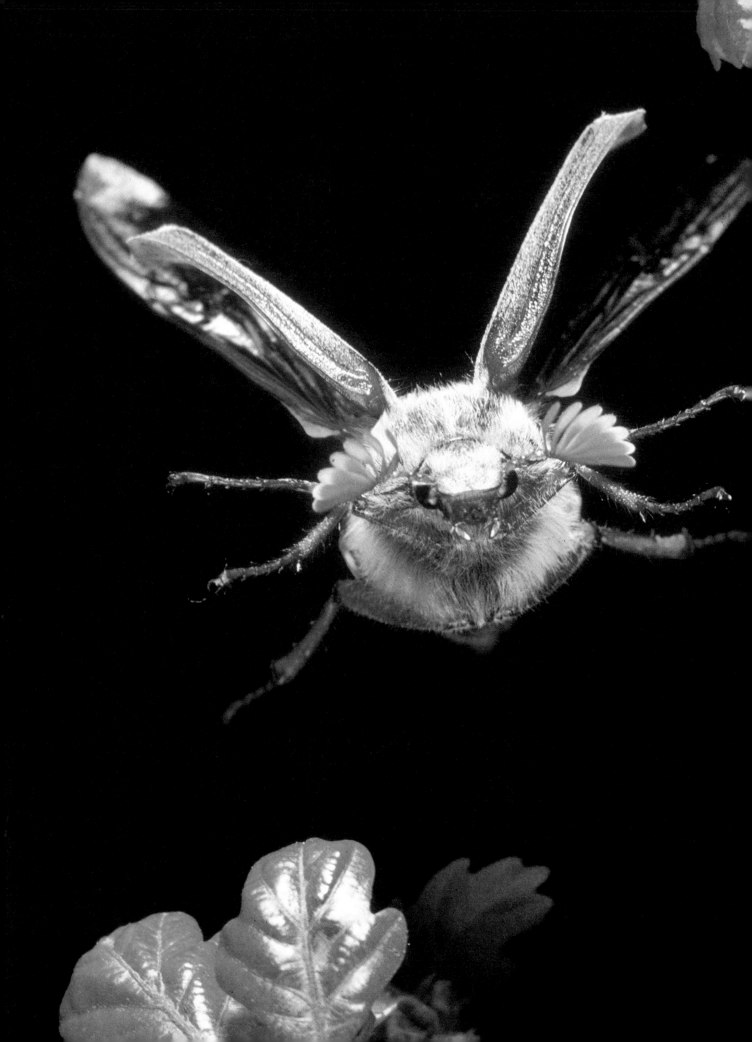

place.' The only way of capturing an insect's rapid wing movements is high-speed flash. Dalton reckoned on an exposure time of 1/25,000. This would give his picture scientific value, and help to explain the true mechanism of insect flight. Until quite recently, insect flight seemed to break all the rules of aerodynamic theory.

A difficulty with high-speed flash was the amount of power needed to produce enough light. He had to be able to use a lens aperture of f/16 to get enough depth of field. He also wanted to use 25 ASA Kodachrome film for its 'unmatched definition and fidelity'. The final technical hurdle was a high-speed shutter. A normal shutter takes between 1/10 and 1/20 before it is fully open and a flash can be fired. This is long enough for some insects to move 30cm (1ft) or more. With as little as 2mm of sharp focus, Dalton needed a delay of only 1/500.

Enquiries in Europe and the USA drew a blank: the equipment was not available. Then he met Ron Perkins, an electronics expert and a keen photographer. He understood Dalton's problem and offered to lend a hand in his spare time.

It took nearly two years, but by 1971 Dalton had what he needed. As a bonus, he also had a multi-flash device. 'With this I could fire three flashes in rapid succession with an adjustable delay between each, showing three different wing positions in the same shot. Also the apparatus made it possible for the first time to study take-off and landing behaviour.

In 1971-72 he photographed more than 100 species of insects in flight, making more than 15,000 exposures for his first major book, *Borne on the Wind.* 'Most insects are so unpredictable that the success rate is still no more than about 50%. I've taken as many as 900 exposures of a single insect before getting the picture I'm after—that was a lacewing for the cover of the book.'

For all insect photography, Dalton uses a 35mm Leicaflex fitted with a 100mm Macro Elmar lens. The camera's focal

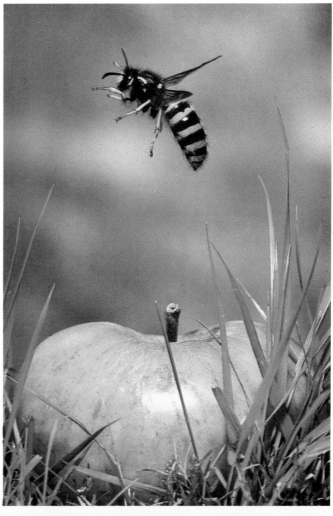

LEFT The cockchafer or Maybug is a clumsy flier, filling air sacks in its body to enable it to fly. Here it is caught by flash at 1/25,000 as it blunders towards Dalton's Leicaflex. 135mm Hectar lens, f/16 on Kodachrome 25.

ABOVE RIGHT Dalton was the first to successfully photograph the mechanism of insect and bird flight. This wasp in vertical take-off is caught, apparently motionless, by his high speed flash. 135mm Hectar lens at f/16.

RIGHT One of Dalton's earlier pictures—a water vole, framed by a dark background. Taken with a 250mm lens on his Leicaflex SL2.

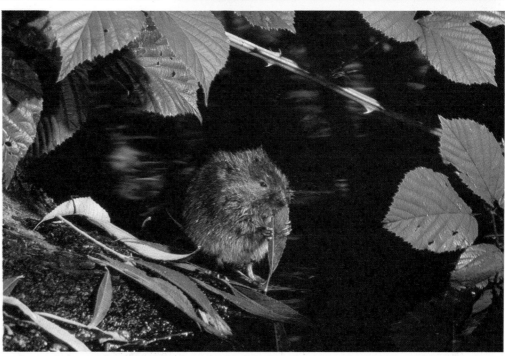

plane shutter is locked open, and the special high-speed shutter is clamped in front of the lens and coupled to the flash unit which in turn is linked to the trigger. If any one of the highly sensitive light beams is broken, it will trip the shutter and fire the flash. In 1/25,000 of a second the insect will have photographed itself.

After several years of concentrating on insect photography, Dalton's interest switched to photographing birds. Some of these pictures were included in his later books *The Miracle of Flight* and *Caught in Motion.* Dalton uses a Hasselblad 500EL/M for bird photography, with a flash exposure around 1/12,000 on Ektachrome 64 film. The much larger 6 x 6cm film area should give improved picture quality.

'I first tried photographing a swallow drinking in 1977. I watched them swooping down to my garden pool in Sussex and thought it would make a good shot, so I gradually netted off part of the pool, slowly reducing the area of clear water to quite a small area. The birds were still coming to drink, so I put up a tripod, then a couple of lights, and then a couple more until after two weeks or so, I was ready to start setting up the camera.

'Then, of course, the problems started. The birds were put off by the noise of the camera, and would only come to drink a few times a day. What's more the electronics of the Hasselblad's motor interfered with the flash, and the shutter would keep firing.' So all he had to show for four weeks work was some tail feathers in the corner of one transparency.

Undaunted, the next summer he was determined to try again. 'I had made a "blimp" for the camera, a sort of glorified tea-cosy, which made it completely silent. Also, Ron had fitted a kind of suppressor in the camera shutter which, with some modification, solved the technical problems.'

So, another three weeks was spent setting up the equipment. The plan was to simulate bright sunlight using four flash heads. The test pictures went well, and a few days later when the flash heads, light beam and sensors had been finely adjusted, the camera was loaded with Ektachrome. 'I left the camera to it. When things are properly set up, the bird triggers the shutter, the shutter fires the flash, and the motor winds on to the next shot, though you're never quite sure what you're getting. But I was shopping in Brighton when the best pictures were taken!'

The example reproduced here gives some idea of the speed at which everything happens. You can see the trail in the water where the bird has scooped up a drink. The whole action is frozen in a single picture.

After insects and birds, Dalton has moved on to photographing flying animals—bats, reptiles and amphibians. While many of these lead a leisurely existence, 'once stimulated, they can move like lightning—and it's at these moments that the high-speed camera really comes into its own.' Dalton has photographed such rapid actions as the common frog plunging into the water, the rattlesnake striking, the chameleon snaking out its tongue to snatch up its prey. Clearly for a photographer of Dalton's imagination, there is no shortage of subjects.

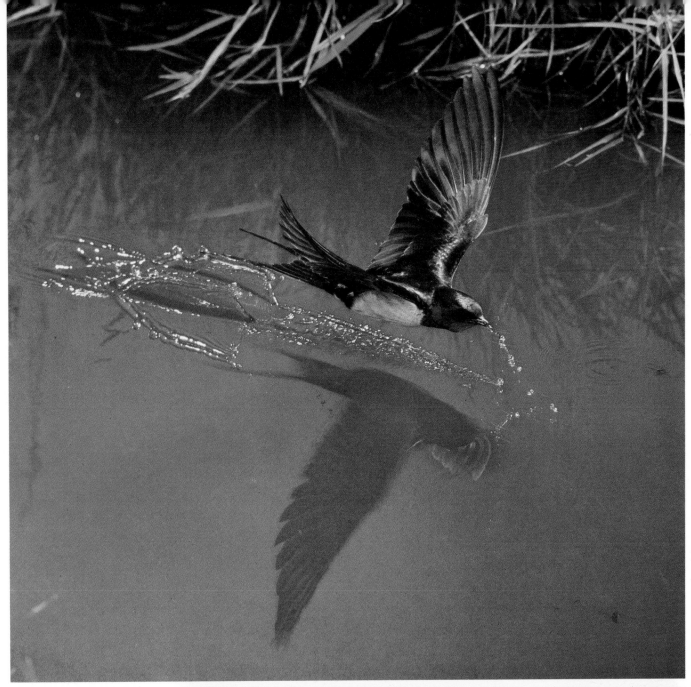

ABOVE For the first time a swallow is shown drinking on the wing. Dalton used a Hasselblad 500EL/M, with a 150mm Sonnar lens. The effective exposure from four flash heads was 1/12,000.

RIGHT Three exposures taken within 1/5 of a second show an owl as it comes in to land. Leicaflex SL2, 100mm lens, three 1/25,000 flashes at f/8.

LEFT A Venezuelan green heliconid butterfly triggers the light sensor, automatically taking its own picture. 1/25,000 at f/16 on Kodachrome 25.

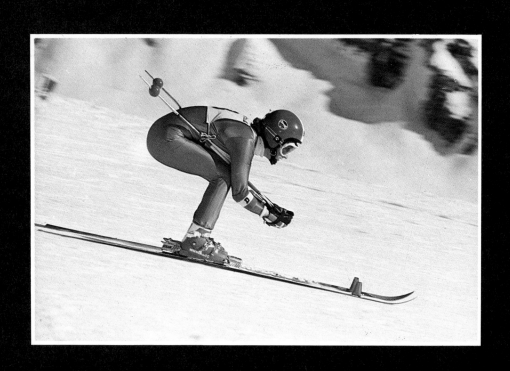

Gerry Cranham

Gerry Cranham came to photography relatively late in his life. He was born in February 1929, and became an aircraft engineering apprentice, a regular soldier and a civilian draughtsman before he took up photography. A middle-distance runner, he was twice the English Southern Counties junior half-mile champion, a torch-bearer at the 1948 Olympics, and the Inter-Services half-mile champion.

Then in 1953, when a foot injury put him out of competitive running, he took up coaching. To show his pupils what was wrong with their styles he bought his first camera, a British-made SLR, the Periflex. Runners started to demand and buy his pictures. 'It started everything off,' he says. 'Within two years I was totally occupied with a new-found profession.'

He sold pictures to his local paper and at the age of 31 his first photograph appeared in *The Observer* newspaper. 'It only gradually dawned on them that they were using the best sports photographer in the country,' wrote *The Observer*'s Geoffrey Nicholson in the catalogue to an exhibition of Cranham photographs at the Victoria and Albert Museum in 1971.

The same year as his debut in *The Observer*, he also sold a remarkable picture of a girl long jumper landing in sand to *Sports Illustrated*. This picture had been taken with an MPP view camera which Cranham carried on his back, cycling to sports events. That camera taught Cranham a vital lesson—its limited depth of field demanded total accuracy. He has never forgotten this elementary fact. 'It is selective focusing that really releases your subject from its background, particularly in sport,' he says. 'In some ways, it is much harder to start now. To be good with 35mm you've got to be much more accurate because you've got a negative that's only 36 x 24mm, whereas we used to have sheets 5 inches by 4 inches. Most of today's films, moreover, are far too fast. They're great when the light is bad, but in really good weather you've got far too much depth of field. It makes photography easier but if you want definition you've got to use slower film and focus carefully or try to shoot with the lens aperture wide open.'

Cranham quickly realized that one view camera did not provide enough versatility and he began to build, piece by piece, the battery of equipment he now owns. In fact, to watch him collecting his equipment together before venturing forth on a task today is to watch a warrior prepare himself. Each item is checked and double-checked.

Fortunately, Cranham is a big man, and he still keeps fit by jogging almost daily. The equipment hanging from him is likely to weigh 20kg (44lb) and frequently he needs to run with it.

When ready for action he has four 35mm cameras, all motorized Nikons, each fitted with a different lens, arranged about himself. Two hang from his neck, resting one above the other on his chest, and one hangs from each shoulder. Which lenses does he use to cover horse racing?

During the winter, when he is covering only jumping, he says he normally carries cameras with 24mm and 50mm lenses on his chest, with 85mm and 180mm lenses on the cameras hanging from his shoulders.

Cranham was the first British photographer to put cameras right underneath the jumps. He hides the 24mm f/2.8 lens in the jump, or even buries it in the earth with a polythene bag protecting the camera body, and releases the shutter via a long extension lead. The effect is stunning: wide angle views with tremendous depth of field. The 50mm f/1.4 lens is the one that Cranham uses for small groups—a trainer talking to a jockey, or a jockey in action. 'Horses are very beautiful, very graceful creatures,' he says, 'and a wide angle lens for this type of picture would make their necks too long and distort them.' He uses his 85mm f/1.8 lens for portraiture and to shoot side-on as horses take the jumps 'so I can stand back and not be noticeable and disrupt a race.' His 180mm f/2.8 lens is used if he wants to get an early shot of a group of horses coming up to him, and then shoot again with another lens, or 'if I want to tighten up a bit on an individual horse'.

In the summer, Cranham will carry the same four lenses but probably with the addition of an 800mm lens with which to shoot even more distant subjects.

'A sports photographer,' say Cranham, 'is very much like a bookmaker. You have to control the odds. I don't know how the horses are going to run, so if I want to get a particular point in a race, say on a bend, I like to have insurance. I might set three, possibly four or even more cameras with long lenses at different angles, and fire them on long cable releases or have somebody helping me.' On one occasion, Cranham ended up with 40 pictures of one incredible incident in which a jockey crashed through a jump ahead of his mount. Most photo-

ABOVE RIGHT To avoid distracting the horses or riders, Cranham works here with a telephoto lens. This also has the effect of compressing the action on the bend because the lens seems to draw the horses closer together. Motorized Nikon F2 with 800mm Nikkor lens. 1/250 at f/8 on Kodachrome.

RIGHT Cranham introduced spectacular zoom-lens techniques in the early 1960s. In this picture he combines the movement of horses and a 200-400mm Tamron lens, plus a slow shutter speed, to create this 'impressionist' effect. 1/30 to 1/60 at f/11 on Kodachrome film.

ABOVE A sweeping effect caught by an 85-200mm Nikkor lens; the double register created by the long exposure and the car vibrating. 1/15 sec at f/22 on Kodachrome 25.

BELOW Cranham took two exposures with a 100mm lens against a black studio background—one of the main image and one panning. 1/30 at f/4 and 1 sec panning at f/32 on Plus X.

BELOW When assigned to photograph rugby player Phil Bennett. Cranham used a special multiplying prism filter on an 85mm lens. 1/250 at f/4 on Kodachrome 64.

RIGHT Every picture is controlled by its lightest part. Cranham panned with the rider using a 400mm lens. 1/15 at f/8 on Kodachrome 25.

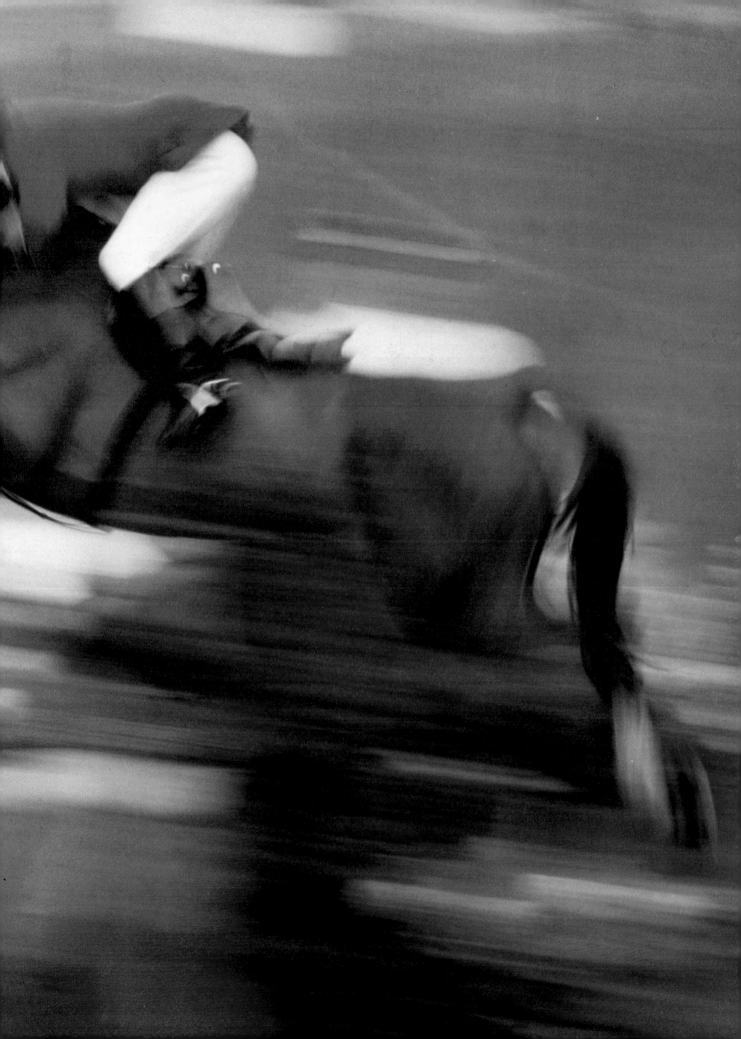

graphers would have been happy to have had just one of those shots.

Cranham's use of lenses and technical innovations is one hallmark of his photography. 'I saw amazing things were possible,' he says, 'and I developed the technique using a very long lens to shoot the peak of the action in sports. I watch an event, looking for the crucial moment and try to be ready for it. When someone is hovering over a high jump bar, I want to catch the facial expression just at that instant—at that peak. The use of the long lens, which crops right in, helps me to achieve this. For me it is a liberating factor, because I can stand back and observe everything far better than when I am in really close. I have learned to hand-hold even a 1000mm lens, which gives me maximum close-ups.' He has developed the technique of using a zoom lens and zooming during the exposure. He also uses blur, filters and other effects. It is part of his attempt 'to widen the approach to sport, coming away from the "conventional" whenever an opportunity is presented.'

Cranham has become internationally renowned for his horse racing pictures. His coverage of National Hunt is so vast and spectacular that the cream of the pictures have become a massive coffee-table volume. Also, he has just completed a book on flat racing round the world.

Though Cranham is best known for his sports photography, and has twice been Sports Photographer of the Year, his field is vast. His industrial pictures can be as striking as his sports pictures. Much of his best work has imprinted itself on our minds anonymously, from hoardings and the advertising pages of the colour supplements. He shoots landscapes continuously and has also done fashion photography. Cranham's physical abilities fused together when photography found him. But this does not tell anything of the hours, even days, he will spend achieving a particular effect with a black and white print in his darkroom, or waiting for the right combination of light and grey in the field.

Cranham agrees that everybody has some luck, but successful sports photography is something else. He studies sport, reads about sport and knows about sport. As he changes from shooting one sport to another, he practises with his cameras, as a fly fisherman might practice his casts so that when the peak comes his own reflexes are right.

'At my end of the game,' says Cranham, 'with all the lenses and equipment, it's like being in a Grand Prix car. It's the difference between driving a Grand Prix car and an ordinary Mini. I get edgy and when the action's happening, I shut off from everything. When you get a great shot, you know, you see it instinctively. Though the peaks of action happen in hundredth of a second they are frozen in your mind.'

RIGHT The long jumper passes through the limited zone of sharp focus in a fraction of a second and it requires immense skill and endless practice to achieve this type of shot. Motorized Nikon F2 with a 300mm Nikkor lens—1/250 at f/2.8 on Kodachrome 25.

FAR RIGHT A rugby try is always difficult to record. That is what makes this picture of Gareth Edwards scoring, shot from amongst the crowd in the stand, a classic. Cranham used a motorized Nikon F2 with 300mm lens. 1/500 at f5.6 on 64 ASA Ektachrome film.

ABOVE The yacht American Eagle taken at the end of the Channel Race during an Admiral's Cup competition using a 105mm lens. 1/500 at f/5.6 on Kodachrome film.

ABOVE LEFT This picture of a hang glider has much of the simplicity of modern art, the bright colours made even brighter by the back lighting of the sun. It was taken at 1/500 at f/5.6. Nikon FE camera, 400mm lens on Kodachrome 25.

EAMONN McCABE

Sportsmen accept the risk of injury, and are rewarded for it. But who stops to consider what a sports photographer has to go through? To get his scoop of the Cambridge crew sinking during the 1978 Boat Race, Eamonn McCabe was on a press launch with the TV camera team directly behind the boats. 'The storm had just broken and nobody could see anything. The TV soundsman's job appeared to be to stop me getting any further forward in the boat. I was leaning right out over the side and the TV people seemed set on pushing me overboard. I was using a 400mm lens on a Nikon when it all started to happen.

'I had got the shot of the crew untying their shoes as they began to sink but a minute later there was a better shot as they were actually in the water. I couldn't see a thing because of the

LEFT Emlyn Hughes and Terry McDermott on their lap of honour for Liverpool Football Club after winning the European Cup. McCabe took this shot with a 180mm lens on a Nikon. It does not matter that the cup is not in the shot as McCabe has captured the players' elation.

BELOW McCabe's scoop shows the critical moment in the 1978 Boat Race when the Cambridge crew began to sink. It happened in pouring rain and he had to work quickly to get the shot. He used a 400mm lens with Tri-X film.

amount of water on the lens so I changed to a 180mm and as that got drenched, I just carried on changing lenses until I was on a 24mm. I remember giving the wet lenses to the journalists round me and at the end of the race I had to collect them all back.'

To the picture editor, watching the race on TV from his comfortable Fleet Street office, it must have looked an easy shot: he saved six columns on the front page for the picture. This was a measure of his faith, as it was McCabe's first boat race. The faith was rewarded—McCabe was the only photographer to get the critical shot.

Eamonn McCabe works, on contract, for *The Observer* Sunday newspaper. He is often called upon to do portraits for the business pages but his main concern is sport, which

BELOW The cricketer Bob Willis with his foot round the physiotherapist's neck is simply stretching his hamstrings. The physiotherapist is not kneeling down! Neither of them noticed McCabe who was a long way away. He took this shot with a 400mm lens on a Nikon with Tri-X film. It is a good example of McCabe's eye for the candid moments of humour in sport.

divides into feature work and news pictures. In general, Sunday and Monday are his days off, Tuesday is a planning day, Saturday is the day for news and the rest of the week he concentrates on features.

The night before an event McCabe will pack the appropriate cameras and lenses. He switched from Nikon to Canon just after the soccer World Cup in 1982, and his basic kit now comprises two new F-1 bodies, a 35mm f/2, an 85mm f1.2, a 200mm f/2.8 and a 400 f/2.8. What he takes depends on the event. For a soccer match he'll use 85mm, 200mm and 400mm lenses. For boxing he will use the 85mm and a 135mm, with a 200mm for close-ups of the boxer being attended by the trainer in his corner. He always uses Tri-X film, which he often 'pushes' to 1600 ASA, and for most events he will take six rolls of film, aiming to get six usable pictures. He uses a monopod rather than a tripod, and his favourite lens is the 400mm. For action shots he always needs a motordrive.

'You can pre-plan the picture for some sports and set yourself up and wait. But for most pitch sports, like soccer, you can't predict where the action is going to be. A motordrive is essential here. I use it more as a "motorwind" than a motordrive.'

McCabe took up photography while visiting California. He had worked in a solicitor's office and in a brewery before being bitten by the travel bug. Sitting in on a college film making course in San Francisco inspired his interest. Returning to England he was an assistant in the photo unit of a Physics Department at the University of London. Then he worked for an American photographer doing everything from studio still life to pop concerts, before setting up on his own and

RIGHT McCabe was positioned by the side of the track for this picture of Daley Thompson building up power to clear a hurdle. He used a 400mm lens with a motor-drive to be sure of getting a shot. He needed a shutter speed of 1/500.

BELOW This intense young man took the croquet tournament more seriously than most, and was a perfect subject for a candid shot. It was taken in the early evening with a 400mm lens.

freelancing from home for local papers. It was not until 1977 that he started working for the national newspapers, chiefly *The Guardian*.

His meteoric rise continued when he got assignments from *The Observer* newspaper. He won the coveted British 'Sports Photographer of the Year' competition three times in the next four years—which is more often than anyone else has won the award. What particularly pleases him about this is that he has done it with black and white pictures. 'Colour pictures had won it for so many years before, I feel a bit like I'm carrying a banner for all the people who work in black and white,' he says. The pictures he has submitted have not been taken specially for the competition, but while on regular assignments for the paper.

The Observer employs six photographers. They do their own film processing, but then pass the negatives to the print department for contacting. From the contact prints, McCabe and the Picture Editor, Tony McGrath, select the best shots,

and then they discuss the final choice with the Sports Editor.

McCabe says, 'To anyone starting out in sports photography I'd recommend choosing a manual camera rather than an automatic. And I'd also suggest sticking to fixed focal length lenses—I've never found zoom lenses fast enough for my purpose. The main use of a zoom lens, to my mind, is zoom effect shots. But these only really work in colour, and virtually all my work is shot in black and white.'

He says the best sports to start shooting are those you know most about, because you can make sure you are in the right place at the right time to get the shots you want. 'Personally I like minority sports best because you can get such good access. At major events like the Olympics you are pushed into a crushed area for photographers and cannot move around to find a fresh viewpoint.'

McCabe's pictures show that, with all sports, fresh viewpoints and new pictures can still be found. But you have to look for them.

RIGHT McCabe photographed Lester Piggott at the start of a race. At the time he had not covered many race meetings and he went without any pre-conceived ideas of what to shoot. One of the most important elements for a newspaper picture is that it should have impact. Using a 105mm lens, McCabe has achieved this by capturing the fierce expressions of both horse and rider.

BELOW 'Minor' sports often produce the more interesting shots. This was taken at the British Table-tennis Championships of a player relaxing between games. McCabe, working from a balcony above the arena, took this shot with a 180mm lens.

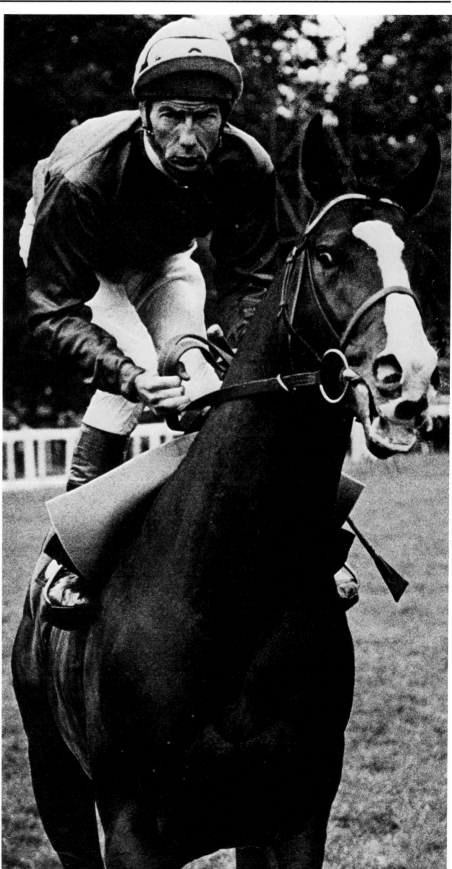

TONY DUFFY

RIGHT Tony Duffy in action at the Montreal Olympics.

Tony Duffy sees himself more as a 'sports nut' than as a sports photographer. This former tax consultant only turned to photography in the lates 60s when he was working for a firm of London accountants. One of the firm's clients, the late comedian Peter Sellers, started a Formula 3 motor racing team. Duffy decided to go to some of the races and take pictures using a Voigtländer camera. His first pictures were taken entirely by trial and error and, because he was always so anxious to take more pictures, he never found time to read a book on the subject. After motor racing he tried his hand at photographing athletes. *Athletics Weekly* published one of his pictures which encouraged Duffy to become a little more serious about what he was doing. The result was that he bought a Nikon F and a Nikkormat and went to the Mexico

Olympics in 1968. As a tourist he gate-crashed events to photograph them. The experience of those games convinced him that he should become a full-time sports photographer; it was a way of doing what he really enjoyed—following sport and travelling.

He set up his own agency, All-Sport, in 1972 and now spends his time travelling the world to major sporting occasions. All-Sport employs five photographers and there are 500,000 pictures on 110 sports in their files. Duffy has won several major awards (including the International Sports Press Association Photo of the Year on three occasions, and the British Sports Photographer of the Year) and his work has appeared in books, magazines and on posters. He is also official photographer to the World Swimming Association and the International Amateur Athletics Association.

He uses 35mm equipment, shooting mainly in colour. In his bag there are two Nikon F2 bodies and an FE in case one of the others goes wrong. He has the whole range of lenses from wide angle to telephoto, but his particular favourites are the 400mm f/3.5 and a 300mm f/2.8. This heavy equipment is mounted on monopods for stability and ease of use. 'The 35mm format is the only one versatile and flexible enough for sports photography. Sports photography is often a matter of the longest lenses used at the largest apertures and fastest speeds, an ability to judge a peak of action, and fast focusing. If

BELOW Some shots that are impossible during sports events are quite simple to pose. US gymnast Shari Smith let Duffy choose his position and held a hand-stand split. The shot was taken in Los Angeles using a Nikon F2 with 50mm lens. The exposure was 1/125 at f/11 on Kodachrome 64 film.

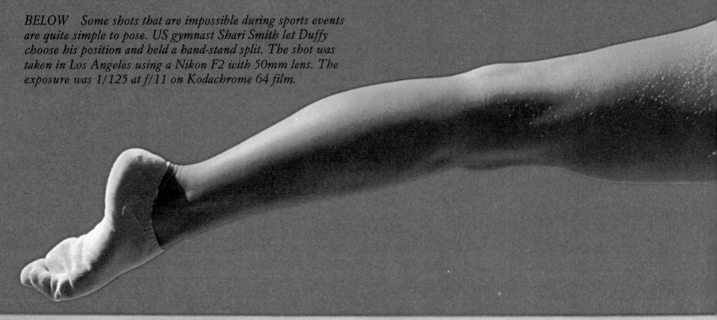

you use a long lens at a large aperture it highlights the subject by throwing the background out of focus. Stadium crowds add colour but can detract from the subject if sharp.

'Fast focusing is the essential part of sports photography. You can only learn to do it by experience. One way is to practise on cars and traffic coming towards you with no film in the camera.

'Normally you have a good idea where you're going to take your picture. It may be a high jumper going over the bar, or a hurdler going over a hurdle, or at the finish of a race. I pre-focus on that point, wait for the athlete and press the button as he comes into focus. The motor-drive shoots at three to four frames per second and that lets you get at least one good shot or capture a whole sequence.

'With a runner at a bend, I'd follow him round with the camera. It's a bit different with athletes coming towards you at

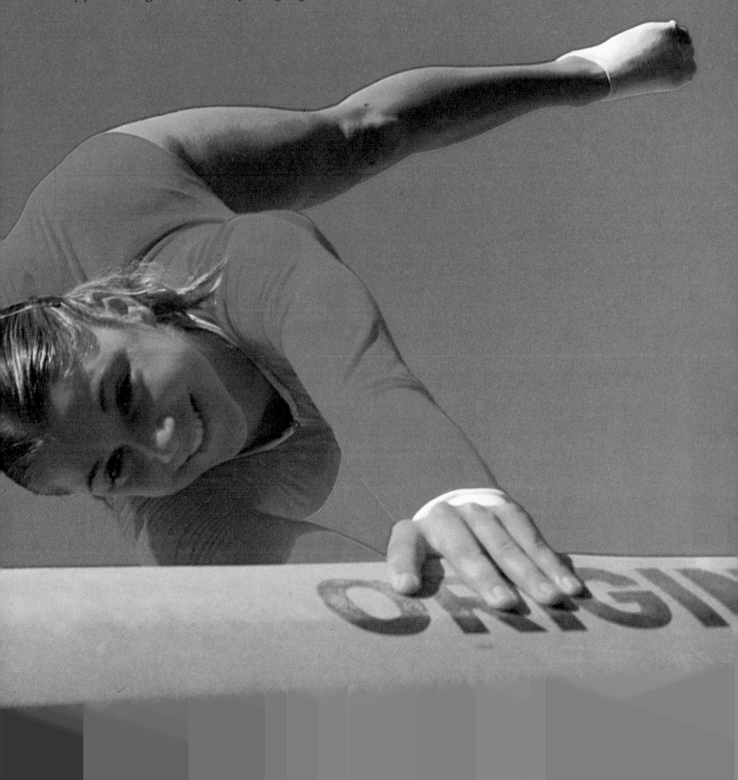

ABOVE Diver Christine Bond was tired. Duffy persuaded her to do one more half twist and prefocused a 600mm lens on the board. With the Nikon F2 camera supported on a monopod, he took a motorized sequence of six frames at 1/500 at f/5.6 on Kodachrome 64 film. This was the best frame.

RIGHT Mike Hazelwood had been the first UK male world water-ski champion for just a few days. Duffy was tracking alongside him in another boat. 'He was high. I knew he might do something so I just kept him in focus'. The exposure was 1/500 at f/5.6 on Kodachrome 64. A 135mm lens was used on a Nikon F2.

the finish. Here I focus about 10 metres (30ft) before the line. I use the motor-drive as the runners come into focus and refocus while I'm shooting so I get them crossing the line.

'The moment of victory, such as Borg winning at Wimbledon, is the picture you've always got to get. As you know the final point is about to happen, the tendency is to panic. You must make a conscious decision not to over-react and you've really got to stay calm. You have more time than you think, and as the moment occurs you must *first* get the player in focus and then use the motor-drive. It's no use shooting away and hoping the player will come into focus.'

Techniques like these are only part of covering sporting events. They also require organization, a thorough knowledge of sports and the participants, as well as the ability to analyze unfamiliar events. Duffy's approach to photographing the world speed ski record competition in the Alps is typical of the way he tackles a new sport. 'The first thing I did was to chat to people about speed skiing, then I had to see the course myself. I went to the top of the 4,420m (14,365ft) mountain and walked down (this took me through a field of 90m (300ft) deep crevasses, without skis!). I was trying to visualize what

138

kind of pictures I would get and to think of every possible angle and combination of lenses.

'As you watch the first two or three runs of a sport like this you are constantly thinking what it would look like on a 200mm, 300mm or even a wide angle lens. You've been feeding all this information into your brain and suddenly you know which lens and which position to choose. Then you ask what else is there? You might choose another angle and see what happens.'

Less exotic sports such as track and field events have their own organizational problems. The photographer may have to follow a running event at the same time as the long jump or shotput. With the field events you must get to know the likely winner and make sure you are in the right spot when their turn comes.

'Starts and finishes make great photographs. You get all that tension. There's all that energy released at the start and all the facial expressions at the finish. This is one thing that the stills camera can show that television cannot. At the start of a race I like to position myself slightly forward and to one side. I also get as low as possible.'

During events, Duffy shoots mainly pictures that show moments of drama and absolute effort. On other occasions he likes to do feature work in which the lighting and background conditions are under his control. Once he photographed skater

ABOVE The 'off' at Ascot. Duffy likes starts: he waited a moment after hearing the gates before pressing the shutter. The shot was taken with a Nikon F camera and 180mm f/2.8 lens. The exposure was 1/500 at f/11 on Ektachrome 200 film.

RIGHT Pietro Albertelli competing in the world speed-ski event. Duffy thought he missed this shot (skiers reach speeds up to 200km/h). The shot was taken with a 400mm f/5.6 lens on a motorized Nikon. The exposure was 1/500 at f/8 on Kodachrome 64.

Robin Cousins 'leaping' over the Rocky Mountains. There were no frozen lakes in Colorado where Cousins was practising. So Duffy bought a large sheet of plastic and persuaded the skater to jump from a standing position off the sheet while he crouched down to hide the foreground and bring the Rockies into the picture.

Tony Duffy seems to have this easy relationship with everyone, from Olympic stars to stadium ground staff. He talks to people all the time, partly out of friendliness and partly in search of new pictures. 'It's always the photographer's eye that counts, not the equipment. I have to push myself constantly to try and find new approaches. Just because I've done something before doesn't mean to say that I can't improve on it.'

John Zimmerman

Most sports photography is reporting, rather than creative. Of course the photographer strives for the best picture he can get, but the performance of the athlete can make or break the picture. American photographer John Zimmerman's most memorable sports pictures are not like this. They are memorable because they are extraordinary in themselves, because that is how Zimmerman creates them.

For example, *Life* magazine commissioned him to shoot Bobby Orr, playing for the Boston Bruins. Joining the world's greatest ice-hockey player on the ice during a game was, of course, out of the question, so Zimmerman went for the next best approach—a remote control camera inside the net itself. The shot also entailed setting up flash units in the stadium and running synchronisation cables to the camera. This was done by chopping a rut in the ice, laying the cables and pouring water over it so that new ice formed.

Unfortunately Orr, a defenceman, wasn't around the opponents net too often, and Zimmerman had to set the shot up for six games to get the perfect shot reproduced here. Even then disaster nearly struck when a player decided to use the camera as a target for his hardest shot. A hockey puck is solid rubber and can travel at around 100 miles per hour. One lens was shattered. So the actual photography is difficult, setting up is even harder, and getting permission to do this is almost impossible. How does Zimmerman do it?

'You keep badgering,' he says, 'and the higher up you go to get an answer, the better off you are. The first time I did this I was lucky because we got to the New York Rangers' general manager and explained what we wanted to do, the kind of photographs it would produce and what we were going to do with them. And he said, "Well, I don't see anything in the rule book that says you *can't* put a camera in the net,"—so we got permission'. He could just as easily have said there's nothing in the rule book says you *can* put a camera in the net! Then he could have asked the President of the hockey league or something, and the idea would have been shot down.

'This is why you can't deal with the lower-echelon people, because they don't want the responsibility for something that could get them in trouble. But generally, in sport, if you get to someone at the top and explain what you want to do, they are really very receptive, because they are aware of the promotional value to the game of what you're doing—especially when it's through a magazine like *Life* or *Sports Illustrated*.'

Some of the marvellous pictures Zimmerman has taken have depended on his ability to get the camera into unusual shooting positions. He has hung out of planes and helicopters, and mounted cameras on the noses of gliders. For basketball pictures he has managed to get remote control cameras only a hand's width from the basket, shooting through clear glass backboards. For ski pictures he has skied the courses and found vantage points inaccessible to photographers working on foot. For pictures of diver Bob Clotworthy he went underwater without an aqualung—the air-bubbles would have spoiled the picture.

Many of his other pictures have depended on some special technique, or camera, or the use of filters. His standard equipment consists of four Hasselblads (two of them motor-driven), six Nikon F2s with motors, two Nikkormats and Nikon lenses from the 6mm fish-eye to 800mm, some

RIGHT Zimmerman wanted to create an impression of the zig-zag movement made by basketball player Nate Archibald as he jumped. He used a Panon camera mounted on a tripod. As the lens swept across the subject, the camera was moved back and forth and then steadied as Archibald neared the basket.

Hulcher sequence cameras, three 5 x 4 cameras, one 5 x 7 and a 10 x 8 camera. He uses ten 800 watt-second flashes and six 200 watt-second models. Two of the Nikons are high speed models giving eight frames per second, while the Hulcher cameras give 20, 40 or 50 frames per second. These are only used on special stories partly because of the problems of editing film. No picture desk with a deadline to meet wants to start looking for a picture from 150m (500 feet) of unprocessed 70mm film. Another factor is the cost—over $100 a roll. For one shot of baseball star Ted Williams batting, for *Sports Illustrated*, Zimmerman had to shoot 19 rolls of film at 50 frames per second—that's about $2000-worth of film to get the exact picture they wanted with the ball on the end of the bat.

The Hulchers have been essential for some sequences, especially those using coloured filters. With the film transport disengaged, they can also be used for high-speed multiple images. Using this technique, Zimmerman managed to get 160 images of a golf swing on one piece of film. For taking pictures half underwater, Zimmerman built a special housing for the camera. This uses a glass that is 8 inches (20cm) from the camera lens, instead of the inch (2.5cm) that is usual for underwater housings. Then a split filter fits over the camera lens—the top half is a neutral density filter, the bottom half is red to correct the blueness found underwater, so the end results look natural. For his strange 'fluid movement' pictures like that of the basketball player, Zimmerman modified a Panon slit camera.

Unfortunately, in the 80s very few magazines have editorial budgets capable of supporting this level of photography. Also, Zimmerman does not want to cover the same sports over and over again. As a result, over the last few years he has become increasingly an advertising photographer, working for clients like Ford and Vivitar. He now shoots very little sport.

Zimmerman is fascinated by equipment and by what can be done with it, but he does not play about. He only modifies equipment when he needs to, in order to get a particular effect. It is the same with putting cameras in unusual positions—you can not go around boring holes in the boards around an ice-hockey rink just on the offchance of getting an interesting picture. Zimmerman is successful because he knows exactly what he is doing. He knows the final effect he wants, and he sets out to solve the problems that stand in the way of getting it. What is remarkable is that he is so successful even when the problems seem insurmountable.

LEFT Zimmerman used a Hulcher motorized sequence camera with film transport disengaged for this multiple image shot. A set of colour filters, used in sequence, create the effect. The picture was made outdoors with sunlight and Mylar reflectors to light the subject against a background of black paper. He used a 105mm lens with Ektachrome 64.

RIGHT To get enough light for this shot of diver Bob Clotworthy, Zimmerman positioned two electronic flashes above the water and another two, housed in clear plastic boxes, just below the surface. When Zimmerman was ready Clotworthy was signalled to dive and the shutter was fired as he entered the water. It was taken with a Leica in an underwater housing with a 28mm lens.

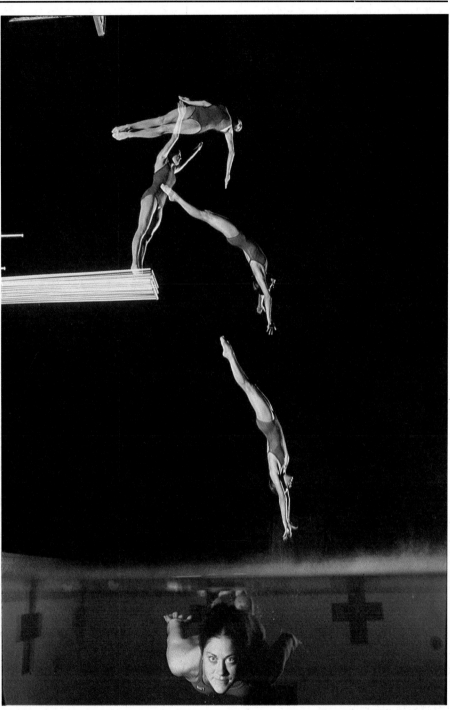

LEFT For a feature on Bobby Orr, Boston Bruins' star ice-hockey player, he set up a remote control Nikon F2 with a motor-drive in the net of one of the goals. Flash heads in each corner of the rink lit both goals. With the shutter and the flash sync cables buried in the ice, Zimmerman fired the shutter from the safety of the seats directly behind the goal. The picture was taken on Kodachrome 64 using a 20mm lens and an aperture of f/5.6.

ABOVE For half-underwater shots of Jenny Chandler, taken at night, Zimmerman used his split-level housing with a Nikon F2. To stop all movement, the camera was mounted on rigid scaffolding anchored on the pool bottom. A scanner was used to trip electronic flashes in sequence above and below the water. The shutter was closed and then another open flash exposure made as she swam towards the camera.

NUDE & GLAMOUR

While the nude has, for thousands of years, been part of the history of art, it is only over the last 20 or so years that it has become part of everyday photography. Nowadays, however, 'topless' and glamour shots appear daily in the popular newspapers, while nudity is comparatively common in the cinema, in the numerous men's magazines', on television and on some holiday beaches. While society's attitude to the nude has changed, its attitude to the nude and glamour photographer has not, in one respect at least. Nude photography is not seen as work! In fact, the degree of difficulty of good nude and glamour photography is emphasized by the gulf between amateur and professional work. In no other area of small and medium format (35mm and 120) photography is the gulf so large. Few amateurs handle lighting well enough, and too often cross the invisible line into 'bad taste'. Nude and glamour photographers also have a major non-photographic problem: finding models. A great many girls will be used once or twice, mainly for their novelty value, even if they have little else to contribute. But what the real pro needs is just a few versatile models who have the ability and imagination to work regularly. There are very few such models, and they often become famous in their own right. In this field most good pictures result from the close collaboration of photographer and model—from teamwork.

JOHN KELLY

LEFT *Picture taken in Ibiza for a Camel cigarettes calendar. The packet and the model's back are lit by the evening sun reflected from the beach.*

RIGHT *Kelly went to Paris where this set and model were already prepared and made up for him. Also on the set were hairdressers, make-up artists and set designers to help with the session. The model just needed a suggestion or two like 'haughty but naughty' to understand her part. Kelly likes to use daylight whenever possible. The bright light behind the model is sunshine. The even foreground lighting comes from a tungsten lamp, near the camera, which has a filter to convert its light to a colour temperature that is compatible with daylight film. The shot was taken on Kodachrome.*

Slides of young women wearing little, if anything, litter John Kelly's studio light-box. 'The key to pictures like these,' he says, 'is finding the right girl.'

The colour and excitement of these pictures is far removed from the collection of big black and white prints he took to *The Sunday Times Magazine* in the 60s. They showed slum clearance in Blackpool. 'I was at art college in the town and I wanted to be a Cartier-Bresson like figure. The people at *The Sunday Times* were responsive, and said I should go round the corner to a magazine called *London Life*. That was a Friday. *London Life* wanted me to start on the Monday. There were still nine months of the course to go at Blackpool, but the college said "leave if you want", so I left.'

By the end of the decade Kelly was working on advertising commissions while supplying news and feature pictures to national newspapers. 'I don't know how I started the work I do now. I can't remember; it was a transitional thing.' Much of the work is speculative, kept in the glamour file that supplies 'stock shots' for many girlie calendars. Kelly's girls have appeared in so many calendars—including Unipart, Camel, Watney's, Ready Mixed Concrete, Semperit, Manikin, Castrol and Lamb's—that the Japanese call him 'King of Calendar'.

He spends 10-15% of his time in the studio, which is equipped with a Studio Strobe 500 electronic flash and some battered tungsten lights which sometimes go on location with him. 'The strobe is good and reliable. You can do most things in the studio with it. I'm doing a newspaper advertisement using a lighting approach that I've used for the past 10 years or so. It involves creating an endless white light; a good, hard

front light which gives plenty of edge definition. I just put a couple of "fish fryers" (large, diffused flash units) in front of the subject to give a light that is like a hard flood or a soft spot, if you see what I mean. It's a very distinctive light and all the detail is there. But I like shooting what I can see, which is why I like tungsten and daylight. I like to mix light sources. There's no substitute for daylight in this kind of work—if you can get it right—but sometimes tungsten adds a bit of sparkle.'

On an important location shoot he will set off with ideas agreed with the client but only minimal equipment: a Nikon, 85mm and 35-70mm zoom Nikkors and a 71-210mm Vivitar Series 1 zoom. A lot of Kodachrome and Ektachrome Professional film is tucked in as well. 'If I've got the equipment I use it. If not, I go ahead anyway. Such sparse equipment

and the sight of a rather worn Vivitar lens must give the clients a fright.

'Most of my work is done on location,' he says. 'I'd always rather be dabbling with the unknown than with fully planned out situations, although I quite like the idea of having sets built for specific things. I like to keep things simple. I have no assistant, just Gerry Barnes who is agent, manager, producer and, if necessary, someone to hold the reflectors. I like to make my own problems. If one starts up I depend a lot on my reportage and feature experience. You never know what kind of problems you'll find in that kind of work. I like working to deadlines and having the experience of not knowing what's going to happen next. I would never have the patience to do the detailed work involved in still life.'

A straightforward approach to photography frees Kelly to deal with the problems of choosing locations, selecting models and then getting them to work together. 'Finding locations is not easy. It depends on who is sponsoring the trip. Magazines pay on publication—which may be six months away—so then I have to put up the money. If it's a calendar, then the art director picks up the tab. Otherwise I choose a location basically for what it has to offer. I've got a friend who can provide locations in Greece, Portugal, Jamaica and Palm Beach. Portugal has the most amazing evening light. I go there two or three times a year.'

Kelly works with both professional and amateur models. He is happy with either because each puts different pressures on him, although the professionals know more about posing for

149

RIGHT *The model is an amateur. The brightly coloured props come from different sources: the cap is hers, the exercise machine, photographed at another session, was kept by for an occasion like this. A polarizing filter darkens the sky, exaggerating the white and yellow, and the girl's tan. Light reflected into the shadows keeps the subject within the contrast range that Kodachrome can reproduce.*

ABOVE *Vivien Neves, who is now Mrs John Kelly, was the first full page nude to appear in* The Times. *She was advertising Fisons, the fertilizer manufacturers. This picture was taken at dusk in the Algarve. Kelly visits Portugal two or three times a year to take photographs. He describes the evening light there as 'fantastic'.*

the camera. Sometimes he chooses them. Sometimes the client, such as one European magazine, sends models to him. 'These girls are all amateurs, literally girls off the street. We have a chat before shooting. I tell them what is wanted and we talk about the kind of clothes they like to wear. Sometimes a girl feels more relaxed in her own clothes but dressing-up can be a good thing because it gets the girl excited. It's all a lot of luck.

'I've had to change my style a bit when working with them. They tend to exaggerate what they are—which is nice. But it is important to render them as sexy-looking girls and not just a particular look. Usually after a few days their personality comes out.

'If a girl is good, then I let her get on with it. She knows more about herself than I do. But I don't want her to do things that she's done for someone else. I don't like talking to the models too much, I prefer just to start them off with some information on the kind of pictures wanted. If a girl is good enough then you can make her look sexy. If she's looking good, all that's needed is a nice drop of light, something alluring to wear and "click".

'I like to deal with the girl's personality photographically. It suits me down to the ground and that's the way magazines such as *Oui* and *Playboy* want their pictures. I'm lazy. I like it when a girl sparkles—the sort of thing when she moves her hand and suddenly she's Charlie Chaplin. Some girls have that ability and some have not, others are just bubbly and lively anyway.

'When you hit a successful situation with a girl, when the light and everything else is right, then everything is down to the face. The whole sexual attraction is 90% in the face. If a girl has got a blemish, an operation mark, a vein, or her breasts are different sizes, you can turn her round. It's very difficult to disguise a face, no matter how many make-up artists you have, because it is the face that helps you formulate the girl's personality.'

RIGHT Kelly took this shot for his slide library on a Barbados location he often uses. He likes simple props like the pink shawl because 'it's often what you don't see that attracts; sometimes all it takes is a flash of shoulder'.

BELOW The strong fill-in light shining up into the girl's face is reflected sunshine, not artificial light. The picture, one of a series, was taken in Los Angeles, using a Vivitar 70-210mm zoom set on macro and Kodachrome film.

Chris Thomson

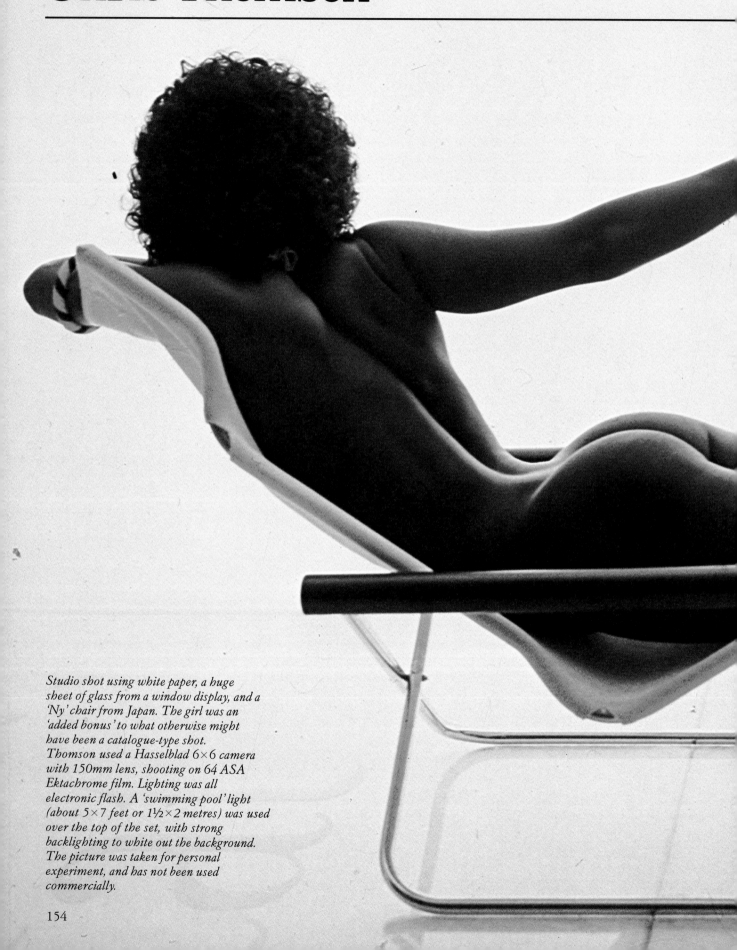

Studio shot using white paper, a huge sheet of glass from a window display, and a 'Ny' chair from Japan. The girl was an 'added bonus' to what otherwise might have been a catalogue-type shot. Thomson used a Hasselblad 6×6 camera with 150mm lens, shooting on 64 ASA Ektachrome film. Lighting was all electronic flash. A 'swimming pool' light (about 5×7 feet or 1½×2 metres) was used over the top of the set, with strong backlighting to white out the background. The picture was taken for personal experiment, and has not been used commercially.

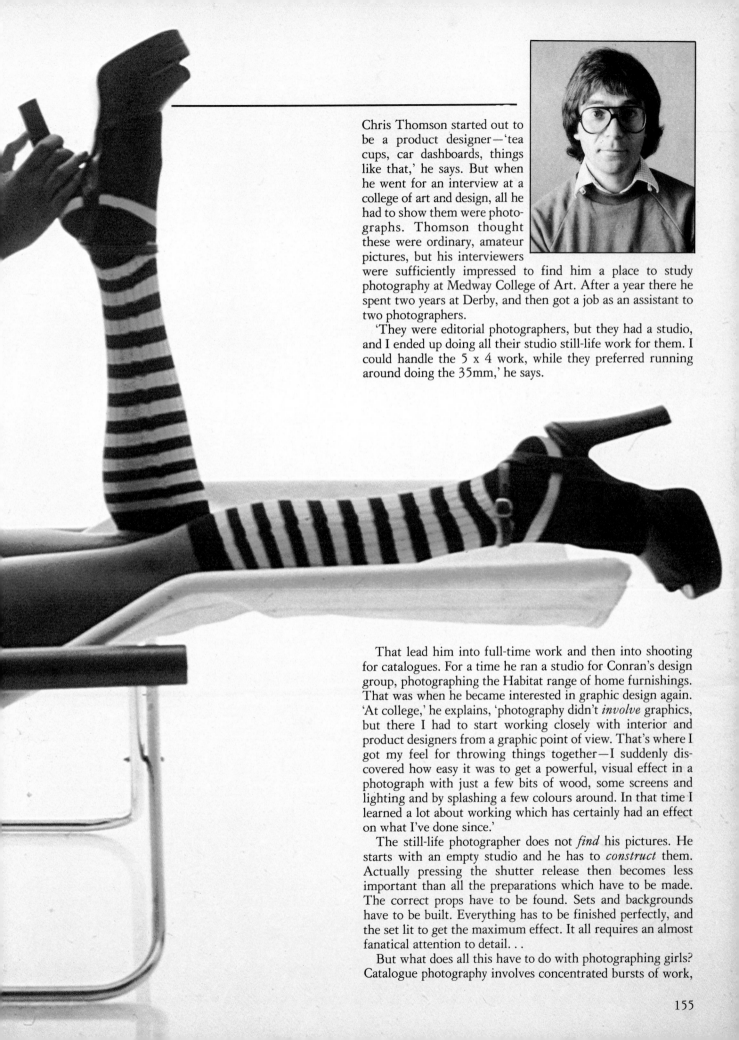

Chris Thomson started out to be a product designer—'tea cups, car dashboards, things like that,' he says. But when he went for an interview at a college of art and design, all he had to show them were photographs. Thomson thought these were ordinary, amateur pictures, but his interviewers were sufficiently impressed to find him a place to study photography at Medway College of Art. After a year there he spent two years at Derby, and then got a job as an assistant to two photographers.

'They were editorial photographers, but they had a studio, and I ended up doing all their studio still-life work for them. I could handle the 5 x 4 work, while they preferred running around doing the 35mm,' he says.

That lead him into full-time work and then into shooting for catalogues. For a time he ran a studio for Conran's design group, photographing the Habitat range of home furnishings. That was when he became interested in graphic design again. 'At college,' he explains, 'photography didn't *involve* graphics, but there I had to start working closely with interior and product designers from a graphic point of view. That's where I got my feel for throwing things together—I suddenly discovered how easy it was to get a powerful, visual effect in a photograph with just a few bits of wood, some screens and lighting and by splashing a few colours around. In that time I learned a lot about working which has certainly had an effect on what I've done since.'

The still-life photographer does not *find* his pictures. He starts with an empty studio and he has to *construct* them. Actually pressing the shutter release then becomes less important than all the preparations which have to be made. The correct props have to be found. Sets and backgrounds have to be built. Everything has to be finished perfectly, and the set lit to get the maximum effect. It all requires an almost fanatical attention to detail. . .

But what does all this have to do with photographing girls? Catalogue photography involves concentrated bursts of work,

with spare time in between. 'So, I had the time and the studio space to try a few experiments. I started doing test shots for girls, for their model cards, but instead of doing a few quick snaps, I had time to play about with my own sets to try something interesting.' Often the 'industrial set' of the day, perhaps involving large sheets of corrugated metal or a stylish new chair, would end up that evening as the setting for a nude.

He did the pictures for the fun of it, but the girls were using them to show people to get modelling work. They got such good reactions that Thomson put a few sheets in his still-life portfolio. From this modest start it all grew into exotic assignments in the Caribbean, calendars for major industrial companies like Dunlop, and free-ranging commissions from magazines like *Penthouse*.

Instead of 5 x 4 or 10 x 8 inch sheet film, he normally uses 35mm or sometimes 6 x 6cm for his girl pictures, but the technical requirements are the same. 'I like very simple lines and shapes,' he says. 'I lose the whole image if there's too much going on, so I start with the basics—a horizon line or an upright—and work from there. Quite often if you're on location, you see there are some quite nice shapes there but it's all confused and they are interrupted by unnecessary distractions. You take more and more out of the frame and the image gets stronger and stronger, until you have the minimum there to create the maximum effect. I don't feel I *have* to show girls' faces, for example, and it doesn't really bother me if the edge of the frame chops bits off them. I know why I'm doing it,

LEFT An experimental shot for Oui *magazine, using a graphic shape and a deliberately restricted colour scheme, taken with an Olympus OM-1 with 135mm lens and Kodachrome film. The girl was lit by direct electronic flash. 'Linear' heads were used behind the blinds for a window-like effect.*

ABOVE AND BELOW Two pictures of the same model, Amanda, taken to show her versatility for use on her promotion card. Both taken with an OM-1 on Kodachrome film. (Above) taken in a studio with bounced electronic flash. (Below) taken by daylight using a red PVC background.

RIGHT A studio shot taken with a Hasselblad with 150mm lens and EPR Ektachrome 64 ASA film. A household mop-head was used as a wig. The white liquid was thinned-down emulsion paint 'which dries very quickly, but it's fun getting it off afterwards'. Lighting was by electronic flash through a large (5×7ft/ 2×1½ metre) diffusing screen next to the camera.

LEFT Taken by the side of a rented villa's swimming pool in Lanzarote, in the Canary Islands. A 135mm lens was used on an OM-1 with 64 ASA Kodachrome film.

and—through the camera—I know if it's right.'

Along with simplifying the composition as much as possible, he also tries to simplify the colours, and he lights the subject to get the cleanest effect. Before the picture is taken, he tries to get all the little details right. ('There's nothing worse than having a good shot where the girl's fingernails look awful,' he says.) Afterwards he has clip-tests done to ensure perfect processing (a few frames clipped from the roll are processed before risking the whole film). The aim is for the girl pictures to be as technically perfect as the still-life work, even on the smaller format. It can only be achieved by absolute control of every aspect of the picture, and that includes the model.

This does not mean the model is merely a mannequin or dummy, to be manipulated at will. Thomson's favourite models, like Amanda Adey, are active participants in the compositions. They must be fit, supple, and aware of the mechanics of their own bodies, so they can slip from one natural shape to another without falling into clichéd poses. They must also have a sense of humour, because working with Thomson can get a girl into some very uncomfortable situations

Thomson is not trying to capture fleeting expressions or to show *character*. His girls are models—actresses for the single eye of the camera. They appear in the pictures not as people but as graphic shapes. 'Some people don't understand that,' he says. 'But if you were to take a car body on to the beach and walk around it, you'd want to make the final shot as interesting as possible. If it's a terrific shot, people think it's a terrific car. I take the same approach with women.

'I want people to be interested in the *pictures*, not just the naked ladies. It would be very sad if that's all it was.'

RIGHT The same pool, and one of the same models. A 24mm wide-angle lens was used on the OM-1, with a polarizing filter to darken the sky.

Uwe Ommer is a young German photographer with a highly individual style. All his pictures have a precise, graphic quality: they are as much about colour, shape and line as the subjects they portray. The secret of their success is simplicity —plain backgrounds and the bold use of light and colour. Introducing other colours or objects would merely be distracting. Still, a lot depends on the girls he photographs. He uses models from agencies, but that does not mean they are automatically suitable for his pictures. 'I adore girls who are exhibitionists,' he says. 'That's what makes the best photographs. If you use two girls together, there will be one who pushes herself in front of the other... That is the one I want to work with.' But Ommer says it is rare to find girls who treat modelling as an art, a way to create good pictures. Most models—even the most professional, who know and understand all the movements and expressions —become mechanical. For them it's just a routine job, done for the money. The girls with real talent are hard to get because they are always booked. Everyone else recognizes their special quality too.'

Ommer likes to plan his pictures

UWE OMMER

Uwe Ommer's career began when, at the age of 18, he won the Young Photographer of Germany prize. He then moved to Paris for a year to learn French, got a job as an assistant, and stayed on. Though he now has an apartment in New York, since he does so much work there, he still will not leave Paris. He has become well established there, has a luxurious studio, and loves the way of life. In any case, in Germany the market for pictures is dispersed between several towns. In France there is only one centre— Paris.

Ommer worked as an assistant to an established photographer doing mainly still life work. 'It takes at least two years to get to know where you can sell your pictures, and to make yourself known,' he says. 'It is a time when you need an agent, but no agent is interested in you until you are already doing plenty of work. It is a vicious circle that most young photographers are familiar with.' He now has agents in New York, Paris, London and Tokyo, plus Germany and Italy. He still does a small amount of still-life work, but it does not give him the same pleasure as photographing women.

before the shooting session, but this is not always possible. He explains, 'It is very difficult to find a girl who is just right for an idea, especially when taking a picture for yourself, rather than for an assignment. Girls who are well known don't need to do that kind of photography, so often you have to use beginners, who don't know how to interpret what you want. In that situation you've got to be adaptable and work with what you've got. Even if you explain to a girl exactly what you want, she might not respond correctly: so much depends on her character and the way she feels. But this can make it exciting and spontaneous.' Sometimes he finds girls who are students or work in ladies fashion boutiques as potential models.

'Working in the studio, it doesn't matter so much if you don't know the model or if you have to improvise—you can reshoot if absolutely necessary. But on location the pressure is ten times greater. Everything has to be carefully supervised. There is usually an entourage of ten or twelve people— assistants, make-up artist, hairdresser, wardrobe assistant and so on. Everybody is together all the time—eating, working and relaxing. There is an incredible amount of work to be done and, of course, we all have to rely on the weather. But to get good pictures, it is the rapport between the photographer and the model that counts. You need to have models you know you can work with.'

Ommer works entirely on 35mm using three Minolta SLR camera bodies and an assortment of eight lenses. The ones he uses most often are the 28mm wide angle, 50mm macro and 300mm telephoto, but his favourite is the 100mm portrait lens. Now he has access to a wide range of Minolta equipment: Minolta approached him for some pictures, and used a selection of his personal work for a calendar. After this, they proposed a contract: the equipment he needed in exchange for one free advertising picture a year.

Film—he works almost exclusively on 25 ASA Kodachrome slide film, as he hates grainy pictures. Lighting—in the studio he generally uses electronic flash for the brilliant, pure colours this produces with Kodachrome.

A large percentage of Ommer's work is personal. He considers these pictures unsuitable for the commercial advertising market. They are the products of his own imagination, and 'they are exercises in style—they do not sell anything.'

Ommer has maintained a high level of originality, and his approach has won him the respect of his many clients.

RIGHT This shot was taken indoors using a spotlight behind the girl and to the left. Ommer took it 'because normally the girl had very straight hair, then one day she frizzed it out like that, making it rather ephemeral, like a spider's web.'

ABOVE Taken for Charles Jourdan, to
advertise sunglasses. When the shot was set up,
the glasses reflected the whole studio. Ommer put
Japanese screens in front of his lights to make a
feature of the reflections. The girl's lipstick and
dress were chosen to match the colours of the
sunglasses.

RIGHT Another advertising shot for Charles
Jourdan. Ommer used a single electronic flash
overhead, and a 50mm macro lens to get
maximum detail in the picture. The red of the
model's shirt and nail varnish were chosen to
match the red bow which is the main feature of
the sunglasses' frame.

SAM HASKINS

Like many famous photographers, Haskins discovered his talent by accident. He was working as a graphic designer in South Africa when his local college announced that they were going to run evening classes in photography. 'I thought it would be useful to me in my graphic design,' he says, 'so I went—and I was totally hooked on photography after that. The course was only two hours a week for a year, but I learned just basic good habits in photographic technique and style.'

The desire to learn more brought Haskins to London for the first time. He studied for three years at the forerunner of the London College of Printing. 'That was in 1949, and we were shooting everything on glass plates because of the scarcity of film. I can remember going to Kodak and being very pleased to get just one roll!' In 1968 he moved to London permanently, his name established by three marvellous books, *Five Girls, Cowboy Kate and Other Stories*, and *African Image*. The grainy, graphic, black and white eroticism of the pictures brought a breath of fresh air to the boudoir of girl photography which at the time was coy or coldly artificial.

Since then Haskins' work has seen continual changes until now it seems the opposite of what it once was—at least to judge by the pictures in his book *Photographics*. This is all in colour instead of black and white. Much of it has been shot on large-format cameras, on sheet film that shows no photographic grain. The pictures are carefully planned, instead of seeming spontaneous. Often they are made by using multiple image techniques—double exposure or slide sandwiches. Sometimes they suggest symbolism, using birds, fishes or trees—though not Haskins' most famous symbol, the apple.

In spite of this, some aspects of his work have stayed the same. He still photographs girls in an erotic way. He always focuses his attention on the graphic qualities of the image. And most of all, his pictures are all fun.

A Haskins picture is not a record of reality. It does not make a social comment or try to change the world. What it tries to do first is delight your eye—to make an immediate appeal. Then it tries to tease your brain, perhaps with a symbol or with a surreal idea, but in a humorous way. His is a dream world in which there are no nightmares.

At least there are no nightmares for the viewer. There are, however, quite a few for the photographer. Haskins limits himself to photographic techniques, rejecting strip-ins, air brushing and similar approaches. 'Often an idea for a picture comes purely as a visual image,' he says, 'then I have to sit and think—how the heck am I going to do this?'

The techniques available are sandwiches with two or more pieces of film, double or multiple exposures on one frame, or somehow conveying more than one image to the lens by means of mirrors or projectors—those are the three basic techniques.

'I've been playing with making one of the elements of a sandwich a black and white picture, as I can control that in the darkroom.'

When combining slides, or aligning two images in a double exposure, it obviously helps to have as large a film area as possible. The size, weight and ease of use of the camera also have an effect so the choice is not automatically a view camera. In fact, Haskins has found that he uses Pentax 6 x 7 cameras most often. A 6 x 7 slide has more than four times the area of a 35mm, but the camera handles like a 35mm SLR—only bigger.

However, he says, 'I find that as I get older I'm becoming more interested in 35mm. A lot of the stuff in the early black and white books wasn't 35mm at all, it was small sections from 6 x 6cm negatives blown up—I was deliberately wasting film! Now I carry a case with three Pentax 6 x 7 bodies and four or five lenses and it's heavy. After carrying it over desert sand dunes for three or four miles I begin to think it's time to start 35mm photography!'

The sand-dunes are not a figment of Haskins' imagination: he shot the 1981 Pentax Calendar in the Arizona desert (see photo, right). Struggling through sand dunes was the only way to reach locations with privacy. 'Go to a famous place like Zabriskie Point, where photographers from all over the world go, you find that they are taking pictures of your model from way up on the surrounding hills.'

On expensive location shoots of this kind he tries to work through the day. 'For shots where the model is in direct sunlight, you try for the oblique light in the early morning and late afternoon. But despite what the text books say, you can shoot right in the middle of the day by choosing the right type of shot.'

In the studio he uses cameras up to 10 x 8 inches, and three types of lighting—tungsten, flash and arc lights. 'I feel that different shots require different types of light. It's silly to limit yourself to one type of lighting, or one type of camera or film. You have to use what works for the shot.'

RIGHT This picture was taken on assignment in the Grand Canyon when shooting the Pentax Calendar for 1981. He used a Pentax 6×7 with 135mm macro lens and Ektachrome film.

ABOVE A sandwich of two pieces of film, one black and white and one colour. Haskins photographed the roof tiles in Scandinavia while shooting a Pentax Calendar. Then he shot the girl on black and white film in the studio against a black background, and over-exposed 4 stops to make the black grey, and the girl bleached white. He used a Pentax 6×7 with 300mm (roof) and 200mm (girl) lenses on Ektachrome 200.

RIGHT This shot is also a black and white/colour sandwich. It was taken for a paper manufacturer, Zanders, using some of their papers. First Haskins built and painted the little 'room' (it was really only 45cm or 18 inches deep) in his studio and took it in colour. Then he photographed the girl on a bicycle on black and white film in the studio. Sinar view cameras were used to take the shots on 5×4 and 10×8 sheet film respectively.

ABOVE This is a straight shot, not a sandwich. The flowers were superimposed on the girl by reflecting them off a sheet of glass held at 45° in front of the camera. It was taken in the studio using tungsten lighting. Haskins says, 'Balancing the light on the girl, the background and the reflection took hours, even using Polaroid to check it all out.' He used a Pentax 6×7 with 200mm lens and Ektachrome 200 film.

RIGHT This was also taken as a single exposure in the studio. Haskins used one of his favourite techniques — combining warm tungsten lighting (filtered through screens) and flash. The blur was produced by the tungsten lighting during an exposure of 1/10. The sharper image was produced by firing the electronic flash, with its inherently brief duration. It was taken with a Pentax 6×7 with a 200mm lens.

STUDIO & STILL LIFE

The studio/still life photographer does not find pictures, he constructs them. He may start with a product to illustrate, or perhaps nothing concrete at all—just an idea. Constructing pictures is a slow process so large-format cameras and elaborate lighting can be used for top-quality results. Instant prints can be taken to check the composition. Care costs both time and money. It also means the photographer is responsible if the final picture falls short of perfection.

Tessa Traeger

RIGHT Tessa Traeger in her London studio. Its north facing windows provide sufficient daylight for many of her pictures.

FAR RIGHT A copy of a Botticelli face drawn with food colouring on marzipan and lit with diffused flash to simulate daylight. MPP camera on Kodak tungsten film.

Tessa Traeger had been photographing regional dishes as a project of her own when an editor from *Vogue* saw them. As a result she was assigned to work on a food series with the writer Arabella Boxer. The first of these distinctive pictures appeared in *Vogue* in 1975, and the collaboration of writer and photographer has continued ever since.

She started photography as a student at art school, learning the craft on a large-format 5 x 4 inch MPP plate camera. Though she sometimes uses 35mm or a 120 roll film Mamiya RB67 camera, most of her work is still done on 5 x 4 using one of her two old MPP cameras, with either a 150mm normal or a 50 year old 300mm telephoto lens. She does not worry about lens distortion because she composes her pictures using a grid in the back of the camera. 'With collages you have to be very careful to get all the lines parallel,' she says. 'I always draw the picture carefully on the background first, put a spirit level on the back of the camera, then adjust the subject to the lines on the grid on the ground glass screen. It doesn't matter if the original isn't square as long as the picture is!' It is this kind of pragmatic approach that enables Tessa to solve technical problems so viewers do not even know they existed.

The greater part of her work is done in one of her two studios—in Chelsea and in Devon. Both provide enough natural light for photography, though she often uses tungsten or flash. 'I have a huge umbrella flash which has silver inside and a soft reflector on the outside,' she says. 'The light quality is so similar to daylight that even I sometimes can't remember which I've used.'

In her London studio she also uses two tungsten lights bounced off the white ceiling, supplemented when necessary with tungsten-balanced movie lights. The tungsten lighting is very even, but can be dim so she may have to use long exposure times such as 30 seconds at f/32.

The subject can be from a few square centimetres to 10m (100 sq ft) in size. It might be a tiny collage of grains or a huge arrangement of fine foods and bottles of champagne. But most

ABOVE Game, photographed for the Vogue *food series on 5×4 inch tungsten light-balanced sheet film using an MPP camera and Balcar electronic flash. She used a poster for the background, and added props to give the effect of a woodland setting. As the poster was too narrow she painted in extra background.*

are small enough to fit on a table, which is where she constructs them. She draws the design out first, and lays out the most important parts of the pattern. Other people help by 'filling in', and sometimes three or four people can be working on a collage at once. (They can also help eat the result afterwards!)

'People always think my pictures take forever, but actually I can do them in about a day—a good, long day's work. With fresh things you can't spend much time arranging them because they just curl up and die.' While arranging her pictures she takes Polaroid test shots to check the lens coverage and sharpness as well as the composition. About half way through she will take a sheet of colour transparency film, and send it out for processing. This provides a check on the film, lighting and exposure. With so much work involved in each picture, she can't afford to take chances.

'I like the idea that all the work goes into a picture before you actually release the shutter, and the photograph is the final confirmation of everything you have been doing until then.

But it's important to choose something that can only be kept in a photograph. If you make a collage of fabric or stones or beads, why photograph it? You can hang it on the wall as it is. The fascination of working with living, perishable things is that the only way to preserve them is to photograph them.'

Tessa Traeger does not substitute mashed potato for ice cream or whatever. 'You have to be careful,' she says, 'because in advertising it's illegal to cheat in any way. People always think that magazines and books are honest and advertisements are dishonest, but it's more often the other way round.'

The backgrounds are often old posters or prints of famous paintings. Sometimes she paints in extra areas to extend them where necessary. By the skilful choice of lighting and camera angle, she often makes the arrangement of food seem to flow naturally into the painting.

Many of her collages are also inspired by famous paintings, old and modern. Tessa Traeger says, 'I think people are quite amused to spot the painting'. The pictures are delicate and detailed but most of all, they are fun!

ABOVE Pork products photographed for Vogue *food against a background of Beryl Cook's painting of Noah. MPP camera, tungsten-type film.*

LEFT A pattern of herbs which Tessa Traeger grew herself. The photo was taken in the Devon studio on 5×4 inch tungsten-balanced film with filters to correct it for daylight use.

FAR LEFT A clever illusion achieved by selectively lighting the girl to bring her out of her dark surroundings, and by the choice of lens and shooting distance to give the right perspective. Tessa found the painting in an antique shop and extended it for use in this illustration for Vogue. *Tungsten film and lighting.*

ED WHITE

After leaving school Ed White worked for two years as a hod carrier. Then finding him between labouring jobs, a friend suggested he apply to the Photographic Department at the London College of Printing. 'I'd always wanted to make pictures, but I'd never really thought seriously of photography.'

Like many other students in the early 70s, White 'dropped out'. But unlike most of them he kept on working, at home. His labouring had provided him with enough cash to buy a camera and lighting gear. Already committed to still-life work, he bought a 10 x 8 Sinar monorail and a 210mm f/5.6 Rodenstock Sironar lens. 'The best £750 I have ever spent. The format is perfect for still life because you can control the image so completely. It's like working with a little colour TV—upside down! Art directors love the size too because it's almost the same as a magazine page. As soon as the picture is processed they can see just what the finished ad will look like.'

Equipped with a 1000J Bowens Intaswitch flash console, White set about shooting a portfolio in his bedroom. Most ex-students work as assistants to established photographers to gain practical and business experience. He went straight to work as a freelance. 'I used a friend's studio at first, but I had to leave because I would take a week to do a shot that most people would tackle in an afternoon. I'm not a natural photographer, I can only achieve something by bashing away until it's perfect, or until I go bananas. One of the miracles of my career is that I survived the first year and a half.'

White's break came when he was commissioned to shoot a Christmas poster for Benson & Hedges cigarettes. A move to his own studio followed. More flash lighting was added—two 5000J strobe consoles and a 2500J Balcar, with a total of six flash heads. Camera equipment—never one of his consuming interests—remains modest. He still uses the same 10 x 8 Sinar, but has added a 300mm Schneider Symmar lens and a 5 x 4 back. The smaller format is used for black and white Polaroid test shots and extreme close-ups. There is also a Polaroid SX-70 for model test shots and an old Nikkormat 35mm SLR.

Lighting control is vital in still-life photography. He has developed a superb 'soft-but-sharp' style. His studio is moderately large at around 150 square metres, and black—even the floor. 'A painter starts with a white canvas and adds colour. I start with black and then take the black away. I build the lights specially for each job with Perspex, skyhooks and tape. I don't believe in simply putting a nice light over the subject and then shooting away.'

The flash heads are all fitted on booms (counter-balanced extension arms) which allow them to be positioned with great precision from behind the camera. The flash light is diffused through large sheets (about 1 x 2m or 3 x 6ft) of white translucent Perspex. 'This gives me a light quality like hazy sunshine, and I can control where the sun shines from.'

'At the start of a session I create the lighting and put the camera where it belongs. Then I set the camera movements. These are very subtle—a few degrees only—and I rarely tilt the camera back since it can distort the image. After that one of my assistants—usually Frances Harper—takes over and she shoots the first test. Oh yes, I only employ girls: two or three at a time. Girls are more methodical, cleaner and tidier and they add a pleasanter atmosphere to what is otherwise an

insane situation. Can you imagine being shut in a darkened room and concentrating on the same object for days at a time?'

Thorough testing is essential for White's demanding style. The first test is usually a 5 x 4 black and white Polaroid to check the exposure. Then he takes a full size Polacolor 10 x 8. 'If you get a good Polacolor you're going to get a bad transparency. Ektachrome has a lot more latitude so the ideal Polacolor test has to have very dark shadows.' Testing is continued until the shot looks right. Then an Ektachrome 64 test is made, usually with exposures bracketed by a half stop either side of correct. 'I'm after a powerful statement expressed with the finest technical quality I can achieve.' With the testing completed the actual pictures are taken—as many as 30 sheets of 10 x 8 Ektachrome 64 being shot. And each sheet costs as much as a whole roll of 35mm slide film. 'Frances handles the camera—I invariably leave at this point. I actually consider it bad luck to be in the studio when the picture is taken. There's your headline—The Photographer Who Won't Touch His Camera!'

In the future, White says, 'I'm going to take photography more seriously; insist on more variety; do more location work. I think it is very easy to become a victim of one's own success in a particular field. The last few years have been pretty static for me in photographic terms because when you are as expensive as I am you are only ever employed to repeat yourself. Art Directors are not in the business to take risks, but "sell soap". So if you take their money you must take their restrictions. Since Stanley Tools, the number of layouts that are all false skies and false perspectives I've turned down or priced myself out of is ridiculous. The exciting campaigns are few. Even in editorial they only want versions of one's folio. I want to take beautiful pictures and yet I don't get enough opportunity to do it.'

But there are compensations. 'Every time I shoot a nice 48 sheet poster it is like having an exhibition,' admits White. 'I get my biggest buzz driving past one of mine.'

RIGHT White had a tulip specially made in wax for this Chanel advertisement. One light placed low down behind the white translucent Perspex background gave the graduated tone effect. On 50 ASA Ektachrome the aperture required was f/45

Each one of these three pictures for Stanley Tools took a week to shoot with 4 or 5 days planning. 'To start with, mock-ups were made to get the right scale. The modelling work was done by a jeweller friend, Matthew Warwick—it took him two months.' The skies were created by using enlarged print film transparencies duped up from 35mm film to about 5ft (1.5m) across. They were taped on to translucent Perspex and backlit with 10,000J of flash. Foreground lighting was 2500J. Only one flash was needed for the foreground but the skies needed a multi-flash technique to build up enough exposure. In total darkness the background was first covered in black velvet to prevent it picking up reflections and the foreground exposure was made. With the velvet removed, the background lights were flashed repeatedly—between 10 and 18 times for each shot.

RIGHT All the pictures were shot on 64 ASA Ektachrome with a 210mm Sironar lens on a Sinar. A green filter gel was used over the background lights and 10 flashes were given to get the correct exposure for the working aperture of between f/64 and f/90. The wood background was sandblasted for texture.

BELOW This was the most complex of the series as both subject and background had to be multi-exposed. Three stages were involved (1) The wooden egg was edge lit with a slide projector. White pushed the egg down the saw during the time exposure, wearing a black glove. An 80A filter was used to balance tungsten light for daylight Ektachrome. (2) With the filter removed a diffused flash lit the saw and egg in its final position. (3) The background exposure was built up with multiple-flashes using brown filter gels.

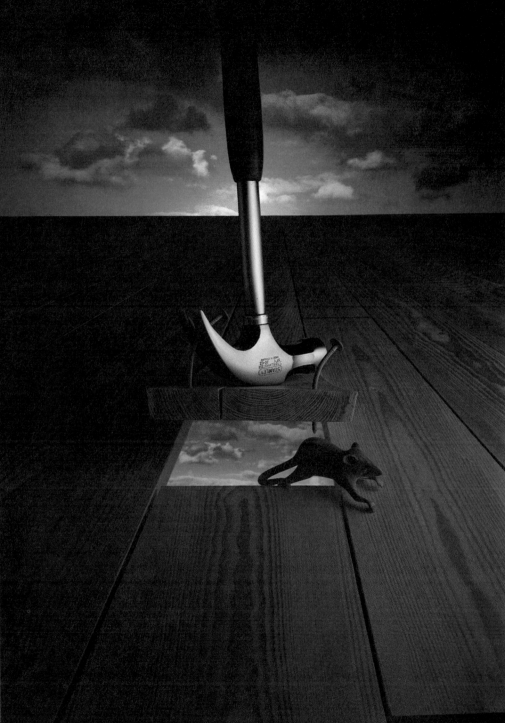

ABOVE Much of this shot's impact comes from the dynamic perspective. The floorboards seem to go on forever but in reality they were fairly short—less than 1m (3ft) long. This false perspective was created by tapering the boards and the effect was reinforced by selecting planks with a tighter wood grain at the back. The hammer was suspended from a boom. Two 5000J flash units provided the light source. The background sky was again created with enlarged transparencies taped on to Perspex. To exaggerate the perspective and obtain the required depth of field, White used a 210mm Sironar lens with a large bellows extension. Polacolor test shots were made to get the correct exposure. Weeks of planning, testing and shooting went into the making of these three pictures. White says, 'People often assume they were done in an afternoon.'

STAK AIVALIOTIS

Most photographers have a certain amount of difficulty coaxing a smile or suitable expression from their models. Stak Aivaliotis has much the same problem—but with pigs, snails, geese, sheep, rattlesnakes, goldfish, ducks, dogs, the famous Guinness toucan and, on one occasion even a fly! It is hardly surprising that he has developed a wealth of different techniques for coping with the diverse specimens he's used for a variety of advertising campaigns.

Stak makes sure that all his animal portraits are shot with regard for the well-being and dignity of the creatures involved, even though live animals present quite a challenge. It is here that skill, experience and a measure of luck are needed. A series of advertisements for the National Westminster Bank found Stak dealing with a surprisingly docile sheep, a co-operative goose and a sleepy piglet.

'I wanted to do a series of animal portraits in the studio. The original idea had been to shoot on location, but I felt a studio picture—using a painted canvas backdrop in the style of Irving

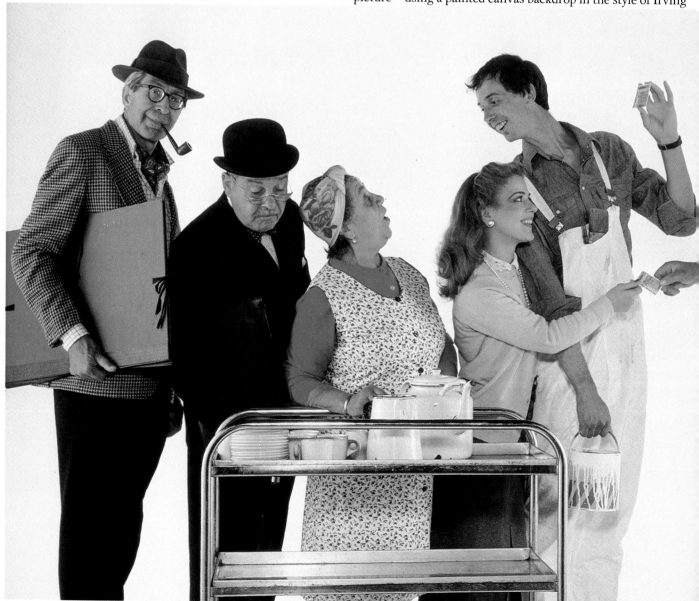

Penn!—would be more effective. His type of background has somehow become symbolic of the portrait.

You might imagine that Stak would use a small mobile motor-driven camera to shoot such unpredictable subjects. In fact he uses a large format Sinar monorail: a camera which does not even have a viewfinder once its film darkslide is inserted. With such equipment, careful preparation is essential. Usually an animal shot takes a day. The morning is spent in setting up and testing. The actual shooting is done in the afternoon. Background and lighting are arranged with a substitute model in place. A rolled up towel acts as a sheep or goose for lighting trials, focusing, black and white Polaroid and Ektachrome test shots. It is essential to get the exposure exactly right at this stage. Bracketing with unpredictable subjects is not wise: chances are that the picture with the best expression would be over- or under-exposed.

Stak's lighting is soft and highly controlled with exactly the right quality of highlight and shadow detail for the job in hand. It is almost always mains-powered flash diffused through large sheets of white Perspex or frosted plastic. The diffusion allows the brightness to be fairly even over a short distance, which allows a certain degree of latitude in positioning the subject.

During his two troubled years at the London College of Printing, Stak won an award for advertising photography. A brief spell as an assistant to Don Silverstein followed. At this time Stak was committed to photography, but he also realised that he had to tackle it his own way, in his own studio. There was only one problem—money. He made a radical move, out of photography and into selling encyclopaedias. Five weeks later he made another change of direction. He joined the family clothing firm with the express intention of accumulating enough capital to open a studio. After seven years hard labour, making and marketing maternity dresses, he realised his ambition. Stak's studio opened in 1973 and slowly the work flowed in.

His breakthrough came with a shot for Guinness. The picture had to show a glass half-filled with lemonade with Guinness floating on top. 'Several people had tried the shot and their efforts didn't match up to the art director's demands. I poured the draught Guinness on to the lemonade over a spoon. The different layers of liquid were stable for quite a long time—about 20 seconds—but I didn't know that until after I'd shot the pictures. The background was smooth white paper, carefully tapered to follow the field of view. This meant that the absolute minimum of white was used, allowing the black space beyond to give the glass its dark edges.

'To pick up the gold Guinness logo I built a curve of white card in front of the camera. A light bounced from one side of this reflector showed up the lettering, allowing it to shade off at one edge and so giving a rounder effect. With the reflector in place I could only see the glass through the camera. When the darkslide went in I couldn't see anything! I shot really quickly

LEFT This shot was taken to show the types of people who would benefit from a transport season ticket. It was taken on a Nikon F2 with a 55mm Micro Nikkor lens set at f/22, with flash on Kodachrome 64.

BELOW One of Stak's superb quality still lifes. To simulate a natural light Stak built a tiny window on the right with a huge studio flash behind it.

Enjoy a quiet Guinness at home.

LEFT Tooky, the Guinness toucan, was photographed using a 5×4 Sinar P with a 210mm lens.

RIGHT Stak had 20sec to shoot before the Guinness sank. He shot this on 10×8 Ektachrome.

BELOW The Guinness country bar was shot in Stak's studio. The bar top was specially made and all the other props hired. Stak used 27 650W tungsten lamps to create a huge soft light.

each time, thinking the Guinness would float only for a few seconds. I shot 20 sheets of 10 x 8 Ektachrome and they were all usable. I was amazed.'

Stak's success with this tricky still life led to other work on the prestigious Guinness account. The most recent pictures have featured Tooky—the talkative toucan. 'He's a real character, tremendous fun to work with. He doesn't really talk—he has *bitten* me a couple of times, though! The shot with his beak tied is a photo-montage—it would have been too cruel to attempt to do it for real. I'd already shot the transparency of Tooky, so all I had to do was have a wooden model made of his beak. This was sprayed orange and the string tied round it. I arranged my lighting to match the original shot so that the shadow qualities would look identical on the final combination print.

'Art directors have firm views on what they require but they aren't paid to think about the problems their demands present. Why should they? As a photographer it's my job to translate their vision on to film. Sometimes they come up with crazy ideas which are damn near impossible to fulfil. But I love the challenge, and the enjoyment I derive is in direct proportion to the difficulty of the task and the way the final result looks.'

Stak's plans for the future lie in three different directions: a continuing obsession with image making for the advertising industry, a move into motion picture work and a shift of gear to tackle some private work. 'I need a deadline to get my personal pictures organized. Ideally I would take six months off work to prepare an exhibition of my own work. It would be a hard slog, but after seven years in the "rag trade", working in photography is sheer unadulterated luxury.'

JEAN RUITER

Jean Ruiter's pictures begin as rough sketches, but the end results are highly stylized combination prints which can include drawing, air-brush work, montage and any other graphic techniques that fit. Advertisers supply him with themes for pictures rather than specific briefs, and as one of Holland's best-known photographers, he is given a free hand to experiment. It has not

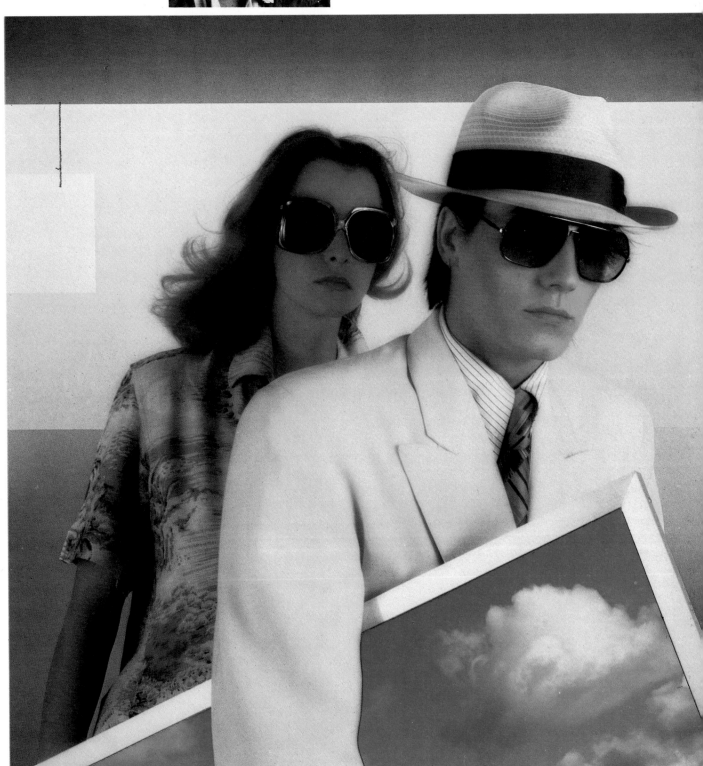

always been that way. He was once refused entrance to a photography school in Amsterdam, but has since had the satisfaction of being invited to lecture there.

His philosophy and principles demand a quite different approach than most commercially-successful photographers. 'My interest in photography started when I was 12 years old,

LEFT This was taken as part of an advertising campaign for Polaroid sunglasses. Using a Linhof 5×7, Ruiter photographed the models on colour negative film. At this stage the man had just a frame under his arm. After making a print, the pictures on the wall and under the man's arm were montaged on to it. Finally the background was air-brushed to make it look like the interior of an art gallery.

BELOW For his 'Face' picture, Ruiter first photographed a model in black and white and dodged out the face in printing. The faint background and tie colour were air-brushed on to the print and the word 'face' written in red paint.

because I had walked into my brother's darkroom and was immediately fascinated by this mysterious world. I made a nuisance of myself until my father bought me a small Agfa box camera. I began photographing everything around me but I wasn't really interested in making beautiful pictures. I wanted to know how a film worked and what the process was all about.

'My father was getting desperate. There I was, 18 years old and no one knew what to do with me. He telephoned a 72-year-old photographer called Van Dijk who agreed that I could become his assistant. Van Dijk turned out to be a famous architectural photographer who built all his own large format cameras and enlargers. The first half year I was with him I wasn't allowed to touch anything at all. With my hands behind my back, I was only allowed to look. The first and only picture I was allowed to take was of a crack in a house interior. But when he died I had learned how to be a professional—I had learned the intense commitment to one's profession and craftsmanship.

'After I'd been working in advertising studios for a while, my father gave me enough money to set up on my own. "That's it" he said, "never again. It's now or never". I knew exactly what I wanted to do so I bought all the cameras I needed, darkroom apparatus, and so on. Other people were busy working with SLR cameras but I bought a Cambo, a large format, view camera made in Holland. I started to experiment with colour and within a few months was commissioned by Philips. My father was greatly pacified!

'I have always continued to experiment and only look to the commercial world to make a living. I work with colour prints, never transparencies. I started doing this very early on because it allows me to control colour in the darkroom and I can incorporate all sorts of graphic techniques—montage, etching, drawing—all these become possible. Many of my commissions now allow me to experiment, and I get paid for it too.

'The cameras I use are all large format—the Linhof is easy to travel with and I can take it in my car. Of course, I always use a tripod for my work. In the studio I use a Sinar because I can control the perspective and any technical problems can be solved. I will use any lens that will give me the effect I want when I have sketched out the picture. Filters are only important to me in the darkroom. What others do when they take a photograph, I do in the darkroom. In the darkroom I have more control over colour. Outside you never know what results you will get; in ten minutes the colours could have changed without you detecting it. I don't have that problem. I can make a colour warmer or cooler and have infinite control.

'I do all my own printing because it is very important to me, I took two and a half years out from photographing and invented my own colour printing machine. The ones available in 1975 were very expensive and the tanks needed 40 or 50 litres of developer. I wanted to invent a system for amateur photographers, or professional photographers who, like me, could only make small quantities at a time, perhaps 10 prints a day. So I sold all my cameras and equipment and moved to Antwerp because it was less expensive to live there and I could spend 16 hours a day working on the problem.

'These two years were very important to me. I had become a successful commercial photographer but I was stereotyped for the kind of images I produced. This irritated me. I wanted to move on, experiment with different things and, most important

LEFT Ruiter's tulip about to be cut is a symbol of aggression. He shot the tulip and scissors on a Linhof view camera with colour negative film and air-brushed the background on the print.

RIGHT The sunglasses and their reflection and the background sky are the only photographs in this picture. These were both taken with a Linhof. All the surrounds were air-brushed on to the print.

BELOW Three separate pictures make up this image which symbolizes pollution. The dirty sea, the arm and the centre picture of clean water were all shot with a Sinar camera. The three colour negatives were combined using dodging and masking techniques. The print was air-brushed to soften the final image.

of all, I wanted to dictate the sort of pictures I took. My time away from the camera was a rebirth—it stimulated me immensely, and I came back to making pictures with renewed enthusiasm.

'In 1978 I returned to Amsterdam and started afresh. I still work commercially but no one tells me how to do things. We talk a lot and I make a lot of drawings. Philips, for instance, will tell me the themes they want me to work on—radar, mass communication, health, ecology, and so on but I have a completely free hand to translate the themes into pictures. All photographers want to explore the medium of photography more intensively. I have mastered all the techniques now and I can concentrate on finding new ideas and making them into pictures.

'At the moment I use air-brushing in my work but I will move on from this soon. I don't use it for visual effect. I only use it to achieve a certain atmosphere. If, for instance, I want a sombre, grey room, it may be too expensive to build a set to create this as I want it, so I take a picture of a room and then air-brush it to get the effect.

'Working out ideas can take days. It's like having a cold. Everything is blocked up and then suddenly it's all right again. Then I start to sketch and plan the picture—a certain landscape to evoke a mood, a window and any other elements. Then I have to find all these things, photograph them, and then incorporate them into my picture. If I can't find the right images, or if the idea starts to grow and change, I give up, throw my sketches away and start again. The result must be what I envisaged with each element right—the light, the background or the model. If one element isn't how I want it, I can't make it right in the darkroom. I never compromise. A compromise means weakening the image. I may have booked models or found a special location, but if it isn't right I cancel the shoot.

'Everything is possible, that's my standpoint. I expect more from myself than being restricted to one form of work. I want more out of it than to just maintain my status. I feel that I'm only just at the beginning, still an amateur—even after working for 18 years. I love work. Fortunately I'm now able to combine my own work with commercial photography and I want to maintain this freedom. If someone gave me a guaranteed income which involved a lot of money, I'd go completely mad within six months. I just cannot be stereotyped or restricted.'

SPECIAL EFFECTS

Photography started as a means of recording the world about us—Fox Talbot called it 'the pencil of nature'. And rapidly, photography became an art, as photographers tried to record nature in harmonious compositions. Artists gave their work form, and photographers looked for form in their own subjects in a similar way. Inevitably, for some photographers, the formal qualities of the picture became more important than the literal transcription of reality. This happened in painting, too, with the various '-isms' such as Cubism. But whereas the artist has complete freedom to paint whatever he likes, the photographer is more limited. He can paint with light, perhaps, but in most pictures, there is some underlying bedrock of reality. This gives the special effects photographer a particular advantage. People will always have, at the back of their minds, the thought that 'this is a photograph so it must be real'. Some photographers use their special effects subtly, to enhance their pictures by exploiting the viewer's sense of reality. Others flaunt their invention, so that the visual impression is everything, and perhaps no one can even guess at the original subject. Because photography is a complicated process there are innumerable ways to do this—at the taking stage, during processing, or by after-treatments such as hand colouring. The techniques adopted help to give each photographer his particular style, which is the major component in the enjoyment of his work.

Chris Alan Wilton

The most complex of Chris Alan Wilton's pictures are mixtures of two, three or even more exposures. They do not represent anything that exists in the 'real' world.

Wilton—speaking in his father's native English with a little of his mother's French accent—finds it difficult to discuss his work. Only pictures can capture his true meaning. The ideas are there, but he does not like to put them into words.

'I'm a gentle person in life,' he explains, 'but in the frame I am the boss. I can see reality, but I cannot change it or affect it, except in a picture. In the frame you can play god. You make a world of your own, like an artist... Except that you need to be gifted to be an artist. I don't think you need to be gifted to take photographs. If people spent as much time as I have on pictures, they could take them too. I think about them all the time; ideas come from everywhere.

'My general approach to photography is more sensual than intellectual. Maybe this explains my preference for colour, although I also appreciate black and white work. I find that an objective representation of the world we live in is impossible. There is no way a picture can be completely objective, so I work at the other end of the spectrum.'

Actually Wilton takes two quite different kinds of picture. He says the approach is 'instinctive, but completely different for each one, and it requires a sort of split outlook.

'First, I take pretty straightforward pictures of country or urban landscapes. I use whatever subject is available, preferably something ordinary, and try to make it extraordinary. Second there is the more personal sort of picture where the image is in

ABOVE A slide of the sun was taken with a 500mm lens and copied to make the image of the sun larger. A magenta filter was used in the copying to increase the saturation of warm colours. The copy slide was then sandwiched with a slide of an aircraft, which Wilton had photographed against an overcast sky with a 200mm lens on a Nikon.

LEFT These stags were photographed first with a 200mm f4 Nikkor lens with a blue filter to provide the deep blue cast. The exposure was made for the sky so that the animals appeared in silhouette. The moon, photographed against a black sky with a 500mm lens, was added by double exposure. The sky was too dark to affect the first exposure.

my head first. I try to materialize this onto a piece of film using any technique or equipment available.'

Even the 'straightforward' pictures can be complex, using filters or special exposure techniques. But this is the 'bread and butter' work which is used on calendars and for illustration. The 'special effects' pictures find all sorts of uses, including record covers. Wilton's work is sold through The Image Bank international photo library. He says 'the market for special effects pictures is limited in any one country, and an international agency therefore increases its viability.'

For special effects he usually makes multiple exposures in the camera, although sometimes he uses a slide duplicator. The process can be so complex that a film may travel through one of his Nikons half a dozen times as the image is built up.

First the film is loaded but not wound on. Wilton opens the shutter, removes the camera lens and raises the mirror so he can mark the edge of the frame on his film. When the film is reloaded, this allows him to position it so it can be re-exposed with all the frames in register. (Not every camera has the precise frame spacing that makes this possible.)

After marking the film, Wilton winds on to the first frame as normal and starts shooting. He uses a viewfinder with a grid etched on it. This enables him to keep a record of his pictures in a notebook, using a similar grid. He makes sure that frame areas to be used for further exposures are kept in deep shadow, and therefore unexposed. Sometimes he masks

off these areas by holding a card in front of the lens.

Sometimes he uses a motor drive to shoot a whole film of the first exposure, to make each frame the same. This allows more experiment later. Sometimes he brackets to get a range of different densities. Then he rewinds the film, and reloads it for the second exposure. He refers to his notebook to find where to place the next subject element. This time he may have to mask off part of the frame he has already exposed. In any event, the two parts will have to have the correct density, so if necessary he brackets exposures again. Then the film may be rewound and reloaded again. . . In theory the process of adding together a series of exposures could continue indefinitely. In fact it seldom goes beyond three. Any more becomes difficult to plan, and the planning must be thorough.

These pictures may be subjective but to make them convincing, Wilton bases them on logic. 'If there are three shadows, each from a different exposure, they must all go the same way. There are things that the mind will accept, and things it will not accept. Just to gain a sense of illusion of reality you must have something logical to help the viewer.

'I use a variety of lenses between 20mm and 500mm on motorized Nikon F2 cameras. I do not use automatic-exposure cameras or automatic flash guns. They are only perfect for average lighting and circumstances; and when conditions are average, I don't take pictures.

'For example, most of my pictures are backlit with the light-source in the frame. The through-the-lens metering is pretty useless in these conditions. Exposure varies according to where the light source appears in the frame. The fact that I use Kodachrome 25 slide film all the time eliminates one

ABOVE Three separate exposures were combined to create this surreal image. (1) First the woman's eye was photographed against a black background using a macro lens. The single flash head was kept low to pick out the eyelash, put highlights in the eye and, most important, to keep the bottom of the frame in dark shadow. (2) The gull was added from a separate transparency by using a slide duplicator and a macro lens. The bird had been photographed at night with flash so that it would be surrounded by blackness. (3) Lastly, the moon was placed in the background. This exposure was made directly on the film with a 500mm lens so that the moon would be a sufficiently large image. The dark night sky did not affect the previous exposures.

RIGHT Wilton sells single exposure shots like this through picture libraries. He took an incident light reading into the sun and exposed for the highlights. The reflected light was so strong that the colour was washed out. He added his own by using a cyan filter.

variable, so I can make these exposures from experience. In the studio I use a Sekonic exposure meter for both tungsten light and flash. Usually I use one light source because there is only one sun. The rest is reflected light. I use filters so that the colour of the light matches in the several exposures on each frame—the equivalent of continuity in movies.

'I like to excite something in the mind of the viewer. It cannot be what I feel myself, because people will have their own ideas about my pictures. But my pictures should be experienced as a pleasure, like music, without being intellectualized. You should just know what is there.'

Francisco Hidalgo

During one of his many visits to New York, Francisco Hidalgo saw a horse-drawn carriage driving through Central Park. Although it was a dull, overcast day he was impressed by the scene and wanted to capture it on film. The movement seemed to him an essential part of the picture, and so, using a zoom lens, he tried to convey this by moving the camera during the exposure. Hidalgo says, 'I like this photograph because it creates an impression of atmosphere, rather than making a record. I prefer to suggest rather than record.'

Hidalgo's photographs are unique images that reveal one man's perception of the world. It is impossible to classify his work, and he is amused by people who try to do so. He has achieved a position where he can choose what work he does, and he only takes subjects that inspire him. He has published several books, and his pictures appear in magazines all over the world. He does not do commercial or advertising photography, but is often asked to produce brochures for companies such as Nikon.

His German wife, Meckie, looks after all his business affairs from their home in Paris, a city he has loved and lived in for over 20 years. This leaves Hidalgo free to concentrate entirely on photography. 'When I am home I go out with a camera only when I am in the mood. I don't go looking for unusual subjects, only for what I like. But when I am abroad, I always carry a camera.' Hidalgo travels a lot, and this gives him the background material for many of his books and his personal projects. He has recently completed books on Hong Kong, Peru, New York, London and Paris. The pictures of New York were taken over a period of ten years. The book, even down to its page design, is entirely Hidalgo's work. He feels that it is unique as a non-American view of the city. Hidalgo is reluctant to explain his photographs. Not merely because he feels they should speak for themselves, but because he feels it is pointless for people to try and copy them. 'If they are fed the technical details they will think that they can repeat an image, without realizing that it is the *photographer* who created the image—not the trappings of equipment.'

During the International Festival of Photography in Venice in 1979, Hidalgo conducted a workshop. 'I feel I have the ability to teach people, both young and old. But their ability to learn depends on their interest. I don't want to teach people to do the same as me. But I can help them to develop their own ideas.'

Hidalgo was not trained as a photographer, but studied fine art in Spain, where he was born. He worked at the art schools in Barcelona and Madrid, then painted extensively at the École des Beaux Arts in Paris. He started working as a draughtsman and graphic designer, and moved into photography as an alternative form of expression out of curiosity. 'I am still taking photographs out of curiosity. The concept is the same, it is only the execution that is different. Photography

RIGHT Many of Hidalgo's pictures are impressionistic. He prefers to show form and light rather than just record the scene. For his picture of a horse-drawn carriage in Central Park, New York, he wanted to suggest movement. To do this he moved the camera sideways during the exposure. He used an 80-200mm zoom lens on a Nikon with Kodachrome 25 film.

194

gives me the chance to travel. Before I was making drawings of Africa, but I had never been there. Before I started taking photographs I never knew what China was like, now I do.'

He taught himself the techniques of photography. 'Nothing in life is complicated. The moment you are interested in something, you always succeed. I learnt how to take photographs because I was curious. I read magazines and realised it was easy to learn how to use a camera. Anyone can do it. But of course, the time it takes depends on each individual's intelligence. Once you know how to do it, it is like playing chess—it is easy to learn, but difficult to become a master.' Hidalgo has been working as a professional photographer for twelve years.

When Hidalgo travels he usually takes four Nikon bodies, about a dozen lenses, and a range of filters and special effects equipment. Once there, he decides what kind of photographs he is going to take, depending on the weather and his mood. He will take out one camera body and three lenses. He does a lot of walking. He always looks for the commonplace—the everyday elements that will characterize the atmosphere of the

city. 'When I went to Japan I was interested in everything that was typical—in effect, everything that was most beautiful.' When he sees something that inspires him he composes the picture in his mind. He uses whatever lens or special effect might be needed to realize that image on film. He never uses special effects for their own sake, but always as a means of achieving the image he has in mind. He does not experiment, he does not bracket exposures, and he does not make mistakes. His pictures are composed entirely in the camera, however complicated they are. He rarely uses a tripod, however many multiple exposures he makes, except when the lighting makes it absolutely necessary, such as at night. He finds the lights of night time exciting and stimulating. During the day, he prefers to shoot by diffuse light. He has a horror of strong sunlight, and consequently his images are never hard and contrasty. The

LEFT This shot was taken in Japan. Although it was late in the day, Hidalgo increased the vibrancy of the colours by adding a magenta filter. By using a 135mm lens wide open, the foreground is thrown out of focus. This directs attention to the bridge.

BELOW Autumn leaves reflected in the water give this picture the yellow cast—not a filter. He used a special soft focus lens to blend the diffused colours.

gentle, natural colours that are so vital to his pictures are virtually taken for granted. Hidalgo wants them always to be in harmony with the composition and the overall picture. He does not take a picture simply because the colours are pleasing, nor does he take a picture if the colours are not right. 'It has to be an automatic response—like perspective for a draughtsman.'

Hidalgo only photographs in colour, even though he has an elaborate darkroom. For him, the real inspiration is at the moment of shooting. It can never be recaptured in the darkroom. He finds it interesting to make colour photostats of his pictures to test them. The copies are contrasty, but will show if the picture works or not.

Although Hidalgo is best known for his cityscapes, he enjoys photographing people. 'I never ask people if I can photograph them. If you ask, they don't know whether to say yes or no. Usually they say no immediately because it is the easiest thing to say. I always talk to people—I can't photograph them without chatting for a while because they interest me. I photograph people as I would like to be photographed. To me, eyes are most important. They say everything.'

BELOW Hidalgo has produced a book of photographs of New York. It is a city he loves and his pictures convey an impression of excitement and energy. His shot of the Manhattan skyline at night looks like a huge exploding firework. It was taken with a 43-86mm Nikkor zoom lens on a Nikon F2. To get the effect of the lights exploding from the centre he zoomed at f/8 for approximately half the 30 second exposure. The slide was taken on 25 ASA Kodachrome.

ABOVE The back streets of Paris provide Hidalgo with a good hunting ground for atmospheric images. A doorway and a yellow parked car would seem banal to most people, but Hidalgo has produced a composition of strong shapes and luminous colours. To get these effects he used a Rodenstock Imagon soft focus lens. This lens takes interchangeable aperture discs with tiny holes in them that will vary the amount of softness. It was shot on 25 ASA Kodachrome.

RIGHT Hidalgo knew exactly what effect he needed to create a romantic impression of this familiar Parisian scene. The picture is a double exposure. The first exposure was of a bunch of flowers, photographed out of focus and under exposed by one stop. The second exposure, of the bridge and tower, was taken with a 24mm lens. This was also slightly under exposed so that the combined result would have saturated colour and would not be too light.

Ryszard Horowitz

BELOW First Horowitz photographed the girl and made a print. Then he re-photographed the print using a number of front-silvered mirrors in a kaleidoscope arrangement to get the final picture.

Shooting pictures on assignment usually follows a set pattern. In advertising, the manufacturer approaches the agency which, when some ideas have been worked out, usually approaches the photographer to bring them to life on film. Ryszard Horowitz works in a very different way. Nine times out of ten he creates both the ideas *and* the pictures, whether it's for advertising, magazines or books. For example, when he was approached by the French edition of *Playboy* magazine they said to him, 'You have five pages. What can you do for us?'

Characteristically he moved away from the clichés of recent

INTRODUCTION TO THE CLASSIC TECHNIQUES

years. Instead he created fantasies out of everyday events in which tiny naked girls balanced on men's hands as they shaved or ate dinner. Surprisingly, each picture involved only one exposure.

That is the way he creates most of the fantastic images that form the bulk of his work. By using the skill he developed as an art director in thinking out new ideas, and combining that with photographic technique, he convinces us, if only for a second, that what we thought to be impossible has come true. Gardens grow in perfume bottles, girls dance on pearl necklaces or pop out of bananas in a dream world that emerges like a genie from a magic camera.

His interest in such ideas began while he was still a schoolboy in Poland reading Kafka. Later, while he was studying fine art in Cracow, he was doubtless affected by the surrealism that was popular among his fellow painters.

Before he could finish his studies, he made a visit to New York and decided to stay. He studied graphic design at the Pratt Institute in Brooklyn and then took a number of jobs as an art director. At the time Alexy Brodovitch, the eminent art

ABOVE An experimental picture which Horowitz took for use on his business card. The girl wore a black turtle-neck sweater which did not show against the black background. She lay on her back, and Horowitz positioned the egg shell in the foreground to achieve this effect. The picture was a single exposure with a 20mm lens on black and white film. A print was later copied on Ektachrome to give this delicately-coloured final slide for reproduction.

director of *Harper's Bazaar*, was running a photography class. Horowitz joined and found it a great stimulus, as did many others who have since achieved prominent positions in the photographic world.

Photography became an obsession, and the quest for greater control of the images a goal. Sometimes he imitated his idols, sometimes he worked for them as an assistant for a few weeks. By 1967 he was ready to open his own studio.

In all the years since, his enthusiasm has never flagged. Although he has achieved commercial success he continues to explore new ideas and methods. 'When I have an idea I like to try it out for myself. As a matter of fact a lot of assignments have been based on my experiments'.

Such continuity between his personal and commercial work is very deliberate. Many photographers create a clear dividing line between the two. Horowitz feels that such divisions foster a snobbish disregard for commercial work. 'I try to create images that are of more lasting value, in the sense that they can be interpreted a number of different ways. You can show something like this out of context'.

His way of working is simple. 'I sketch out my ideas in small drawings and talk about them to the person commissioning the job. I then translate them into photography. Under various circumstances, I choose the camera to solve the problem in

ABOVE AND RIGHT The diagram above shows how the banana picture was taken. The banana was placed on a sloping, artificial foreground with the model some way behind. Electronic flash was used to light the banana, to balance the lighting. The picture was taken as a single exposure with a 20mm lens on a 35mm SLR, while on location in Bordeaux.

BELOW Taken with a single exposure for the French edition of Playboy, a 20mm ultra-wide was used at its minimum aperture of f/22 to give enough depth of field to keep both the face (very close to the camera) and the girl (several feet away) sharp.

LEFT This triple-exposure was made for the jewellery firm
Cianni. A flash exposure was made for the foreground with the
necklace; next a separate exposure was made for the girl; and
then the sun was added. Using flash for the foreground meant
using a very small aperture, which left the sky area unexposed
for later exposures.

ABOVE Three separate exposures were needed for this
picture; (1) the girl in silhouette (2) the clouds and (3) the lips.
The lips were outlined in a special make-up and strongly lit.
Exposures were found by trial and error on Polaroid film, and the
final shot taken on Ektachrome, once all the details had been
decided.

the best possible manner. I get very upset when people come
along and tell me, "You have to do it on 8 x 10," or, "You have
to do it on 35mm". If it works I don't open my mouth, but if it
doesn't. . .

'There are certain limitations to various formats and certain
advantages that others have to offer. Obviously you don't
achieve the same kind of look in 8 x 10 that you do in 35mm.
It's not a question of whether you like one or dislike the other,
it's whether what you're working with is the right tool to solve
a certain problem. I never limit myself to a particular sort of
camera.'

Certainly the problems Horowitz sets himself would defeat
most photographers. If at all possible he will restrict himself to
one exposure, but 'the best possible result' is his aim. If that
means exposing the same piece of film a number of times, that
is what he will do. Sometimes this need arises from the
complex nature of the image. Sometimes it occurs because
two surfaces which are incompatible for lighting purposes,

such as silver and wool, have to be brought together in one
image. Such is his skill that even the most discerning eye has
great difficulty seeing just how he achieved the final result.

This use of technique is important to him. 'I like to create
intricate images that stop people and make them wonder how
things were done.' Yet, despite his amusement at teasing his
audience, virtuosity for its own sake disturbs him. 'What
bothers me very much is seeing images that are just technique
where there's no essence, no substance, to the image itself. It's
over-whelming because it's technically brilliant.'

All in all, his skills and his attitude have added up to a very
successful career and that only makes it easier for him to work
in the way he wants. 'They come to me because they like the
look of things that I do, or like my thinking.' However, as he is
quick to emphasize, there are no short cuts to such a position.
'You have to really understand the medium, to understand the
way the film works, the way the camera works. It takes years
of experiment.'

John Thornton

John Thornton has an obsession, though it is not one you can see when you look at the subjects of his photographs. His obsession is with making pictures of scenes which are literally and scientifically impossible, but which must be 'true' because they have been captured on a single frame of unretouched film. When Thornton turns on a tap, a stream of flame—pure energy—flows out. He opens a door to reveal a wall of solid water. He brings statues to life. Levitation is ordinary; gravity is defied as a matter of course. And all of these miracles are recorded in poster-like, saturated colour.

Over the past six or seven years John Thornton has become internationally famous for these personal, fantasy photographs, and published a book of them, *Pipe Dreams*.

But exhibitions and international acclaim do not pay the running costs of a studio, for the assistants, models, stylists or props, and the masses of equipment, from 35mm to 10 x 8 cameras, needed to produce the pictures.

ABOVE John Thornton with his Mick-a-matic camera. Mickey has a flash-cube between his ears and a lens in his nose, and takes pictures on 127 roll film.

RIGHT 'Walking the dog' was photographed in the studio against a matt black background. The leash was a length of shop-window display lighting which comes in a coil, like a plastic tube, with little bulbs that flash on and off. The girl's dress, from a Kings Road boutique, was taped and stapled tight. Then the final picture was taken as a single exposure in three parts: (1) a time exposure of 16 seconds to allow the leash to burn in, so it would not be swamped by (2) an instantaneous electronic flash exposure to light the model and the dog. Then (3) as soon as the flash fired, Thornton's assistant drew in the outline with a torch; this took about four seconds.

All this had to be done in complete darkness, so that the girl (who might move slightly) would not register on the film during the time exposure necessary for the leash.

ABOVE Pure energy 'on tap' is one of the dreams of John Thornton's fantasy world. It looks real but would you know how it was done? To make this picture he photographed the idea, quite literally, on 35mm Kodachrome. Flames, of course, only go in an upward direction and to get the flame to 'pour' out of the tap Thornton photographed the tap upside down. The tap was filled with lighter fluid which was then ignited and the hand had to reach upwards to the tap handle. To produce the flame was fairly simple, but to pose the hand so that it looked to be in a natural down-reaching position was much more difficult.

When you visit his studio, you see the sort of work that pays the bills—commercial advertising photography. What you will find is immaculately executed advertising photographs—the kind that win awards—but they usually will not show girls in bizarre situations, which is something found in his fantasy photographs.

He was born in Australia, and started as assistant to an advertising photographer in Sydney. He left Australia for South Africa—'to dodge being killed in Vietnam', he says—and opened his own advertising studio in Cape Town. Later he was sent to Portugal on a month's location for a South African fashion magazine, and afterwards paid what was meant to be a short

visit to London. He never left. He was 22. He had £50 in his pocket, a Hasselblad and a Nikon.

He did not actually take London by storm, and the early days were a struggle, but he persevered, and eventually started to get jobs. Often they were 'problem jobs', where the agency could not think of the right photographer to handle them. They were technically challenging, however, and stimulated him. After a few years Thornton had achieved financial security, his name was well known in the advertising business. 'I get a great kick out of doing ads, but I don't see photography just as a means to make money. For me photography has always been a love, a passion, something I'm involved with 100%, otherwise I'd probably never have started shooting pictures for myself.'

But whereas some advertising photographers like to shoot black and white reportage, or portraits, or documentary pictures, for a change from the demands of advertising work, Thornton applies those same, highly developed advertising skills to his fantasy photographs. Indeed, the fantasy photographs are even more difficult to do!

'I like to give myself terrible problems,' Thornton admits, 'because I don't take pictures you can see through the viewfinder. To start with I make drawings for most of them, I make notes about them, then marry them together into pictures. A lot of them push my technical ability to the n'th degree, to find out how I can get them to work.' It's the same process used in advertising photography, except that instead of the art director providing the 'brief' (sketch layout + idea), Thornton provides his own. The technical approach may be the same, in terms of painting or building sets, setting up lighting, hiring props and models and so on, but the aims are different. The art director usually wants things to look natural, whereas in his fantasy pictures Thornton aims at the surreal: hands coming out of the ceiling, flame or water coming out of mouths, cats floating.

'I don't consider it gimmickry to do this,' says Thornton, 'just as I don't consider it gimmickry for a painter like Magritte to have, say, a railway engine coming out of a fireplace. But where he's able to do it in painting, because there's no bounds to what you can paint, I have the limitations of photographic technique to overcome to produce a lot of my images. That is to say, in some way they have to be staged, but staged in such a way that the end result looks simple. You wouldn't think much of a ventriloquist if you could see his lips move . . .

'A particular picture may require the construction of anything from a book 1½m (5ft) high to a whole room, or a whole wall may be built and shifted across the country, as it was for the 'door into water' picture. To get several different elements of a picture on one piece of film may require several separate exposures, and Thornton often mixes daylight, studio flash, pocket flash guns and moving lights (often torches) with long 'time' exposures. Because of this Thornton can rarely 'see' the final picture directly in the viewfinder, it can only exist on the film. But when you see the final picture it has to look real: that's the fun of them.

'With the book published,' Thornton says, 'people have seen what I can do and have started offering me jobs along similar lines. One art director came down with a copy of the book and said, "Could I have a little bit of this picture and a little bit of that one?" I was able to say, "Well, we could light it this way, put this colour wall in, give you that in blue

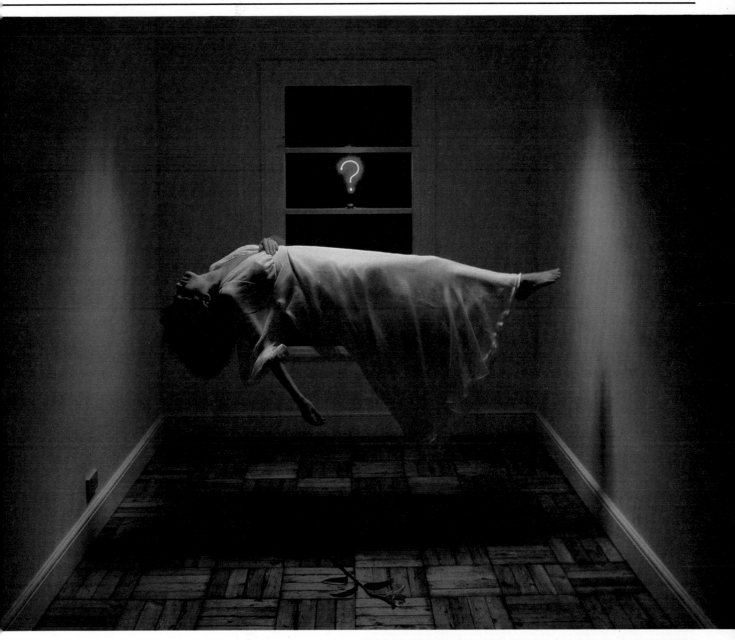

ABOVE This picture would have been impossible to do in a real room, but it was taken in a three-walled room set built in the studio. 'Really, it's very simple,' Thornton says. 'There are two bars coming out of the window supporting a very narrow board and the girl is actually lying on it. The bars are cantilevered out of the back of the set. There is a wind machine blowing through the window to lift the dress and give it a bit of form. Lighting is from one umbrella flash packed over the model above the set, giving the symmetrical shape on the walls and floor. After making an exposure for the flash, the neon question mark—mounted on a black velvet background—was put in at the back and a separate time exposure was made for that. 'It was actually done as a record sleeve for someone in Iceland who had made a record called Life After Death. *I started with the title. 'When people ask me how it was done, I say "Haven't you seen levitation before?"' The diagram on the right reveals all.*

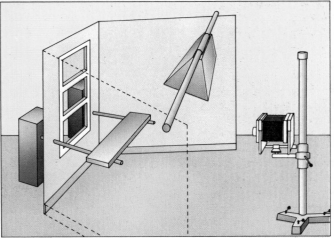

rather than yellow" . . . and so on. Previously, advertising commissions suggested fantasy pictures, and now it's happening the other way round. 'In the end,' says Thornton, 'I believe the photographer is more than just an operator, and I think people want more than an operator. I'm showing that I'm capable of a more creative approach by doing my fantasy pictures.'

One last question. John Thornton is a quietly spoken, reasonable young man, so why does he specialize in bizarre situations? Where do his ideas come from? 'Some people think of me as some sort of weirdo,' he admits, 'but I don't think so. People tell me stories or make casual remarks like "There isn't enough room in here to swing a cat", and I think "Oh, that would make a nice picture". I sometimes use thoughts that other people feed me to create ideas for pictures. Other times it is visual stimulation that creates the original image. I'm not interested in bondage, but the punning idea of being "tied up" is one I've used in some of my pictures. As the painter Allen Jones once said, you are not what your pictures are, you're only illustrating a point of view that's not necessarily your point of view. I'm only making illustrations, and you don't have to be something to illustrate it.' And for an advertising photographer whose pictures sell you cigarettes *and* try to stop you smoking, that is perfectly reasonable.

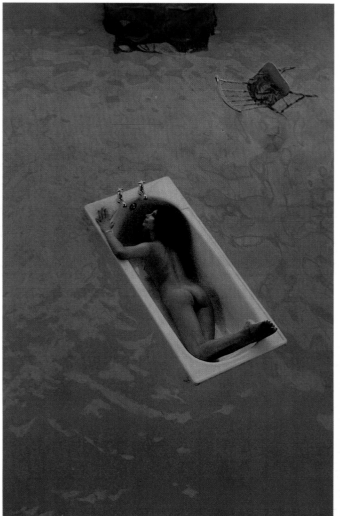

ABOVE This photograph shows the location and set used for 'Floating', the picture on the right. Scaffolding was built over the pool to support Thornton, his camera and electronic flash. Two flashes under the wall panels, either side of the girl and directed towards the water, give it an opalescent quality. The final picture was taken on Polaroid: they financed the picture. Thornton's assistant stood in the water to hold the door open and if Thornton had slipped from the scaffolding, he would have taken the flash heads into the pool and killed all three of them.

LEFT The original idea for 'Bathtub escape' came from a story about someone floating out of a flooded basement on a piece of furniture. To make the bath float properly it had to be weighted underneath and have a keel added. The bath and chair were held in position with fishing line. Electronic flash was used to light the far end of the set, while the model was lit by daylight from large skylights overhead. The final picture was taken through a hole in the roof using a 50mm lens on a Nikon and Kodachrome film. The photograph below shows how it all came together. This is the view of the location you are not supposed to see.

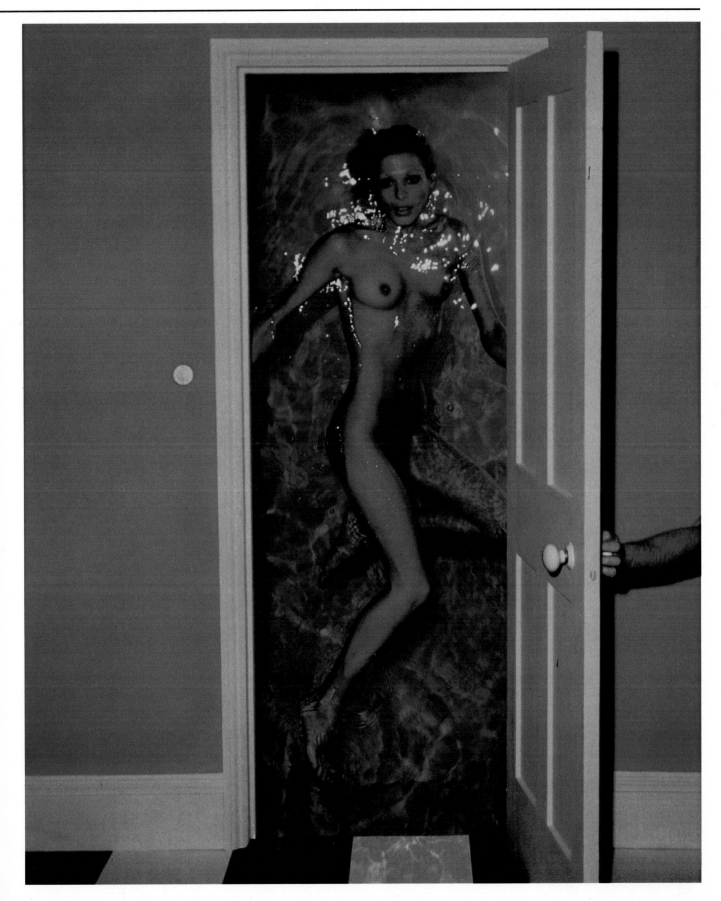

A SENSE OF STYLE

The contemporary photographer has a fantastic range of special effects available, but it takes a real expert to use them well. The problem is that, even with the use of different effects, all the pictures tend to end up looking the same. On the other hand, photographers who use the same equipment and techniques can end up with completely different results.

In this section, compare the work of Bill Brandt and Jeanloup Sieff. Both photographers like to use wide-angle lenses to photograph the nude in black and white, and both have a preference for dark, contrasty printing. Though these photographers clearly belong to different generations, both photographed the nude in the same decades. Nonetheless the two men produce quite different results. This is because style is individual, though the techniques are available to everyone.

So, what is style?

Style is the photographic expression of a particular way of seeing. Each of the photographers in this section has found a particular way of expressing his individual vision. There are always original and new ways to see things, and photography will always offer new ways to record not only a subject, but an individual's vision. This book has shown some of the possibilities, but by no means all of them. The range is infinite.

According to Bill Brandt, 'Photography has no *rules*. It is not a *sport*. It is the result which counts, no matter how it was achieved.' The photographer creates the work not only by choosing and composing the subject, but also by choosing the camera, lens and film, and by all the darkroom work he does—manipulating tone and contrast by burning in some parts of the print, and holding back others. Everything contributes to the final photograph, and in the end to the development of a personal photographic style. There must also be feeling and a depth of understanding. Sensitivity is the key to Brandt's pictures. He describes it as the perception to create atmosphere. He says 'that's the spell that charges the commonplace with beauty'.

Brandt was born in London in May, 1904, but brought up in Germany and Switzerland. In 1929 he went to Paris and was a student-assistant to Man Ray. There he encountered new ideas on portraiture and Surrealism which contributed to his later work. In 1931 he returned to London and worked as a social documentary photographer for *Lilliput, Weekly Illustrated, Picture Post* and other magazines. He depicted the comfortable middle-class life in his book *The English at Home*, 1936. He photographed the working classes during the depression. He looks back now with fondness, but not longing, for the time he spent in Newcastle and Jarrow, photographing miners before World War II. 'I would knock on someone's door and say I was taking photographs, could I take pictures of them? Everyone was so friendly and warm. They let me photograph them at work, having a meal and even in the bath!'

In 1938 Brandt published *A Night in London*, then during the War he was commissioned to take pictures of London during the black-outs. He also recorded underground shelters for the Home Office and bomb damage for the National Buildings Record, producing many moving and sensitive studies. After the War he turned his attention more towards portraits, landscapes and nudes. Many of the portraits were of writers, and published in the book *Literary Britain* in 1951. The nudes led to *Perspective of Nudes*, 1961.

Brandt's portraits were often austere, like the haunting image of painter Francis Bacon. It was taken on Primrose Hill, London, at dusk. On a sunny day this is a popular park, but through his composition and dramatic, contrasty printing, Brandt has produced a feeling of desolation and intense solitude. Many portraits used compositions that were strikingly original. Brandt would place his subject near the edge

BILL BRANDT

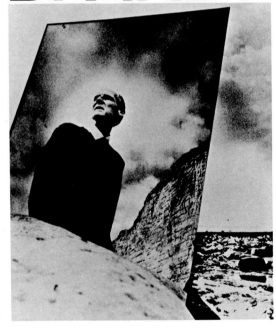

of the frame, or even partly out of it. He used unusual viewpoints and extreme close-ups, if these seemed to suit the subject. 'I don't like passport-type photographs,' he says. 'I like interesting backgrounds. Samuel Beckett wanted a plain background so I didn't do the shot.' He also rejects the candid approach to portraiture, which catches a person unposed. 'A portrait,' he says, 'is something you should be able to look at for years. A composed expression lasts forever.'

His book *Bill Brandt: Portraits* includes work taken from 1928 to 1981, and shows his continuity of style. The earlier pictures have been reprinted in the more contrasty style of the later work. Most have been taken with a Rolleiflex twin-lens reflex camera, viewing the image on a ground-glass screen instead of looking at the subject straight through the camera, as with an SLR. This seems to encourage a more calculated and composed approach.

The choice of camera was also significant for his nudes. His original and disturbing view of the female form developed almost by accident. 'My early pictures were taken by the camera; I had nothing to do with it,' he says with a smile. The early nudes were taken with a Kodak 8 x 6 inch mahogany stand camera which he found in a second-hand shop in Covent Garden, London, in 1945. It had no shutter, a pinhole-sized aperture and an extremely wide angle lens. Made in 1900, the model was used by the police and by auctioneers for factual recording. Because of the small aperture, indoor exposures—made by removing and replacing the lens cap—were often three minutes long. Using modern Tri-X in the camera's darkslides he was able to get exposures down to about one second. Even so, the image on the ground-glass viewing screen was so dim that composition involved a fair amount of experience and guesswork. He says, 'Now I use a Hasselblad with a wide-angle to fit in the whole room. I loved the distortion it created. I didn't realize it would work like that . . .'

The figures in Brandt's nude photographs look hauntingly out of heavy shadows. Limbs are distorted or exaggerated, but the emphasis is always on the design. Brandt is a sculptor of the human form. His nudes on pebble beaches are photographed with a great awareness of form, texture and balance. The abstract nude parallels the abstract form of nature. The results can be seen in *Bill Brandt: Nudes 1945-1980*.

ABOVE Bill Brandt: Self portrait with mirror, East Sussex coast, 1966.

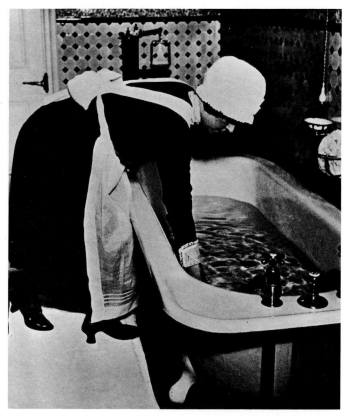

ABOVE Brandt's photograph of a maid preparing a bath before dinner was part of his series on a middle-class household.

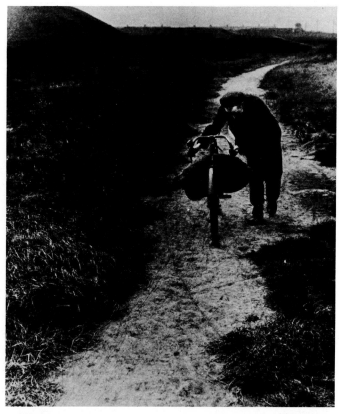

ABOVE A coal searcher going home to Jarrow was taken in the 1930s. People were not used to being photographed then.

ABOVE 'Halifax had a dreamlike quality in the 1930s. It has all changed now.' Brandt took this photograph with a Rolleiflex.

ABOVE Francis Bacon in 1963. Brandt says, 'It was difficult to find the right time. I wanted the lamp lit but not too dark.'

ABOVE A mirror is a common device in Brandt's photographs, used to distort the image and enhance design.

ABOVE Many of Brandt's nudes are taken on the pebble beaches of East Sussex. Taken with a Hasselblad.

ABOVE The girl's body taken from an unusual angle with a wide-angle lens creates contrast between the rocks and her skin.

ABOVE For many nude photographs Brandt uses an empty room in his home. Light and form are again contrasted.

ABOVE *Light from only one side of the room creates a perfect line along the girl's back, emphasizing her shape. The curves of her body contrast with the lines in the corner of the room. This picture was taken with his five shilling camera.*

Jeanloup Sieff

Jeanloup Sieff is one of the best-known photographers in France, not only because of his fine photography, but because of his constant availability to explain and defend his art. This has made him the ideal of many young photographers who strive to emulate his graphic innovations and technical excellence.

Like Bill Brandt he has become known for his very high contrast black and white pictures, taken with wide-angle lenses, of nudes in nature and indoors. Although the pictures of these two masters are quite different, both agree that photography is a matter of mood and personal taste, not rules. Sieff says 'I think rules are nothing but a protection against one's inability to see, to photograph. Photography is not a number of technical problems reserved for an elite, it is a viewpoint—an individual look. It is a Cartier-Bresson viewpoint, a Hamilton viewpoint—everyone has his own rules.

'Nonetheless, some technique is useful. You must know what is important and what you can ignore. You must be able to decide whether or not to use a film with a certain speed or a certain grain, but it should always be related to the subject you are photographing. Technique shouldn't stand in your way but you must know how things work. I taught myself when I was 14 and I tried all kinds of things. Now I know what I like—what negative, what kind of tonality. But it is not a rule, it is my personal taste. Each picture is different and requires a different treatment.

'I try to use daylight if I can, even if it's very weak and I have to expose for five seconds on a tripod. With artificial light, if it can't be avoided, the principle is: keep it simple. Remember that it is the subject that is important and not the lighting. Artificial light will never make the subject more interesting in itself. I always use a single light source because there is one sun, and the light it gives, whether it is direct or reflected, has one direction.

'Today I use one film and one developer because I'm lazy, but when I was young I experimented with all the developers because I was eager to learn all the techniques. I have since discovered that it is not so important. I still use my 25-year-old Leica, even though I have a Hasselblad and an 8 x 10 inch view camera, which I've probably used only twice in ten years. My dream is to photograph landscapes with the 8 x 10 camera, but the idea of spending an hour focusing makes me feel sick—which is bad because the quality of an 8 x 10 negative is beautiful. I sometimes use a Hasselblad in the studio but it's

ABOVE Sieff used a 21mm wide angle lens and chose a low viewpoint to emphasize perspective. He waited until the car reached a point where the lines of the hills and the roadway converged. He shot on Tri-X using a Leica M3 rangefinder camera.

RIGHT Photographing in Death Valley in the USA, Sieff made the bush the focal point to highlight the surrounding desolation. He stopped down to the minimum aperture to get sharp texture in both mountains and cracked mud flats.

much too heavy to carry outdoors. I use a square format camera when I want a square picture. I don't like to crop pictures.

'I use Tri-X and Ilford HP5 films if I shoot in black and white—400 ASA medium grain and good exposure latitude. This type of film is universal and will adapt to almost any situation. For colour, Kodachrome is an extremely good film—when it is developed correctly—no grain, great tonal separation and fabulous colours. The problem is that only the 25 ASA version is good. I underexpose by half a stop to get richer colours and more saturation in the slides. For roll film there are faster films but they have more grain. I use Ektachrome when it is really dark.

'Film changes all the time these days, and so does printing paper. The shortage of good quality papers is a problem; when I was 16 I used four different kinds of paper: Kodak, Lumière, Ilford and Dupont. Now there is little choice. I use many grades of resin-coated paper but I don't like its texture.

'I have no particular preferences in my choice of lenses: basically it depends on the results I want to get. I have a sentimental attachment (nothing really technical) to my old

The girls in Sieff's landscapes occupy only a small part of the frame. They give a sense of scale and a contrast in form and texture with the settings. To exaggerate the surface differences, Sieff prints on hard paper, restricting tones for strong contrasts.

ABOVE The soft light and pose give this picture a sculptural quality. The window acts as a floodlight, with the light diffused by covering it with tissue paper. Sieff used a Leica M3 with a 21mm wide-angle lens to get the feeling of spaciousness.

RIGHT To get maximum detail to show the texture of the rocks, Sieff used a small aperture for maximum depth of field. He shot on Tri-X and developed in D-76.

LEFT For this shot choice of aperture was limited by the necessity to set the shutter fast enough to stop the model's movement. Printing on hard paper brings out the contrasty, almost etched effect.

ABOVE Printing on a soft paper shows the gradation of skin tone from highlight to shadow.

LEFT Window light from two sides makes the model look skeletal. He used a 21mm lens on a Leica, tilting for distortion.

RIGHT The model, photographed against a studio backdrop, was lit by a single 1000W bulb. Sieff used a spot meter to take his exposure reading from the highlight area. He printed on Grade 3 paper to get the delicate tonal range. It was taken with a 55mm lens on a Nikon F.

beaten-up 50mm. I use a tripod all the time in the studio and occasionally for outdoor work.'

Sieff was born in Paris in November 1933. He started photography, like many others, with a camera given him by his uncle on his 14th birthday. It was a plastic Photax with two speeds and three f-stops. He later tried the entrance exam to a famous French cinematographic school, but failed. He left another photographic school in Paris after only three weeks and stayed at a Swiss school at Vevey for only eight months—'the weather was really too cold'. Where he really learned was in amateur photography clubs, where he mastered the techniques of darkroom work. Badly in need of money he worked as a freelance photographer for French magazines like *Elle* and ended up working for a short time as a photojournalist with the Magnum agency.

Sieff considers photography not as a profession, but as a hobby—'an amusement, a way to pass the time. It is the love of walking with a camera and seeing something that I like—an instinctive reflex. I did a photograph for *Vogue* magazine of the actors from *Hair* when they were in Paris. I just put them together the way I thought they should be, just as if I were arranging flowers in a vase—a small one with a big one, a yellow and a white one. My interest was purely aesthetic, a certain face next to another one, and so on.

Sieff's advice to a young photographer is: 'Don't ask yourself too many questions, shoot pictures because you like them. If you are talented you will be able to make some money; if you are not talented at all, you will make even more money. But if you are a genius, I can only advise you *not* to keep on going: you have absolutely no way of making it in photography!'

JAMES WEDGE

Black and white gives the photographer great control. Colour tends to be more restricted—unless, as James Wedge does, you apply the colour yourself, by hand.

Wedge started by studying millinery at the Royal College of Art, and soon opened his own boutique on the King's Road in Chelsea. Clients ranged from The Beatles to Lady Astor, and his hats were appearing in *Vogue* and other magazines. Then Susannah York sold him a Nikon for £50, and he soon became fascinated by photography. He sold the boutique, bought a little studio, and launched himself into the world of professional photography. It was not easy.

'I knew nothing,' said Wedge. 'To begin with I didn't even know how to load the camera. I didn't know about lighting or processing, I hardly knew the difference between colour and black and white, but I started practising photographing model girls which I enjoyed.'

Before long, Wedge had a portfolio of what he describes today as 'pretty awful stuff' which he took round to most of the magazines. 'I didn't get much joy out of it, but I kept going.' The experience of making the rounds taught him one thing—to succeed personally, his work would have to be different.

With his experience in fashion, Wedge had very definite ideas of how things should look—the only difficulty was in translating these ideas on to paper. 'The problem,' he says, 'was that I liked colour but I was never happy with colour prints. If you look at a photograph of a hand in a magazine,

RIGHT Using FP4 film, Wedge made a collage from two prints for this fashion shot. He photographed the model against a white background using an 85mm lens, then hand coloured the print of the girl, exaggerating the colours for a pin-up effect. Next, he cut out the girl using a scalpel, keeping a line around her. He then struck this on to another background photograph of the radiator grille of a car and rephotographed them both.

RIGHT This may look like an old print from a Twenties album but it is in fact a modern, coloured picture. The set was built in the studio and lit using bounced flash for soft overall lighting. He used a 100mm lens on a Hasselblad. Hand colouring the black and white print entailed fine brush work and careful control of the colours. From the time the picture was taken, it took 4 days work to reach this final picture for a fashion feature.

ABOVE This advertisement for a Portuguese wine was taken using a 100mm lens in daylight, with reflectors bouncing back the light from the windows. Wedge then carefully hand coloured the black and white print. He used 'rosy' colours for a rosé wine.

LEFT Make-up and colour film could not give Wedge the delicate effect he wanted so he used black and white film and hand coloured the print to get this result.

RIGHT Taken with a 35mm lens on a 35mm SLR. Wedge needed a long exposure of 1/15 and a large aperture because of poor light on the stairs.

FAR RIGHT Wedge used light and hand colouring to create the atmosphere for this picture. He used one flash head placed low down and bounced off an umbrella.

you think it's a normal colour, but if you put your hand down on top of it, you see that in no way could it be a realistic copy of anyone's skin tone. It seemed to me that by putting colour on an ordinary black and white print, you could in a way have more impact than with a colour print, simply because you weren't implying that there was any great truthfulness.'

Although the hand colouring set Wedge's work apart from others and soon became his trade mark, it was not achieved easily. Wedge's early efforts using ink applied with paint brushes and cotton wool strike him today as rather crude. 'I taught myself the hard way,' said Wedge, 'by keeping at it.' The period of experimentation took over a year. The key to the effect that Wedge was seeking came with his increasing dexterity with an airbrush and the discovery of Johnsons' photo dyes. 'I airbrush most of the area of a photograph and paint the very fine details in with a brush. But if there's any secret it's in the masking. It should take longer to mask an area than to colour it.'

When Wedge had finally mastered the art of colouring prints, Johnsons discontinued their line of dyes. So Wedge bought up all the available stock, and was able to survive until they were reintroduced.

Even with experience, hand colouring is never easy to do well. Also it is time-consuming, and this makes it expensive to do professionally. Only when it is done for major advertising campaigns like Mateus Rosé can it be considered well paid. A consolation is that Wedge always tries to keep the artwork after reproduction. Each one is unique, and may one day be valuable.

The choice of camera is very important to Wedge. For his personal work he now uses a Contax RTS camera with 28, 35, 85 and 135mm Zeiss lenses, plus a Yashica 500mm mirror lens. For his professional work he uses the Contax or a Mamiya RB67 roll-film camera, which he adopted when shooting an advertising campaign for Mamiya cameras. He prefers the 6 x 7cm format 'for the extra quality it brings to reproduction'. The equipment is always less important than the end result.

The fashion world also gave Wedge a fresh way of looking at photography. He not only made collages with paper and material, but also learned how to manipulate images in the darkroom. He started portraying his erotic fantasies and the resulting photographs became the first successful pictures he had taken purely for himself.

The subject of erotic fantasy is one to which he has stuck. 'I'm hooked,' he explains. 'If I was presented with a beautiful woman and I was taking pictures of her for myself, then I would try and do something more than just have the camera copy her beauty. I would try and get something deeper and in the end it would turn out erotic.

'Most of the pictures I've taken though are either of girlfriends or close friends, purely because when I'm doing my own work, I find it difficult to be with someone I don't know very well.'

Mario de Biasi

While some photographers see the world in black and white, and others want to colour it themselves, Mario de Biasi photographs the world in colour. Though he does not add or manipulate the colour, nonetheless de Biasi seems to inhabit an extraordinarily colourful world. Perhaps this is because he is a colourful character himself.

He is known as 'the mad Italian', a nickname earned for the risks he took photographing the Hungarian uprising in 1956. De Biasi, now chief staff photographer at *Epoca* magazine, has not changed. After more than 30 years in photography he still says: 'Never hesitate to reach a place, even if it is dangerous, if there's a possibility of taking a photograph which is different from those of 100 other photographers.'

Once de Biasi looked an Omani religious leader in the eye and invented seven starving sons and a sack-happy editor—a ploy that got him permission to photograph a mosque. De

ABOVE De Biasi posed these boutique owners for a series on how the fashion industry had become an element in the growth of tourism in Ibiza. By taking the picture quickly he has managed to retain a sense of spontaneity. He used a 20mm wide angle lens on a Nikon, exposing for 1/125 at f/11 on Kodachrome 64 film.

Biasi has thrown buckets of water down the cobbles of medieval streets to make the atmosphere 'feel right'. He is said to be a 'maestro' at reconstructing events, and although he always takes care not to distort the facts, he happily crops and dodges news pictures when he feels it is necessary.

Some people never crop their pictures. De Biasi says 'I don't think I can really agree with this way of operating, particularly when it is done systematically. Especially if you find yourself in a crowd and you can't go forward or back in order to improve the framing! It often happens that you can't ask a person who's

RIGHT To illustrate a
feature on skiing, de Biasi
wanted a dramatic and unusual
picture. He lay on his back in
the snow where the ski run
crossed a steep slope. The skier
was asked to jump right over
him. De Baisi used a motor-
drive at the speed of 5 frames
per second. He set a shutter
speed of 1/1000 to stop the
movement of the cascade of
snow. The picture was shot on
Kodachrome 64 with a 20mm
ultra wide-angle lens on a
Nikon 35mm SLR.

in the way to move, and in such cases the only solution is cropping at the printing stage. I think that's the most legitimate solution. Making the exposure is only one link in the chain which brings you to the final image.'

Whatever he says, it would be incorrect to describe de Baisi as anything other than an enthusiast and a perfectionist. His output is enormous. It includes hundreds of covers for *Epoca* news magazine, a dozen books, international shows and reportage from all over the world. There would seem to be no subject that he considers unsuitable and de Biasi insists that, in his free time, photography is his hobby.

His speciality is portraits that show 'the character in shirt sleeves', the private individual behind the public face. De Biasi will spend days with someone seeking an unguarded moment. He likes taking people by surprise, before they can raise their defences. 'Candid photography is more than the ability to manipulate the camera. You've got to train your eye not just to capture the instant but to anticipate it. Experience helps your reflexes. The exposure must be judged, rather than relying on the exposure meter, without being distracted from the event. With practice these operations become automatic, like changing gear in a car.'

De Biasi says that the photographer must not only overcome technical problems but develop 'sympathy' as well. 'Unlike some colleagues I'm convinced that the profession of photo-journalism does not hold any mysterious secrets. Personally, I've learned almost everything by reading books and photographic magazines. What you need to cultivate is a great sensitivity to photographic seeing. Experience, personality and your own culture do the rest. 'I've always tried not to follow the fashions of the moment. Photo reportage is, above all, *life*, and if life isn't interesting then you had better change your job.

'Once I preferred to visualize the composition in the viewfinder. Now I don't feel it is necessary. I prefer to imagine the photograph, visualizing the result before putting the camera to my eye. This happens naturally because for many years I used three fixed lenses which I almost never changed. For preference I used three bodies with 20mm, 55mm and 200mm lenses. In the last two years I've been using an Olympus OM-2, with 20mm, 50mm and the 75-150mm zoom. This is my basic equipment. With time, your instincts get better. Now it's more or less automatic that I can evaluate exactly the angle of view each lens will give me.

ABOVE *By careful framing with a 75-150mm zoom lens on an Olympus OM-2, de Biasi has made an abstract of this scene. It is in fact, a train in a huge lignite mine near Cologne. Soft lighting produces no shadows to give the subject away. Exposure was 1/125 at f/8 on Kodachrome 64 film.*

RIGHT *De Biasi asked the head priest of a temple in Kyoto, Japan, to step outside into the snow so that he could take his portrait. The bright colours of the robes make a striking contrast to the almost monochrome background. De Biasi shot on Ektachrome film, using a 55mm macro lens to capture all the detail sharply.*

'Besides my Nikon, Olympus and lenses, I always carry an extension ring for macro photography. There are skylight filters on all my lenses. I carry a Weston exposure meter and a Lunasix meter in case of emergency. I have a little electric torch, some jeweller's screw-drivers, a tube of universal glue, two rolls of adhesive tape, a lot of plastic bags (useful for exposed film), a pair of scissors which double as a pair of pliers, a tin opener, coat hangers and fuses. And—I almost forgot—I also carry some passport photographs!'

The 'mythical photojournalist', who lives out of a suitcase, exists in de Biasi. He is ready to travel anywhere at any time. But do not let his easy-going exterior hide the thorough

professionalism underneath.

'In order to avoid wasting a trip abroad I always take the subject with two different cameras and with different lenses, often repeating the shot. If one film gets damaged the whole job can be saved with other photographs.'

And de Biasi's professionalism does not stop when he has taken the pictures. The film must be returned in good time to be processed and printed on to the page. This is one reason why he chooses Ektachrome rather than Kodachrome: Ektachrome may not resolve detail as well but it can be processed in hours rather than days like Kodachrome. Time is precious in the news publishing business.

ABOVE An imprisoned head from one of the temples at Angkor Wat in Cambodia, was taken for a series on 'The Wonders of the World'. For over 500 years these temples had remained abandoned and consequently the vegetation had engulfed them. By concentrating on the head alone, using a 200mm lens, de Biasi emphasizes the eerie quality of the subject.

LEFT This photograph was taken at dawn on a footpath in Chichicastenango, Guatemala. The man was drunk and throughout the night his mother, wife and son had slept beside him. The garish colours, which are almost fluorescent, are obtained by treating the fabric with natural dyes. This shot was taken with an exposure of 1/125 at f/5.6 on 64 ASA Ektachrome.

CHEYCO LEIDMANN

ABOVE By shooting at between 4am and 5am Leidmann makes use of the luminous blue light of the early morning. The neon sign and the brilliantly-coloured costume are characteristic of Leidmann.

RIGHT Leidmann often contrasts a close-up subject with the open space of a distant skyline. This shot was taken in Las Vegas at dusk. All the shots in Foxy Lady *were taken with a Nikon camera on a tripod with an 18mm ultra wide-angle lens, and lit by flash.*

After just half a dozen years in photography, Cheyco Leidmann has acquired a worldwide reputation as an extraordinary photographer. He is best known for brilliantly-coloured and highly stylised, sexy, surreal images.

Although he had worked for such clients as BMW, Sony and Volvo, it was not until he was commissioned by the Dutch calendar company Verkerke Ltd that he was given the opportunity to do the kind of pictures he had always wanted to do. They asked him for a prestige calendar of erotic pictures. The comfortable budget allowed him to take a series of pictures, each one different and each a masterpiece of imagination. He knew that it would be difficult to persuade the company to accept a different form of eroticism from the traditional nudes and admits that presenting the pictures was one of the worst moments of his career. 'These people were just sitting there—there was no response, nothing.' But finally they accepted the pictures and the calendar was a great success, winning the Kodak Prize.

All the pictures were taken in the western USA, mainly California. Every image required a different location, painstakingly chosen to fit his original idea. He described the project as 'A real dream—time, money and this paradise: California has everything—music, sunshine, the Pacific, palm trees, cars, girls.'

After making the calendar, Leidmann decided to take the theme a step further and produce a book, *Foxy Lady*, from which all these pictures are taken. The project took about six months to complete over a period of 18 months. Another 60 pictures were needed to complement the original 12 which had taken four weeks to photograph. Each photograph was treated as a totally separate entity: he wanted every picture to be perfect. It had to be different from the one before with lots of detail to capture and hold the attention. 'Each picture is an invention—a picture that holds a story and allows the viewer to develop his own interpretation.'

Leidmann felt that he wanted his pictures to get away from the commercially acceptable idea of beauty—statuesque females and icy elegance. This would be too much of a limitation. 'Photography for me is a sort of visualized thought: an idea come to fruition. It isn't technique. It is formed from what I have experienced and my perception.'

He grew up in a small village in the Black Forest, Germany and now lives and works in Paris. He chose Paris because it is the only cultural centre in Europe where he feels he has the freedom to do what he wants, but his photographic career began in Munich, where he worked mainly in a studio. Now he works entirely on location. He was very glad to get rid of his studio. He hated the sterile, unrealistic atmosphere that it created. 'If you grow up with space, you can't work in a prison. People flip out working in a studio—I can't do it anymore. I need to see the sun.'

Since locations are very important he is very careful in choosing them. Once he has the idea for a picture he will travel around until he finds just the right place. Whatever the time of day or the kind of light he always uses flash and always works with a tripod. He never deviates from the original concept of a picture and will shoot a whole roll of film for one image, varying the exposures and changing the position of the model slightly. He always strives to get perfectly sharp pictures. He dislikes soft focus filters and he feels he needs a clear image to put his ideas across. Up until now he has always worked on 35mm but he is gradually changing over to the 5 x 4 format.

Colour is also very important in his pictures—'its psychological impact is enormous. It can trigger a shock in the viewer. Colour is one of the fundamental elements for representing reality. Its absence betrays realism.'

Leidmann is never short of ideas. He describes his energy drive as 'neurotic'. He realises that to achieve a respected position where people take note of what he has to offer he has to be continually progressing. As soon as he has finished one project he is bored with it and absorbed with the next. Since

Foxy Lady he has produced another book—*Banana Split*. He has already put that project out of his mind and is busy working on his next book which will be nothing to do with eroticism. He says, 'For a long time I dreamed of these pictures, this erotic perfume that is neither nudity nor fashion. For me, surrealism in photography consists of showing normal things in strange places. But it's all been done before. We all copy someone else. Because there is so little room for new ideas, that is all I think about.'

PAGE 236 TOP Cheyco Leidmann has cleverly used the wheel hub to reflect the palm trees and buildings of Los Angeles. Even in bright sunlight he always uses flash to capture the bright colours and obtain extreme depth of field.

PAGE 236 BOTTOM The skyline of Los Angeles was shot at dusk. Flash from the right gives the dark shadows and shows the warm skin tones in contrast to the deep blue of the sky.

PAGE 237 TOP Contrasting colours and shapes divide this shot into two distinct halves. Leidmann often crops out the models' faces to avoid the picture being dominated by their personality and to retain the symbolism of the image.

PAGE 237 BOTTOM This was taken at Malibu Beach. Flash on the models creates an eerie effect changing the colour of the surroundings and creating strong angular shadows. The clothes and the plant provide the bright colour contrast.

PAGES 238-9 The Foxy Lady number plate was specially made for the Verkerke calendar. Simplicity and shape are the key to the picture with the silhouetted leg as a symbol of eroticism. The exposure was 1/30 at f/22 on Ektachrome 64.

235

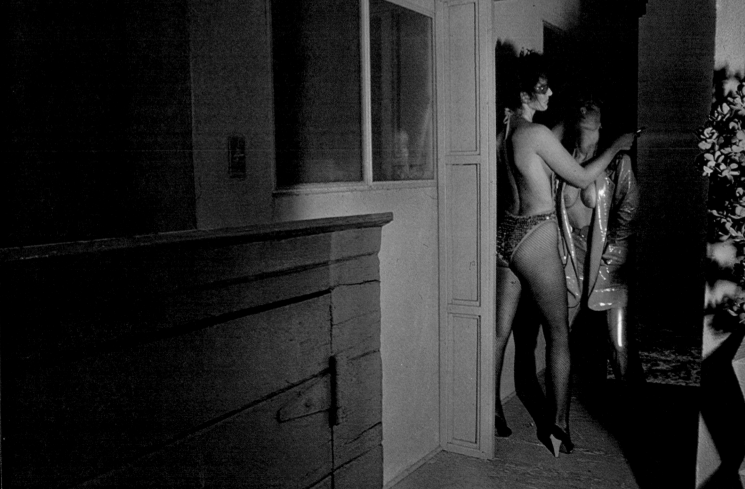

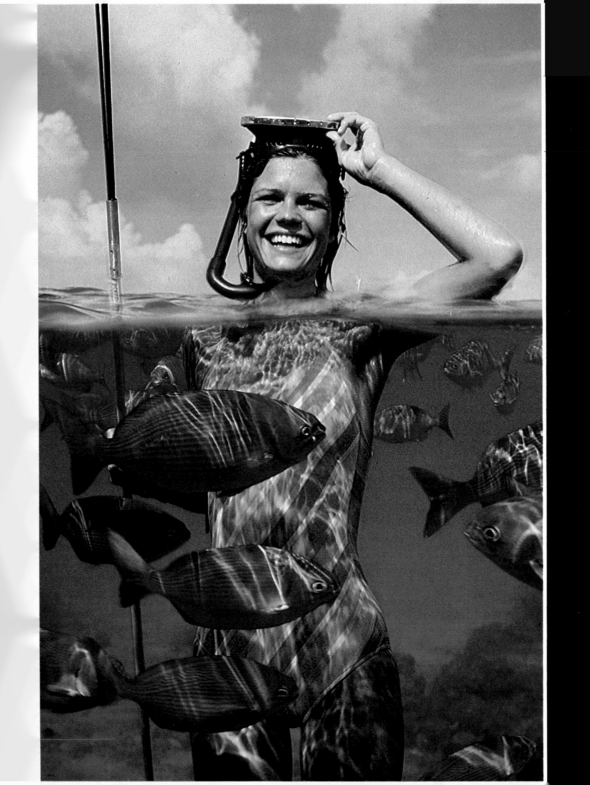

TECHNICAL SECTION

In principle there is no difference between the way that professional and amateur photographers take pictures. Whether the exposure and focus are set manually or automatically, both must be done before that essential act of releasing the shutter and exposing the film.

In practice, of course, things are different. As has already emerged. Not all professionals use the 35mm SLR cameras and films familiar to every keen amateur. Some of the other equipment used, such as large electronic flash consoles and view cameras, are rarely seen outside of the professional studio. The following technical section concentrates on these unfamiliar pieces of equipment and explains the materials and techniques used by the successful photographers featured in this book.

It also covers the ways in which photography as a profession is different from photography as a hobby. Amateurs, for example, can photograph what they choose, and learn from their mistakes. Professionals are generally told what to photograph, and if they make too many mistakes, soon go out of business.

There are some photographic approaches that have become accepted because, on the whole, they work well. In general you will find them useful as a starting point with a particular subject. Then, once you have mastered the basics, you will be in a good position to go on and introduce your own innovations. If that means 'breaking the rules', so be it. If you can produce an effective photograph, no one will much care how you did it—except other photographers who may want to copy the technique!

In fact, copying not only the techniques but the styles of the great photographers is a good way to learn how to control your pictures, and thus take better ones. This could be the beginning of a worthwhile career in photography.

THE PROFESSIONAL TOUCH

Because photographic images are made using a piece of machinery—the camera —it is tempting to see photography simply as a mechanical process, and the photographer as a mechanic. But stepping into the world of the professional reveals how simplistic this view is.

Different photographers work in very different ways—as this book shows. The successful photojournalist's camera is constantly at hand, and pressing the shutter release is instinctive, almost as automatic as the knee-jerk reflex. Yet a studio still-life photographer may allow an assistant to set up the camera, and may not even press the shutter release. The only thing that unites these two approaches is the photographers' personal vision. Each picture carries the stamp of the photographer's personality, regardless of who pressed the shutter release.

Increasingly, the role of the photographer is becoming narrower, and more involved with the act of visualizing and creating the picture, rather than with the mechanics of operating the studio, selling pictures or processing film. These tasks do not demand the photographer's individuality and insight, so they can be delegated to a group of people chosen by the photographer.

Many of the pictures in this book are the result of just such a team effort, in which the photographer directed a group of individual specialists.

THE ASSISTANT

The title 'photographer's assistant' covers all manner of sins. At the most menial level, the third assistant in a busy studio might just sweep up, make the coffee, answer the telephone, and take film to the laboratory.

At the other end of the scale, many assistants have extensive responsibilities, and may be competent photographers in their own right.

Generally, though, the task of a full-time assistant is to keep things running smoothly. This involves loading film, ensuring that items such as tape, fuses, card for reflectors and so on are always at hand, and dealing with the other specialists who might be needed on the shoot. In addition, an assistant might have to build sets, set up the lighting, and generally free the photographer to concentrate on the more creative aspects of the business.

Traditionally, working as an assistant has been seen as a stepping stone to a career as a photographer—John Swannell worked as David Bailey's assistant, and Bailey, in his turn, assisted John French (a highly successful fashion photographer of the early 60s)—as did Terence Donovan.

The assistant has access to the equipment and studio of the master photographer and, if exhaustion has not overcome enthusiasm at the end of a 12-hour day, the assistant can use these facilities to build up a personal portfolio.

However, in an attempt to cut down overheads, some photographers now employ assistants only when they need them, and pay on a day-to-day basis. An assistant who works freelance in this way may not even aspire to be a photographer, and simply aims to make a career from assisting.

THE STYLIST

The photographer's stylist is a professional 'finder', and is employed to beg, borrow and hire props, to pick locations, and possibly to arrange a selection of models from which the photographer will choose the most suitable face (or body) for a picture.

The stylist's tools are the telephone, a car or van, a Polariod camera for making a record of locations, a comprehensive card index, and a very good memory.

Many manufacturers and retailers can be persuaded to lend props and locations for a picture, in exchange for the company name appearing in a picture credit. A good stylist will be able to coax and cajole even a reluctant source to part with free goods or services.

HAIR AND MAKE-UP ARTISTS

Unless otherwise requested, a model will turn up at a fashion shoot with 'clean

hair, clean face', and although on low-budget editorial shoots for magazines the photographer and model will between them create the hair and face that the client wants, most advertising pictures need the services of a hairdresser and make-up artist.

A photographer or client may demand a 'look' that the model herself would not contemplate wearing outside the studio, because the camera and the eye often see things differently. For example, in order to make a model's skin texture look completely smooth, the photographer may ask for quite dark make-up. Overexposure then lightens the skintones, and creates an image of impossible perfection.

Certain colours of make-up, such as red lipstick, appear a different colour on film, and the professional make-up artist will choose a pallet of colours with this in mind.

The same applies to hair styles. They look good in front of the camera for ten minutes, but the curls might drop out after an hour, or lose their perfection in even a light breeze.

THE MODEL-MAKER

The skills of model-makers are like those of the musical accompanist—if they are good, you don't notice them. Ed White's pictures for Stanley Tools (pages 178-9) are the exception to this rule, as here, the model-maker plays the leading role.

A more common assignment for a model-maker is to build very large, or very small replicas of common objects. For example, if a picture calls for a pen to appear twice life size in a magazine illustration, the photographer could not simply take a picture of a pen resting on a pad of paper, and enlarge the photograph. To do so would greatly enlarge all the manufacturing faults in the pen, and the texture of the paper would look like coarse cardboard. The solution is to call in the model-maker to create a giant pen that, in the finished picture, is indistinguishable from the real thing.

Conversely, a client who is advertising pork pies may wish his product to look more generously proportioned in the picture than it is in reality. The answer to his problem is to have the model-maker turn out a plate that is slightly smaller than average, so that the pie looks bigger.

THE RETOUCHER

However much care a photographer takes in planning and shooting a picture, sometimes it is impossible for everything to be perfect. A location which is otherwise suitable for a picture of a Victorian fox-hunt may be marred by an electricity pylon, or by telephone wires and a TV aerial on a thatched cottage. A retoucher can remove the offending intrusion.

But a retoucher's skills do not stop at just putting things right. With more time and work, a retoucher can create a scene that never actually existed, by montaging together a background from a library photograph, and a foreground shot in the studio. Such photocomposition work can be very expensive though, and most photographers will try to create illusions like this in the camera—perhaps by using a projected background—rather than take the picture to a retoucher.

THE PHOTOGRAPHER'S AGENT

All photographers have a portfolio—a book of their best work in the form of published pages, original transparencies, or dupes (duplicate copy transparencies). By employing an agent, the photographer can get this portfolio seen by potential clients without leaving the studio.

An agent or representative does not usually handle just one photographer, as this would not bring enough income. Instead, an agent will represent five or six different photographers, each of whom specializes in a different area of photography. A balanced stable of photographers might consist of individuals who concentrate on fashion, food, travel, still life, and glamour.

THE PICTURE LIBRARY

By lodging existing transparencies with a picture library, a photographer can get income from material that would otherwise be gathering dust in a filing cabinet.

Picture libraries often specialize in specific areas of interest. Some cover just science and technology, or natural history, or even space flight. A publication that needs a picture of a particular subject will call the library, who will send a selection.

A typical example of studio collaboration—between stylist, set-builder and photographer, James Wedge, who hand tinted the final print.

CAMERAS & LENSES

35mm CAMERAS

The 35mm single lens reflex camera is standard equipment for many, many professional photographers. It is perhaps the ideal location camera—light in weight, and quick and convenient to use. The range of lenses available is enormous (there are more than 60 in the Nikon catalogue) and bolt-on accessories such as motor-drives increase the versatility of the cameras still further.

In order to make the maximum possible use of the modular construction of these cameras, most photographers opt for the top model of the range, and adapt the camera to suit their own particular needs. Some of the more unusual components in the camera range reflect this specialized professional demand.

Action or sports finders show a clear image of the focusing screen even when the photographer's eye is 5cm (2 inches) from the camera. Few amateurs would need such a device, but for a professional wearing goggles or a safety helmet, the camera would be useless without it.

These most expensive models in a camera system are built to withstand considerable use. Ashvin Gatha points out that on a single trip he might shoot 300 rolls of film, or 10,000 exposures, and he makes numerous trips every year. Only a solidly built camera will stand up to such punishment. A simpler model from the same system uses the same lenses, and takes equally good pictures, but its construction and price tag reflect the fact that only a tiny percentage of amateur photographers use more than five rolls of film *per year*.

A remarkable number of photographers mention that they use Nikon equipment. Since nowadays there is little difference in quality between the cameras and lenses of the better manufacturers, this may seem surprising, but it is at least partly due to the fact that Nikon have sensibly avoided making their cameras obsolete. A Nikon lens made yesterday will function perfectly when fitted to a Nikon F camera made in 1959. Nikon were also the first manufacturers to introduce a motor drive, and

this was enough to woo many photographers away from other brands. Today, an established photographer may have 15 or 20 Nikon lenses, so changing systems would be an expensive business—and Nikon's lead remains.

35mm LENSES

To a professional photographer, a lens is simply a tool, and must earn its keep. No photographer will purchase new equipment unless convinced that the lens will directly result in improved pictures, and therefore increased picture sales, or else that lens will make it possible to take pictures in extreme conditions that would normally preclude photography.

Low-light lenses fall into the latter category, and for some branches of photography, such as sports, they are essential. Eamonn McCabe is shown on page 131 holding the 400mm f/3.5 lens with which he takes many of his pictures. A 'standard' aperture at this focal length would be f/5.6—one and a half stops slower. Without such lenses, sports photographers would be forced to use unacceptably slow shutter speeds in dim light, or would have to use faster film, and accept the loss of quality.

The cost of such exotic glassware is considerable. For example, a 200mm f/2 lens is nine times as expensive as the f/4 equivalent, a high price to pay for two extra stops.

ROLL-FILM CAMERAS

For much professional work, particularly in the studio, the 35mm format is too small, and roll-film reflex cameras come into their own. These cameras are loaded with 120 film—a 2½ inch (6.5cm) wide strip which is rolled onto plastic spools, and backed by paper. Different 120 cameras take pictures of various sizes: some are as big as 6x7cm, or as small as 6x4.5cm. Most cameras produce an image which measures 6x6cm. Since the area of this square picture is approximately four times that of 35mm film, it needs proportionally less enlargement, so the quality of the final image is better.

In dim light, a fast lens is essential for freezing rapid movement—as in this Eamonn McCabe picture.

The bulk and weight of a low light lens is considerable. Compare the 400mm f/4.5 lens shown here with the standard lens alongside it.

A few roll-film cameras have two lenses, one for viewing the subject, and the other for forming the image on film.

Twin lens reflex cameras include the now-obsolete Rolleiflex, and its simpler cousin, the Rolleicord, referred to by Eve Arnold.

Most modern roll-film cameras, though, are SLRs. Details vary with make, but the **Hasselblad 500CM** is a typical—and classic—example of the type. It has a box-shaped body, which houses the reflex mirror, the focusing screen, a rudimentary shutter, and film wind mechanism. On to the front of the camera fits the lens; on to the back, an interchangeable film magazine; and on to the top, either a folding hood, which shades and protects the focusing screen, or an eye-level pentaprism that produces an image which is the right way round.

Without this prism, the camera must be held at waist level, and the image on the screen is back-to-front. This is an inconvenient arrangement that takes some getting used to, since when you swing the camera to the left, the image on the screen moves off to the right!

The lens barrel of the Hasselblad 500 CM contains both the iris diaphragm and the leaf shutter for film exposure.

The simple shutter in the camera body is there only to protect the film from fogging when changing lenses.

Leaf shutters are constructed in such a manner that the camera can be synchronized with flash at any speed. This is a very useful feature when taking pictures by a combination of flash and daylight, such as fill-in flash. It enables the photographer to control independently the exposure from the two different light sources by adjusting the shutter speed and aperture in unison.

The most important feature of the Hasselblad and similar cameras is that an interchangeable **magazine back** holds the film. A single roll of film provides between 10 and 15 exposures, so reloading is frequent. With a pre-loaded magazine alongside the camera, changing film takes only a matter of seconds to complete.

With two magazines, a photographer can use both colour and black-and-white, changing film in mid-roll if necessary. To prevent light from fogging the film when doing this, each magazine is fitted with a metal blade that covers the film when the magazine is removed from the camera. This is the **darkslide** that Patrick Lichfield refers to on page 24. Safety interlocks prevent the shutter release from being pressed when the metal slide is in place, and also lock the magazine on to the camera when the blade is removed. This prevents accidental fogging of the film, and avoids blank frames.

The standard film magazine can also be exchanged for one that takes Polaroid film for instant lighting tests, or for the 70mm magazine, which John Zimmerman mentions on page 142. This magazine takes sprocketed 70mm film in cassettes that resemble those used in 35mm cameras. Each cassette holds up to 100 frames of film.

Other roll-film cameras differ in detail from the Hasselblad 500CM, but with the exception of the Pentax 6x7, which looks like an overgrown 35mm SLR, all share the same boxy shape. Not all have interchangeable backs, though. Instead, some have a **charger**, which is a small plastic insert that is loaded with film and dropped into the camera back. Thus the film can be changed just as quickly as on a camera that has interchangeable magazines, but not in mid roll.

Focal plane shutters are found in quite a few roll-film SLRs, housed in the camera body, instead of a leaf shutter in the lens. This arrangement has two advantages. A focal plane shutter can be constructed with a higher top speed—the Hasselblad 2000FC has a focal plane shutter that gives exposures as brief as 1/2000, compared to 1/500 on the leaf-shuttered Hasselblad 500CM. The other advantage is economy. Instead of buying a separate shutter with each lens—and paying for it each time—the photographer buys just one shutter, the one built into the camera. Focal plane shutters have one big disadvantage, though, which is that they cannot be synchronized with flash at the faster speeds.

The electronic automation that has revolutionized 35mm camera design has made slower inroads into the construction of the roll-film cameras. In their basic form, most 120 SLRs are manual cameras. They often have mechanically governed shutters, and have no on-board meter. This is usually available as an accessory, built into a prism view-

Besides interchangeable lenses, the Hasselblad roll-film camera can be fitted with a broad range of accessories. This picture shows a meter prism, lever wind, magazine, and lens hood.

During exposure, the mirror that normally reflects light into the viewfinder of a reflex camera flips up, so that the image from the lens can reach the film.

The Pentax 6x7 looks like a 35mm SLR, but its much larger size reflects the bigger frame format of the roll film that it uses.

finder. However, even with a metering prism, the photographer may be required to read off the shutter speed or aperture from a display in the viewfinder window, and transfer this data to the camera's controls.

Although this sounds like a rather cumbersome process, it does not often cause difficulties in practice. Roll-film SLRs are rarely used in circumstances that demand instant response to changing light conditions. Often, the photographer will use a separate hand-held meter, or a flash meter, so full automation would be wasted.

Furthermore, other functions of roll-film cameras are more laboured than those of 35mm models. For example, few 120 SLRs have an instant return mirror. On pressing the shutter release, the image in the viewfinder disappears, and only reappears when the film is wound. A motor drive obviously speeds things up a little, and some but not all cameras have a motor—either built in or available as an accessory. Even so, the fastest motor drive for a 120 camera advances film more slowly than even the slowest motor winder on a 35mm camera.

The standard lens for a roll-film SLR has a focal length that gives the same field of view as a 50mm lens on a 35mm camera. Accessory lenses are not so varied as those for the smaller format. The longest available focal length in most roll-film systems is around 500mm. This produces a five or six times magnification compared to the standard lens. By comparison, a 1000mm lens on a 35mm camera magnifies the subject by a factor of 20.

Although this might sound like a drawback, in practice it presents few problems, because the larger image size of a roll-film negative or transparency can be cropped down to frame the subject more tightly. Lenses with focal lengths longer than 500mm would, in any case, prove too bulky and cumbersome to be useful.

SHEET-FILM CAMERAS

Some professional applications demand a bigger image, or a more precisely controlled one, than even a roll-film camera can provide. Sheet-film cameras satisfy this demand.

These large cameras go by other names. They are often called **plate cameras**, because, instead of film, their predecessors used plates of glass coated with a light-sensitive emulsion. Nowadays, though, such cameras use sheets of film, usually 10x8 or 5x4 inches, but sometimes intermediate sizes such as 6½x8½ inches, or larger sizes. Some cameras are called field cameras, technical cameras, or for obvious reasons **large format cameras**. Kenneth Griffiths is seen staring into the lens of his field camera on page 78.

On **monorail cameras**, the various components slide along a single metal bar—a monorail. Ed White appears with a monorail camera in his picture on page 176.

Whatever the name, these large cameras have several features in common. They are incredibly simple in construction. Each has a lens and shutter fitted into a panel at the front, and a sheet of ground glass in a panel at the back. The two panels are joined by a light-tight bellows.

Where does the film go? The film is not loaded directly into the camera. Rather, it is loaded into **film holders**, just as roll film is loaded into magazines. But instead of holding enough film for 12 pictures, the holder for sheet film takes

Sheet film is best suited to subjects where quality is of paramount importance—as in this still life by Tessa Traeger.

Sheet-film cameras though expensive are structurally simple. Just a lens, a sheet of film, and a bellows in between.

just two sheets, back to back.

This holder, which is shaped like a very shallow box, must be loaded in total darkness, then sealed up with darkslides. Once loaded, the film holder can then be slid into position just in front of the ground glass panel that forms the back of the camera. But before doing this, the camera must be set up and focused.

USING SHEET FILM

The routine for taking a picture on sheet film is so vastly different from using a 35mm camera, that it is worth looking at the procedure in detail, step by step:

First, the photographer fixes the camera to a heavy tripod. It is almost impossible to hand-hold a modern sheet-film camera.

Next, he locks the shutter open, and moves the iris diaphragm to its widest aperture. If he now points the camera at the subject, he will see a dim, out-of-focus image on the ground glass screen at the back. The image is upside down, and the wrong way round, and because it is so dim, he must cover the back of the camera (and his head) with a black cloth, to exclude stray light.

Having done this, he can compose the picture—still inverted and reversed—on the ground-glass screen, and focus. Focusing is accomplished by moving the front and back panels closer together, or further apart, using two knobs.

Once the image on the screen is sharp, and the picture composed as he wants it, he can come out from under the black cloth, and slide a sheet film holder into place at the back of the camera. This puts a sheet of film—covered at present by a protective dark slide—into the position previously occupied by the ground glass screen on which he focused. The glass itself is pushed backwards when the film holder is inserted.

Next, he closes the shutter, sets the shutter speed to the required value, and closes down the aperture to the correct f-stop.

Now for the moment of truth—he withdraws the darkslide that protects the film, and presses the shutter release, to take the picture.

This probably sounds like a complicated and time-consuming business—which it is.

CAMERA MOVEMENTS

Photographers are prepared to put up with the elaborate ritual of the sheet-film camera not just because of the finely-detailed images it produces, but also because the camera allows much closer control over how the subjects appear in the photograph. Camera movements accomplish this control.

The lens on a 35mm or roll-film camera is fixed in position relative to the film. Granted, it moves forwards to focus on close objects, and back to focus on distant ones, but the axis of the lens always stays at right angles to the film. Look now at Ed White's camera in the picture on page 176. The lens panel at the front is tilted forwards. This means that the top of the film (which is the bottom of the picture—remember that the image is upside down) is farther from the lens than the bottom of the film.

The effect of this lens tilt is simultaneously to bring into focus close parts of the subject at the bottom of the picture, and distant parts at the top. Turn now to Ed White's picture of the hammer, floorboards and mouse. You can see how this looks on film. Instead of being at right angles to the lens axis, as it usually is, the **zone of sharp focus** lies in the same plane as the floorboards, so these are sharp from the immediate foreground right through to the distant horizon. Even if the lens is at full aperture—so depth of field is negligible—every one of the nailed-down floorboards will be sharp. This perhaps illustrates the value to the still-life photographer of just one camera movement.

As well as tilting, the lens of a sheet-film camera moves up and down, and from side to side, and so does the film panel. These movements, however, do not affect the position of the plane of sharp focus. Instead, they move the image around on the focusing screen, so that, for example, by sliding the lens upwards the photographer can take a picture of the whole of a tall building, without tilting the camera upwards. Keeping the camera level ensures that in the finished picture, the sides of the building do not appear to converge towards the upper storeys. Such converging verticals are not acceptable in a professional architectural photograph.

Some indication of the value of this

Tilting the camera up to take in the top of a building causes the walls to converge on film. Sliding up the lens of a sheet film camera, on the other hand, keeps the verticals parallel.

Swinging and tilting the lens and film of a sheet-film camera helps to control depth of field. Ed White used camera movements to create perspective.

particular camera movement can be gained from the fact that manufacturers of lenses for 35mm cameras duplicate the 'rising front' movement on perspective control lenses. Such lenses, however, give only a fraction of the flexibility and control of a sheet-film camera.

The advantage of a perspective control lens, though, is that it can be used on a smaller format camera. Most perspective control lenses have a focal length of 35mm, and can be shifted by about 10 or 11mm (slightly less than ½in) in any one direction. Some manufacturers produce perspective control lenses with a wider angle of view—Nikon, for example, make a 28mm perspective control lens.

Just as lenses for sheet-film cameras have only a limited image circle (and therefore limited camera movements) so too do perspective control lenses for 35mm cameras. The far limit of movement is usually indicated by a mark on the lens mount, and occasionally, a mechanical coupling device prevents the lens from being shifted so far that the edge of the image circle will cut into one corner of the frame.

Most perspective control lenses simply slide from side to side, and duplicate the 'rising front' and 'cross front' movements of a sheet film camera. They cannot, therefore, be used to control the position of the plane of sharp focus of a picture. However, one manufacturer—Canon—produces a perspective control lens that will also swing and tilt.

Not all sheet-film cameras have the facility for equal amounts of camera movements. Monorail cameras give the most versatility, and movements on many of these cameras are limited only by the lens in use. A field camera has more limited movements, but is less cumbersome to carry around than is a monorail. A field camera could be used almost anywhere that you could set up a tripod, but a monorail is more at home in the studio.

Prior to the popularization of roll-film and 35mm cameras, hand-held sheet-film cameras were standard equipment for the press photographer. These cameras had minimal movement, but they did have coupled rangefinders so that they could be focused without using the ground glass screen. The **Speed Graphic**

that Patrick Lichfield refers to on page 24 is one such camera.

SHEET-FILM CAMERA LENSES

Every lens, for whatever type of camera, produces a circular image—the film frame is just a central rectangle or square. For example, a lens designed for use on a 35mm camera produces an **image circle** of about 45mm diameter. The diagonal of a 35mm negative or slide is only 43mm, so the rectangular frame fits neatly into the image circle.

On a sheet-film camera, however, the circular image must be quite a bit bigger than the frame diagonal. This is because, by using camera movements, the photographer shifts the film frame around—and effectively chooses to use some part of the image circle other than the centre.

Thus the size of the image circle determines the maximum possible camera movement. Lenses for sheet film cameras are sold with a specification telling the user how big the image circle of the lens is, usually both at full aperture and at the smaller apertures that would be used much more often.

A photographer who needs extremely large camera movements might choose a lens designed for a bigger film format. Such a lens provides a larger image circle, permitting greater displacement of the lens. Conversely, still-life photographers sometimes economize by using lenses designed for smaller formats, because when focused on close subjects, any lens produces a bigger image circle than when the subject is at infinity.

The focal length of the standard lens for a sheet-film camera varies according to the size of the film. For example, the standard lens for a 5x4 camera has a focal length of 150mm, while for a 10x8 camera, 300mm would be considered a 'normal' focal length.

Large ranges of lenses are unnecessary for sheet-film cameras, since the big film format can be cropped down to close in on small subject details though, of course, this wastes some of the potential of the big image. Three lenses would be considered an adequate outfit for a 5x4 camera, and many photographers manage with just one or two—even though they might have five or six lenses for their 35mm cameras.

FILMS

Professional photographers are very fussy about film. After all, they have to be—their business and livelihoods depend on the colour, sharpness and permanence of the pictures they produce.

A glance through the preceding pages will reveal that almost all the photographers use **transparency film** (slides). There are sound reasons for this. The most important reason is that colour reproduction—that is to say, the methods by which books and magazines are printed—gives optimum results ·from colour transparency film. Virtually every picture in this book was reproduced from a colour slide, and even when a photographer uses colour negative film and makes a print, the picture will often be rephotographed onto 5x4 film to make a transparency for reproduction.

A second reason for using colour slides is that the sharpness of transparency film greatly exceeds that of negatives and grain is much finer. This is particularly relevant with 35mm film, which needs more enlargement than other formats.

A third motive for using slides is that film exposed in the camera makes the final picture. Making a colour print from a negative means passing the image through an enlarging lens—and no matter how good the lens, this reduces the quality of the picture.

These points are all-important to the professional, but this is not to say that every amateur photographer will get better pictures by using slide film. The reverse is probably true, in fact, because slide film must be exposed very precisely and does not have the enormous latitude to exposure and lighting errors that colour negative film has. Many of the cameras used by hobbyist photographers are designed for use with colour negative film, and will give poor results with other types.

Much of the slide film used professionally is Kodak's **Ektachrome**, or E6 compatible films from a different manufacturer. To the working photographer, the great advantage of such film is that its speed can be varied by changing the processing cycle. Cutting the time that the film spends in the first developer reduces the film speed, leading to a darker image. This is called **pulling the film**. Increasing the first development time—**pushing the film**—lightens the picture.

Sports or action photographers who take pictures in dim light often use this pushing facility. They deliberately underexpose their films by setting the ISO/ASA dial to a speed higher than the film's nominal rating. This allows them to use a faster shutter speed to stop action, or a small aperture for extra depth of field. Increased development at the processing stage compensates for the underexposure, so the pictures do not look too dark.

Pushing and pulling of film is also a useful way of 'fine tuning' the density of the picture, even when the photographer believes that the level of exposure was correct, as explained in the section headed 'exposure control'.

'PROFESSIONAL' FILM

If you have ever watched a professional photographer at work, you may have noticed packs of film marked 'Professional film'. The film in these cartons is made on the same machinery, and from the same materials as regular film of the same speed. So how does it differ from amateur film?

Professional films are in peak condition when they are sold. They are 'ripe' and they are meant to be used straight away, or else refrigerated until exposure. Amateur film, on the other hand, is despatched by the manufacturer when it is unripe. The dealer may keep the film on shelves for six months, and an amateur photographer typically takes another three months to use the whole roll. By the time the amateur film is processed, it is just ripe—whereas treated in the same way, a professional film would be past its peak.

In fact, amateurs who buy and use professional film stocks will actually get poorer results unless they adopt the habits of the pro, exposing and processing the film immediately.

EKTACHROME v KODACHROME

In addition to their popular Ektachrome films, Kodak manufacture two other slide films—**Kodachrome 25 and 64**—which have speeds of ISO/ASA 25 and 64 respectively. These films cannot be processed in the same chemicals as Ektachrome films and in fact, outside the USA, they must be sent back to Kodak for development.

Despite the slow speed of these films, and the inevitable delay involved in sending them by post to a distant laboratory (Ektachrome needs only one or two hours in a local lab) many pros use Kodachrome. This is because it is sharper, less grainy, truer in colour, and more permanent than any other film. A full explanation of why Kodachrome is so clearly superior is highly technical, but many working photographers have been convinced of the better image qualities of Kodachrome film by a side-by-side comparison of Kodachrome and other films.

To those individuals who, like Eric Hosking (see page 106), shoot pictures for a library or archive, a fading colour image is worthless.

A number of Hosking's bird photographs were taken 10, 20, or even 40 years ago, and though some of the early colour pictures in his file have faded noticeably—and irreversibly—those shot on Kodachrome are still as bright as when they were first processed.

BATCH NUMBERS

Full-time photographers use a great deal of film. They may buy 200 or 300 rolls of 35mm film at a time, and put it into a deep-freeze until they need it. Keeping film stocks like this ensures consistency from roll to roll, because it enables the photographer to buy film from just one manufacturing batch. Slight variations of film speed always occur from batch to batch, but never between individual rolls of the same batch, and for this reason, the batch number is stamped on the side of the film carton. When buying film in multiples of five or ten, make sure that all rolls are from the same batch.

Packs of professional film actually carry an individual film speed on the instruction sheet. This speed rating is a **true film speed**, that the manufacturer has determined by testing. It is frequently different from the **nominal film speed** printed on the box, though the difference is very minor. Most professional photographers will also test the film themselves, and may choose to expose the film at a speed different from that recommended by the manufacturer, if they want darker or lighter slides.

Most professional photographs are taken on transparency film—it gives better colour, but needs more careful exposure.

35mm film—actual size

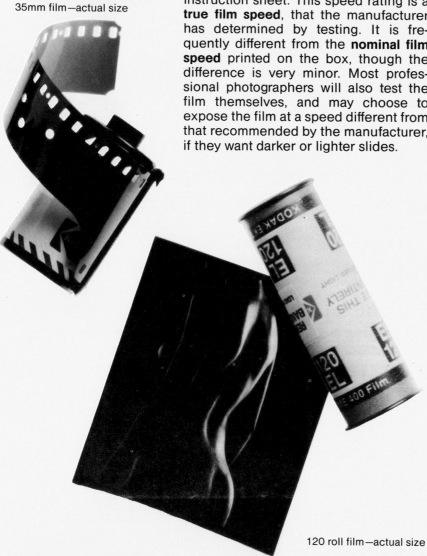

120 roll film—actual size

INSTANT FILMS

The impact that instant film has made on professional photography is inestimable. It has taken out the guesswork, and some would say it has made skill and experience unnecessary.

For lighting and exposure tests, photographers use Polaroid products exclusively. Equipment manufacturers design all their instant film holders to take only Polaroid film-packs, not Kodak film. Perhaps this is an example of 'the chicken and the egg'.

Polaroid film adaptors are available for all sheet film cameras, many roll-film cameras, and a handful of 35mm cameras. All these adaptors work with Polaroid's **peel-apart films**—not with the SX-70 plastic sandwich type. This is because peel-apart film is sold in a variety of different forms, including a version that gives both a black and white negative, and a black and white print.

For lighting tests, though, most photographers use **Polacolor 2**. This gives a fully-developed colour print within about 90 seconds, and at ISO/ASA 80, is within 1/3 stop of the speed of the most popular slide films, which are rated at either ISO/ASA 64 or 100. A full explanation of how instant film is used appears under the heading 'exposure control'.

BLACK AND WHITE FILM

The use of black and white film is shrinking gradually, but for some applications, colour is unlikely to replace it.

Black and white film has simplicity and immediacy in its favour. Photographers such as Terence Donovan (page 26) like to be able to step into a darkroom, and control the appearance of a print with great precision. Although this is possible with colour film, it is a great deal more complicated.

For the news photographer such as Terry Fincher, colour will never replace black and white film, unless the daily papers start to print their news pages in colour—and this is highly unlikely. Using a makeshift darkroom in a hotel bathroom, a photojournalist can turn out a black and white print within an hour of pressing the shutter release, and can send this, via a facsimile machine, all over the world. For catching deadlines, black and white cannot be matched.

LIGHTING

One of the hallmarks of a professional photographer is the ability to know when and how to use artificial light. A few successful photographers, it is true, go through their entire career without ever using even a small hand flash gun, but most use some sort of artificial light quite often. Indeed, certain styles of photography would be impossible using sunlight as the only light-source

TUNGSTEN LIGHT

Tungsten lamps are used more for location work than in the studio. They are light in weight, utterly reliable—the worst that can go wrong is a blown bulb—and uncomplicated to use. Professional photographers rarely use the inexpensive **photoflood bulbs** that fit into the lighting equipment normally sold to amateurs. Instead, they more often use lamps that were designed originally for use in the film industry. These units are fitted with long-life **tungsten-halogen tubes** which produce between 650 and 2000 watts.

Unless the camera is loaded with black and white film, or colour film balanced for tungsten light, a filter converts the colour of the beam to match the colour of daylight. This filter is made from heatproof glass, coated with a minutely thin layer of metal. Such **dichroic filters** do not fade in continuous use, whereas a dyed filter would gradually discolour. And since the filter is used over the light source, not the camera lens, the photographer can mix tungsten light and daylight without fear of the unpleasant colour casts that normally disfigure mixed-light pictures. Anthea Sieveking talks about these lamps and filters in her interview.

ELECTRONIC FLASH

Tungsten light is only useful for lighting relatively small subjects, because large spaces need a lot of light, and the power consumed and heat generated by massed tungsten lamps is enormous. And because tungsten lights often force the photographer to use quite long exposures, subject movement increasingly becomes a problem.

For these reasons, professional photographers use electronic flash extensively. Even the smallest professional units are big by amateur standards, and often draw power not from pen-cells in the gun itself, but from rechargeable batteries in a pack slung over the photographer's shoulder.

A typical **press portable flash unit** will give an aperture of f/16 on ISO/ASA 100 film, when directed straight at a subject 3m (10ft) away. This may sound like an unnecessary surplus of power, but few professionals actually point the flash directly at the subject if they can help it, as such an approach creates very unflattering lighting. Indoors, a photographer might bounce the light off the ceiling overhead to diffuse the light, and

FILL-IN FLASH

The exposure latitude of colour film is relatively limited, and for really top-class results, the shadows in a picture should be no more than three stops darker than the highlights. On a sunny day, the difference in brightness may be nearer five or six stops, but it is possible to reduce this range by using a flash unit to light the shadows. This technique is called fill-in flash.

With an automatic flashgun, all that is required in principle is to set the flash unit to two or three times the nominal speed of the film in the camera, and then choose a shutter speed by using the camera's meter in the usual way. The flash will provide ½ or ⅓ of its normal power, thus kicking some light into the shadows, and reducing the contrast.

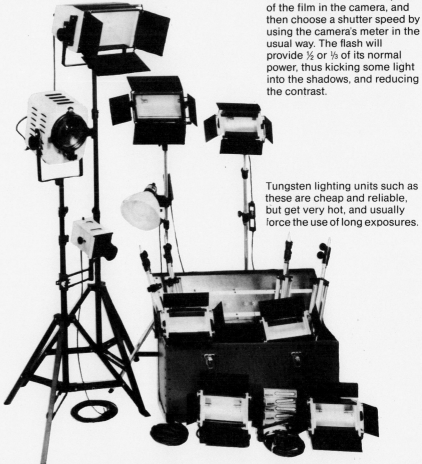

Tungsten lighting units such as these are cheap and reliable, but get very hot, and usually force the use of long exposures.

Electronic flash is vital for certain types of photography—it created the sparkle and glitter in this picture by Herbert Shulz

Monobloc studio flash units are quite cheap, yet they are easily portable, and quick to set up. However, they are limited in their power output.

this always cuts the light output down by two or three stops. The aperture needed with bounce flash would then be f/5.6 or f/8—and on a roll film camera, this is not far off the full aperture of the lens so depth of field is shallow.

A further reason for using a powerful portable flash unit is that it allows the photographer to fill in the shadows of a sunlit portrait with flash-light, even when the subject is quite a distance away. This technique is called **fill-in flash**, and is explained (on page 251).

STUDIO FLASH UNITS

In the studio, electronic flash is the rule, and tungsten light the exception. However, studio flash units are radically different from the small hot-shoe flash guns commonly fitted to 35mm cameras.

The first and major difference is in power. Since studio flash is rarely directed straight at the subject, power is not measured with the guide-number system familiar from portable units. Such figures are meaningless when the flash is bounced into a reflective umbrella, or diffused with opal plastic. Instead, gross power output is measured in joules —often also called watt-seconds.

A typical hot-shoe mounted flash has an output of about 20 joules. By comparison, the smallest mains-powered flash gives off 100 joules, and a large studio still-life set-up may require as much as 25,000 joules. That is a lot of light!

The power output of all studio flash units can be cut down progressively to reduce the intensity of the flash, but once the power level has been set, it does not automatically vary according to the subject distance, and in this sense, a studio flash unit operates like a manual flash gun, rather than a 'computer' automatic flash.

The second major difference between portable and studio units is the **modelling light** which is fitted to studio flash units. This is a small tungsten light fitted close to the flash tube, which simulates the effect of the flash. Since the modelling light is switched on all the time the unit is in use, it is possible to see at a glance how moving the flash will affect the light falling on the subject.

The third difference is versatility. Around the flash tube, the photographer is able to fit a wide range of different **reflectors.** For example, the light can be diffused by directing the flash into a reflective umbrella, or through sheets of white plastic. The biggest flash-units are nick-named **fish-friers** and **swimming-pools**—terms which were coined to convey the enormous size of the reflectors that house the flash tubes. Some of these units are as big as a tent, and create an evenly illuminated surface measuring two metres square. Such a light-source creates very soft light which closely resembles daylight from a window.

Every studio flash unit has two major components: the **head** that houses both the modelling light and the tube that actually makes the flash; and the power supply, that contains large **capacitors** and **step-up transformers** to provide the high voltages needed to operate the flash head.

The smallest studio flash units integrate these two components into a single

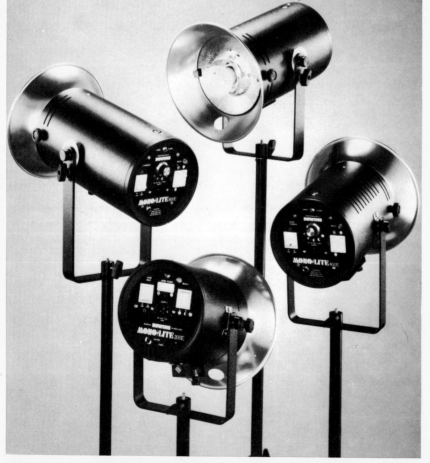

housing that sits atop the lighting stand. These **monobloc units** are convenient, especially for location work, and provide up to 1000 joules of power. However, when the weight of the unit is raised on the lighting stand to a height of around three metres, (3¼ yds) the whole apparatus sways rather alarmingly, and stability can at times be a problem.

For larger amounts of light, the power supply stays safely at floor level, in a box the size of a small suitcase, and only the light-weight flash-head perches at the top of the stand. A typical unit of this type has a power output of around 2000 joules, and this can be split among two or three heads. Alternatively, two or more power supplies can be used to feed energy to a single flash-head, thereby producing up to 8000 joules from just one big light.

The most powerful flash units are not exactly portable. The power supply takes the form of a **console** which is the size of a two-drawer filing cabinet, and this channels about 5000 joules to several flash heads. For very large sets that require even more light, the photographer will link together several consoles, or perhaps use a bespoke console made to individual specifications.

Such powerful flash units create bursts of light many times brighter than the sun—though only for a fraction of a second. Perhaps it is surprising that so much energy is needed just to expose film. The explanation is to be found in the sheet-film cameras commonly used for still-life photographs. Lenses for these cameras have very limited depth of field, and for a still-life photograph on 5x4 film, the lens may be stopped down to f/22 or f/32. On 10x8 film, f/64 is not uncommon.

Obviously, the cost of these units is considerable, and photographers constantly seek ways of cutting down on their power requirements. Still-life photographers are fortunate in that they usually deal only with static subjects. They often manage with very little power by the simple trick of blacking out the studio, and firing the flash several times over, with the shutter held open.

Unfortunately, this technique does not work with living objects, or even with liquids which might move during the two or three seconds that the flash unit takes to recycle—thus causing a double image.

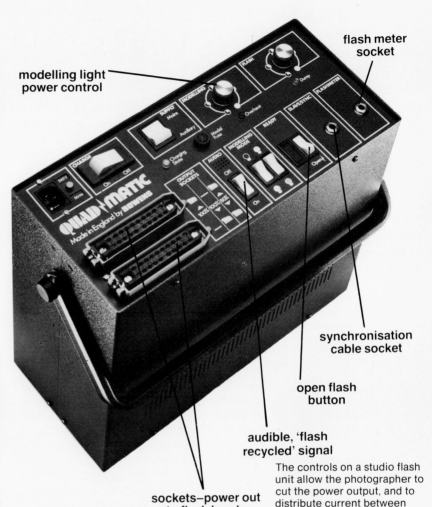

modelling light power control

flash meter socket

synchronisation cable socket

open flash button

audible, 'flash recycled' signal

sockets—power out to flash heads

The controls on a studio flash unit allow the photographer to cut the power output, and to distribute current between several flash heads.

AMATEUR TIP

More power from flash
When taking still life pictures indoors, boost the power of a small portable flash by locking open the camera's shutter, and popping the flash several times. To start with, set the aperture according to the flash unit's guide number, then close down the aperture as follows:

2 pops close lens 1 stop
4 pops close lens 2 stops
8 pops close lens 3 stops
16 pops close lens 4 stops.

Heavy cables carry current from the power pack to flash heads like these, which combine a flash tube and modelling light.

EXPOSURE & COLOUR

Every photographer knows the importance of correct exposure, but professionals are more particular than most people about the density of their transparencies. While amateurs usually aim to be within one stop of the correct setting, few pros would be happy with more than half a stop over- or underexposure. Here is how they apply their critical standards to day-to-day photography.

METERS

Although the meters built into SLR cameras are perfectly accurate under average conditions, there are occasionally situations that can fool **TTL (through the lens) metering**. For this reason, many professionals prefer to use a separate hand-held meter instead of, or in addition to, their cameras' TTL meters. As an alternative, they may use one or more of the techniques outlined below to control image density.

All TTL meters measure the light from the central portion of the camera's field of view. For a typical scenic subject, this is fine, but suppose that the photographer is interested in just a small part of the subject, perhaps a part that is not in the centre of the picture. In these circumstances, it is simpler to use a hand-held **reflected light meter** to measure the brightness of the area of interest, rather than removing the camera from the tripod to take a close-up reading with the TTL meter.

Besides taking reflected light readings, in this way, most meters measure **incident light**, that is to say, the light falling on the subject, rather than the light reflected. Incident light metering is the most accurate method for transparency film, because the reading is not affected by very dark or light subjects—which may mislead a reflected light meter.

Since an incident light meter must be held at the subject position, and pointed at the camera, as shown, no camera can have a built-in incident light meter. Despite this minor inconvenience, the accuracy of incident light meters makes them popular with professionals.

Reflected light meters (above) measure the light that bounces off the subject. In the incident mode (below), the meter reads the light that falls on the subject, and is not misled by very dark or light toned subjects.

Spotmeters are popular, too, but are used mainly for subjects that cannot be approached to take a reading in a conventional manner—such as spotlit performers on a large, dark stage. Looking through the viewfinder of a spotmeter, the photographer sees an image that resembles the view through a 35mm SLR fitted with a 200mm lens. In the middle of the field of view, a tiny circle marks the area of the meter's sensitivity. By placing this circle over, say, the performer's face, the photographer can take a very selective, precise meter reading which ignores the unimportant darkness of the stage.

For photography in the studio, a **flash meter** is a useful, but not an essential piece of equipment. Flash meters usually measure only the light from the flash units, and ignore ambient light, as if the studio was totally dark. On firing the flash, the display on the meter shows the correct aperture using **LEDs** (light emitting diodes), an **LCD** (a liquid crystal display), or with a needle that swings across a scale. Most flash meters can accumulate readings in case the photographer 'pops' the flash several times to increase the overall exposure. A few flash meters can also measure ambient light, or a combination of both flash and ambient light.

Some photographers, however, do not bother with a flash meter, they simply guess the aperture when using flash in the studio! Possibly this sounds like a haphazard and unreliable method of judging exposure, but in fact it is not. A glance at the power supply to the flash quickly tells the photographer how much energy is being directed to each flash head, and experience will give a pretty good idea of what the aperture should be. A Polaroid test then helps to home in on the exact exposure. Some photographers are so adept at this guesswork that they can produce a perfect Polaroid print first try.

POLAROID TESTS

An instant film test not only helps a photographer to verify that the exposure

is approximately correct, but it also checks every piece of equipment the photographer is using—the flash, the lens, the shutter, the synchronization of flash and shutter, and so on. The only thing it does not check is the film itself, because the characteristics of Polaroid film are never quite the same as transparency film. A Polacolor 2 print is more contrasty than regular film, so a lighting set-up that produces a good Polaroid may result in rather a flat transparency lacking 'sparkle'. Furthermore, like any film, Polaroid varies from batch to batch, and changes colour and density according to the temperature at which it develops.

Many photographers have the rather surprising habit of warming the Polaroid print in one armpit while the image develops. Even in air-conditioned studios, they swear that this technique produces more consistent results.

Despite these slight drawbacks, Polaroid is a valuable tool, particularly for checking lighting balance. If a set utilizes both flash and ambient light, Polaroid film is a vital way of checking the relative brightness of each individual light source. For example, an architectural shot of a house interior will probably have at least three light sources: the photographer's flash units, the windows of the room, and tungsten table and pendant lights. Changing the camera's shutter speed alters the brightness on film of the continuous light sources—the daylight and tungsten lamps—but the flash exposure is affected only by changing the aperture. Exposure and flash meter readings may reveal the approximate relationship between these sources, and will give a rough estimate of the effect of changing the shutter speed and aperture. But only a Polaroid test will give a visual indication—and the photographer can show this to the client for approval.

BRACKETING

Even after taking a Polaroid test—or perhaps just a meter reading—a great many photographers bracket their pictures. They make one exposure at the setting they believe to be correct, then take two more pictures. One of these they slightly overexpose, and the other one is deliberately underexposed by an equal amount. Thus the 'high' and 'low' pictures bracket the middle one. Usually these three exposures, bracketed at half or one stop intervals, will ensure that at least one picture is perfectly exposed, but when a photographer is particularly anxious to get the picture right, or is uncertain about the exposure, five or even more bracketed pictures may be necessary, each at different settings.

When using studio flash, bracketing is usually done by changing the power output of the flash heads, rather than by changing the camera aperture. This ensures that depth of field does not change from one shot to the next.

Bracketing pictures is not always the answer to exposure problems, and consumes a lot of film. And in portrait photography, a photographers' maxim might be: 'The most perfectly exposed pictures of a bracketed series invariably show the model at his or her worst.'

With portraits and other pictures of live subjects, there may be only one picture that pleases the client, even if the photographer exposed 100 rolls of film, and this one picture *must* be perfectly exposed.

FILM TESTS

To cope with this challenge, a photographer using sheets of film will not bracket, and instead will make all the

Polaroid lighting tests are invariably made on peel-apart film—not the 'one step' type.

Light meters for measuring flash exposure are similar to ordinary meters—except that they display only the aperture.

To achieve the saturated colour of this picture, Robert Farber used a polarizing filter with Kodachrome 64.

exposures at one aperture, with a single lighting set-up. Then, by processing just one sheet of film in advance of the rest, a check can be made on whether the exposure was exactly right. If it was not, the remainder of the sheets of film can be pushed or pulled in processing, to correct for the exposure error.

This is fine with single sheets of film, but what if the photographer was using a 35mm camera? Nobody wants to process a whole roll of 36 pictures just to check exposure.

Clip tests can be run by the laboratory with roll film and 35mm. This is a very simple procedure that wastes only a little film. At the start of the roll, the photographer shoots a few test frames—five or six on 35mm, and two or three on roll film. These frames may just show the model on the set, doing nothing in particular. They may even be pictures of the photographer's assistant, standing in before the real model arrives. The subject matter is not all that important, because these frames will not be shown to the client.

After the session, the photographer asks the lab to run a clip test. In the darkroom, a technician snips off the first few frames that were exposed as a test, and labels and stores the balance of the film. The clip test is then processed, and the photographer checks the exposure as before, requesting a processing adjustment if necessary.

CONTROLLING COLOUR

Just as exposure control is more important to the professional than to the amateur, so too is the control of colour. The colour negative films that are so popular among amateur photographers are remarkably forgiving of the changing colours of light, because colour imbalances are easy to correct at the printing stage. Some of the most recent film types—notably Kodak's 'VR' range of films—can be exposed without corrective filtration in almost any light, and still produce reasonably good results.

Transparency film is less tolerant, however, and the professional photographer has therefore to be constantly conscious of the colour of the light that illuminates the subject, and must always be ready to use filtration should the light change.

Ordinary transparency film gives the best results in daylight—a combination of light from the sun, and light from blue sky. If daylight film is exposed using any other light sources, the resulting pictures will show incorrect colour—the slides will have a **colour cast**. The exception to this rule is electronic flash, which has the same colour as daylight.

Photographers quantify the colours of light using the **colour temperature system**. Under this system, the colour of each light source is measured, and assigned a colour temperature value, usually in Kelvins. For example, the orange glow of a 100W household bulb has a colour temperature of around 2900 Kelvins (2900K), and the light from clear blue sky when the sun is obscured by clouds measures about 20,000 on the Kelvin scale.

If daylight-balanced colour slide film is used in lighting other than sunlight or electronic flash, a filter is necessary to correct the colour rendition. This filter usually goes over the camera lens, but in some circumstances it must be fitted over the light source, as dichroic filters, for example, are fitted over tungsten lamps.

The colour temperature system simplifies filtration by assuming that light is either too yellow, or too blue. While this is true for sources that produce light by heat, such as the sun, or a light bulb, the assumption is not valid when applied to cool light sources such as fluorescent tubes. These light sources cannot be assigned a specific colour temperature—they are too red or too green.

When light from such a source falls on the subject, complete colour correction is sometimes impossible, but a reasonably close approximation to true colours can be achieved using **colour correction filters.** Unlike the filters used for changing colour temperature, which have arbitary numbers assigned by the manufacturer, colour correction filters follow a logical system. They are available in six colours—Red, Yellow, Green, Cyan, Blue and Magenta—and six strengths. The weakest filter value in each colour is almost clear, and the strongest is a rich, saturated colour.

These filters are used not only when the light source does not match the film's sensitivity, but also to compensate for small batch-to-batch variations in the colour response of the film.